NEW YORK SEPTEMBER 11
BY MAGNUM PHOTOGRAPHERS

Steve McCurry • Susan Meiselas

Larry Towell • Gilles Peress • Thomas Hoepker • Alex Webb

Paul Fusco • Eli Reed • David Alan Harvey

Bruce Gilden • Chien-Chi Chang • Bruce Davidson • Hiroji Kubota

Dennis Stock • Burt Glinn • Richard Kalvar

Josef Koudelka • Raymond Depardon

Additional photographs by Evan Fairbanks, Adam Wiseman, Ann-Marie Conlon

Introduction by David Halberstam

New York, NY

SEPTEMBER 1, 1939

I sit in one of the dives
On Fifty-second Street
Uncertain and afraid
As the clever hopes expire
Of a low dishonest decade:
Waves of anger and fear
Circulate over the bright
And darkened lands of the earth,
Obsessing our private lives;
The unmentionable odour of death
Offends the September night.

.....................................

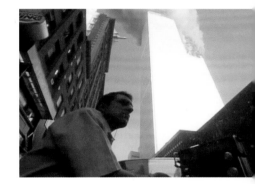

Into this neutral air
Where blind skyscrapers use
Their full height to proclaim
The strength of Collective Man,
Each language pours its vain
Competitive excuse:
But who can live for long
In an euphoric dream...

—W. H. Auden

NEW YORK SEPTEMBER 11

by David Halberstam

The date, September 11, 2001, now has a certain permanence, graven on our collective memory, like a very few others December 7, 1941, and November 22, 1963, dates which seem to separate yesterday from today, and then from now. They become the rarest of moments; ordinary people will forever be able to tell you where they were and what they were doing when they first heard the news, as if the terrible deed had happened to them, which in some ways it did.

Up until that moment America had been spared the ravages of the last century of modern warfare. The bombing of the World Trade Center and the Pentagon ended an amazing historical period in American life, one which I place at 87 years, beginning with World War I (we actually entered it three years late) during which we rose to unwanted superpower status, became the most powerful nation in the world, and yet none of the terrible carnage of that era took place on our soil. We had come to believe as a people, protected as we were for so long by our two great oceans, that we were immune to the awful dangers and cruelties and viruses of the rest of the world.

That sense of immunity, as these photographs so dramatically show, ended on September 11, 2001; for New Yorkers more than most Americans, what happened was particularly personal. The World Trade Center was a unique landmark for us, a wanted and needed guiding beacon, to be seen, when we had been out of the city, and when making our return, a sign that we were finally approaching the city in which we lived.

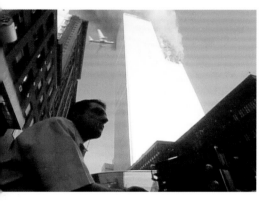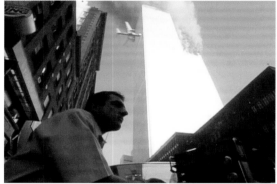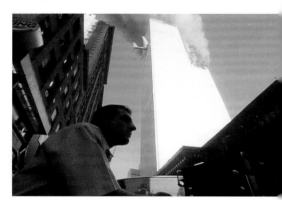

Each tower was in its own way a marvel of what man can do in reaching to the sky from a city where space was always of the essence; each reflected the talents and sheer hard work of thousands and thousands of men and women who never knew each other but were bound together in something larger than themselves; each became in the end a symbol of what man can do to man when he acts upon his cruelest impulses.

Each building was also in its own way a universe, a small self-contained city. To understand why the rubble is so enormous, imagine if you will ten skyscrapers of twenty floors each, destroyed in one stunning, frightening moment.

Each tower was in some way a part of our lives. I, like almost all New Yorkers, had not just been guided back to the city by them, but had been there often, eaten at their restaurants, grand and lowly, from those with three stars to those which offered only slices of pizza. I had attended business conferences there, had interviewed a visiting VIP for a book there. For several years I worked out at a gym in an adjoining building, a building which itself may not last and may have to be torn down.

All of us have certain earlier memories of being there, and of the wonder of what the buildings represented architecturally: I who am fearfully and pathologically acrophobic can remember about ten years ago giving a lecture there, and finding to my extreme discomfort that it was scheduled for the very top of one of the towers. I was so terrified that I held on to the table in front of me as if for life itself for the full hour.

And now those two buildings are rubble, and New York is not the same, and in that part of our brain where we have catalogued the other clips of our saddest moments—the Zapruder film, and the film clips of the Challenger disaster—we place the images of this moment, ever real, forever immediate, never to be forgotten. We also add the phrase Ground Zero to our language.

I am reminded as I write this, about something that has always moved me in our society: the nobility of ordinary people in times of great crisis. The people who were the architects of this attack sought among other things to show the rest of the world how weak and decadent a nation we had become. Yet in the immediacy of the crisis, firefighters and police sacrificed their own safety (and the security of their own families) in order to save complete strangers; as they did that, they provided the evidence that was the exact opposite of what the architects of violence hoped for.

As I write, it is only 16 days since it happened, and the city—always, I think the most energized place in the world—is slowly and steadily coming back, returning to its million

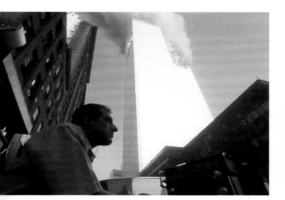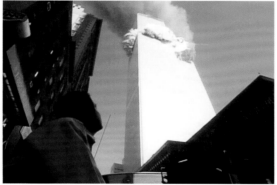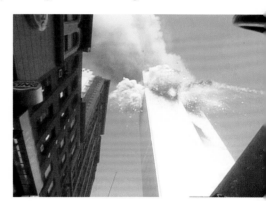

smaller daily human concerns and crises. Being a New Yorker is as much a condition as it is a geographic description of where you choose to live. Millions of us are people who have come here from all over the world, most of us I think by choice, more often than not, among the newer and poorer among us, because they want to be here, and because they believe, that unlike in the place where they originally started out their life's journeys, if they work hard here, they can rise above what they were when they were born, and most assuredly their children can rise even higher. That makes it, ironically enough, freedom's place, and I cannot think of a stronger force with which to bond people together.

Cameraman Evan Fairbanks had been working in downtown Manhattan on the morning of the attack and ran out with his video camera when he heard the commotion. As he was filming the towers, the second airplane appeared and crashed into 2 World Trade Center. Fairbanks called us that evening, and when we saw his extraordinary footage we concurred that it was a good fit with our documentary tradition. So Magnum agreed to distribute his videotape and the still images from that shoot, including those reproduced on these pages.

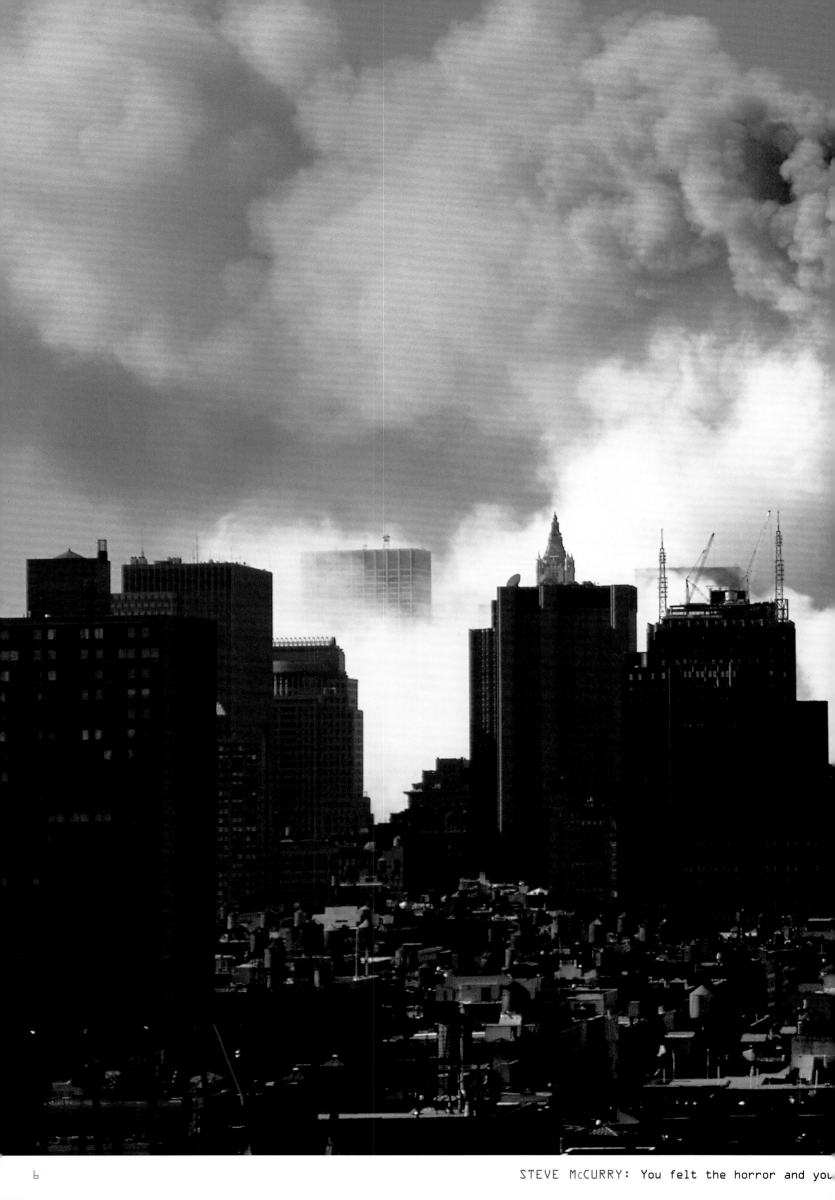

STEVE McCURRY: You felt the horror and you

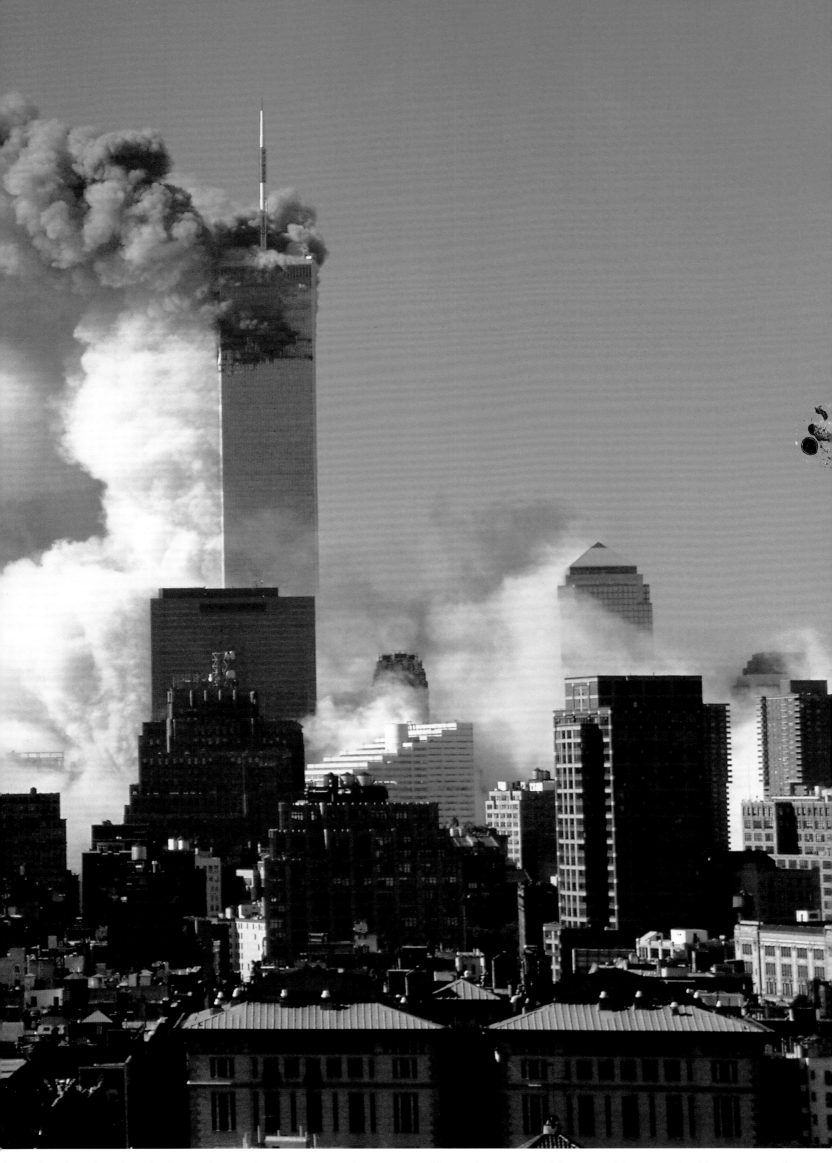

immediately, instinctively understood as soon as the tower collapsed that our lives would never be the same again.

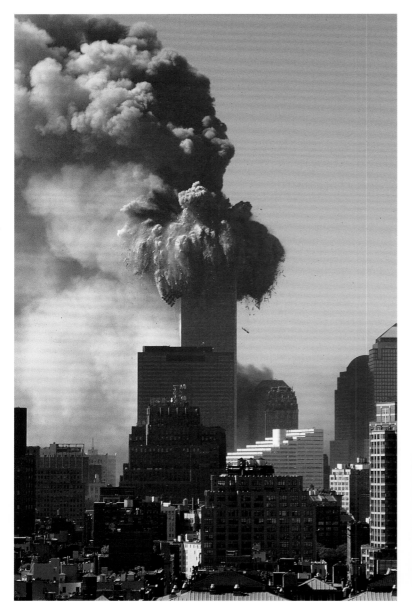
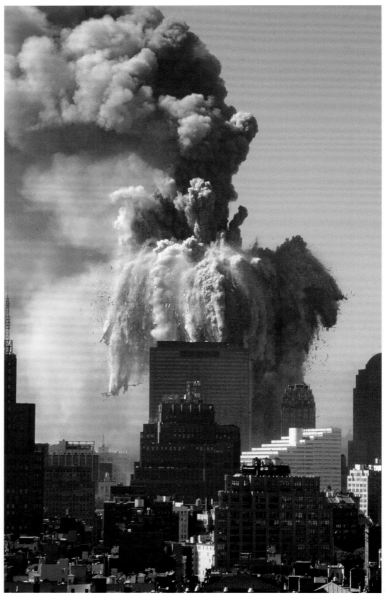

STEVE McCURRY: Who would have ever dreamed that one tower
would have come down, let alone two? It was just indescribable,
the terrible sadness. You might just as well have told me
that my mother or father had been killed in an accident, or that
my best friend had died. It was a sorrow of that magnitude.

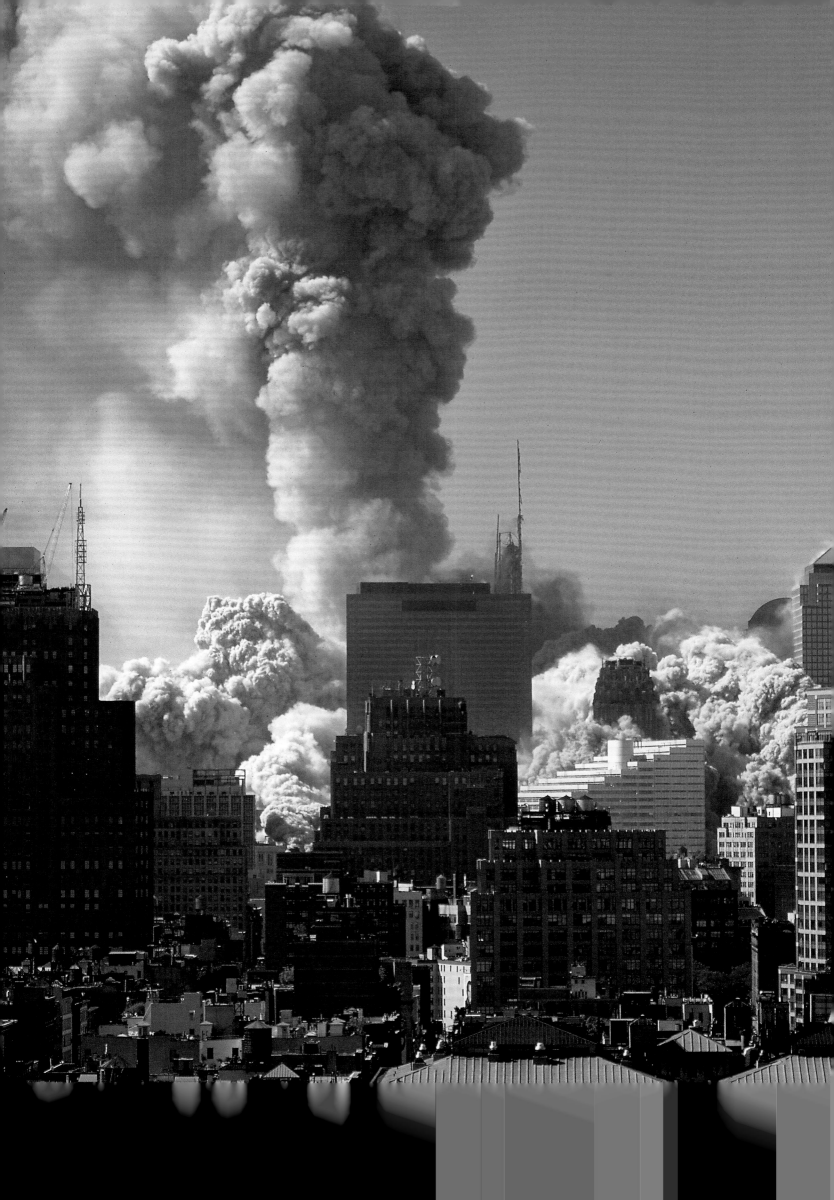

STEVE McCURRY

When this happened, I was in my office on the north side of Washington Square Park. You can actually see the World Trade Center from my office. I had just gotten back from China the day before, and I was opening up my mail. My assistant's mother called and said, "Look out your window." I did. And then I immediately grabbed my camera and ran up on the roof. I have an unobstructed view of all of downtown from the top of my building.

When I reached my roof, both buildings were already on fire. I started shooting as fast as I could. Between the time I got up on my roof and the time the first tower collapsed was probably thirty or forty minutes. To see it actually come down was absolutely unbelievable, one of the worst things I've ever witnessed. To just see it collapse, knowing how many people there must have been in the building—and the spectators, emergency workers, firefighters, police, who were there.

I had seen these buildings every day from my window. They were framed for me by the Washington Square arch below. In the Village, when you're on Fifth Avenue, Sixth Avenue, Seventh Avenue, you see them constantly; they're a part of your life. To have them crumble, it's like ripping your heart out.

Immediately after the towers came down, my assistant and I collected the equipment and walked downtown. The police had cordoned off the area, but we were able to get through. We stayed until about eight-thirty that first night.

The next morning I knew that I had to go back again. I could not leave it at that. So I got up at about three-thirty in the morning and walked down there in the darkness, because I knew the only way to get down there would be under cover of darkness. We walked down the West Side Highway and got to the press pen. I surveyed the situation, and then I crawled along a concrete barrier for about a hundred yards. At the end of the barrier there was a cyclone fence with a wire holding two parts of the fence together, so I cut my way through the fence. I just was not going to be stopped. A police woman yelled out to us, but we just kept going. We walked along beside a group of National Guards. We sort of blended in. I was dressed mostly in khaki. I hid my cameras.

There was a question about the buildings we were shooting from. Were they safe? Were they going to collapse? There were a couple of buildings nearby on fire. We were continually being asked to leave. I probably spent as much time just avoiding getting ousted from the area as I did taking pictures. They kept saying, "You have to leave. You have to go back." We would retreat for a moment and then double back immediately.

I worked all Wednesday morning. By afternoon, there were a lot more police officers, National Guard, firefighters. It became very difficult to walk around. On Thursday we were actually escorted from the zone. By that time, they had gotten much more organized.

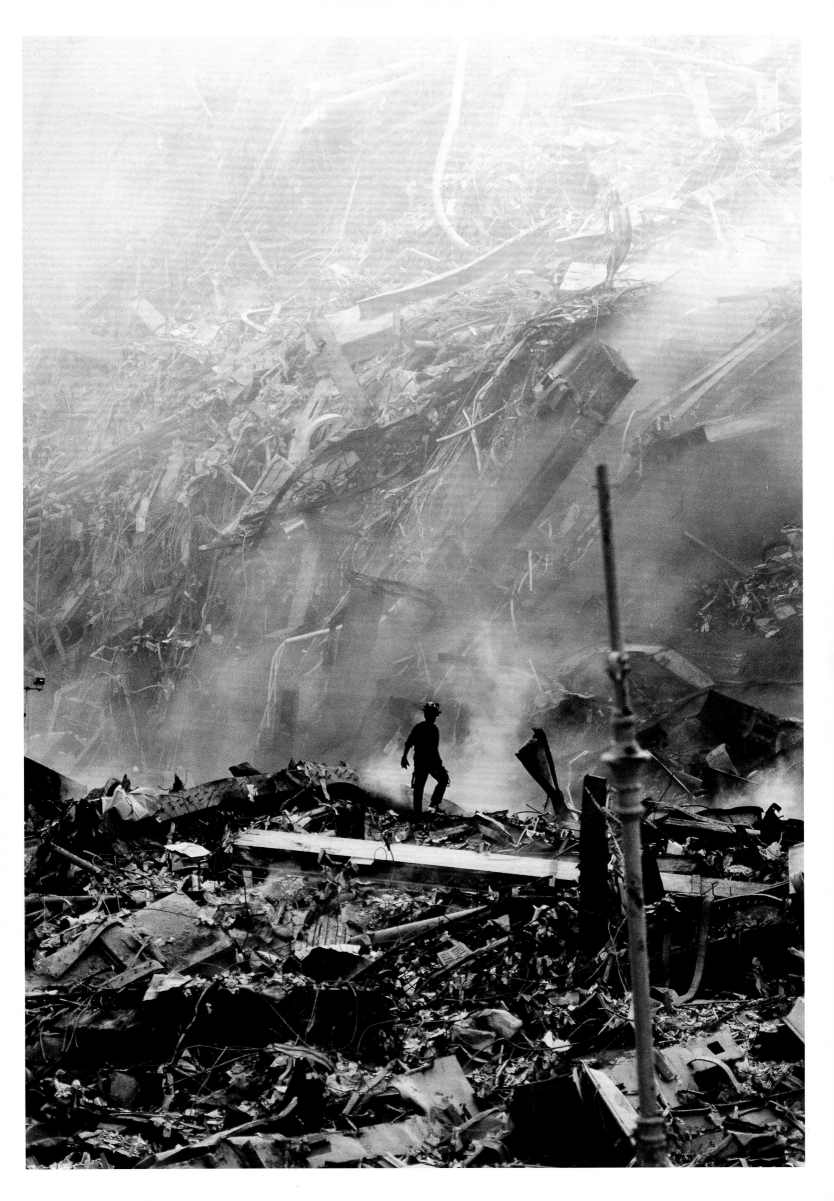

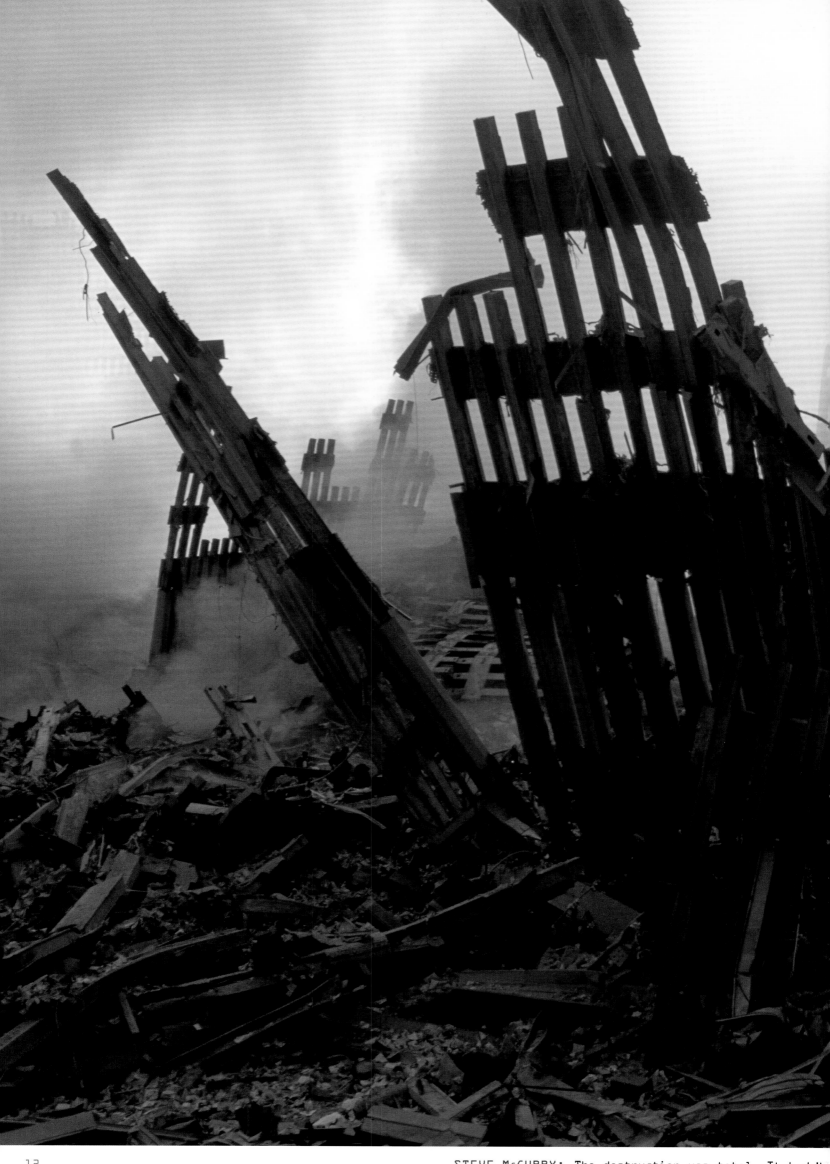

STEVE McCURRY: The destruction was total. It hadn't

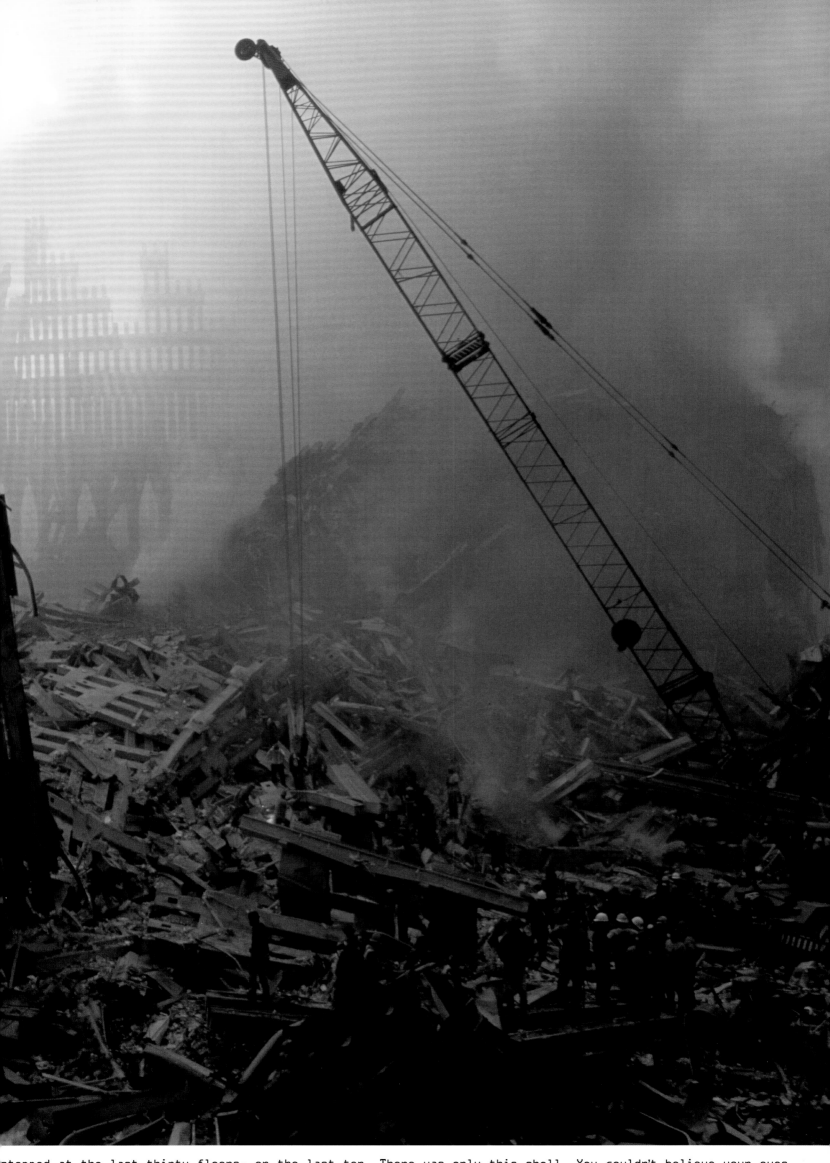

stopped at the last thirty floors, or the last ten. There was only this shell. You couldn't believe your eyes.

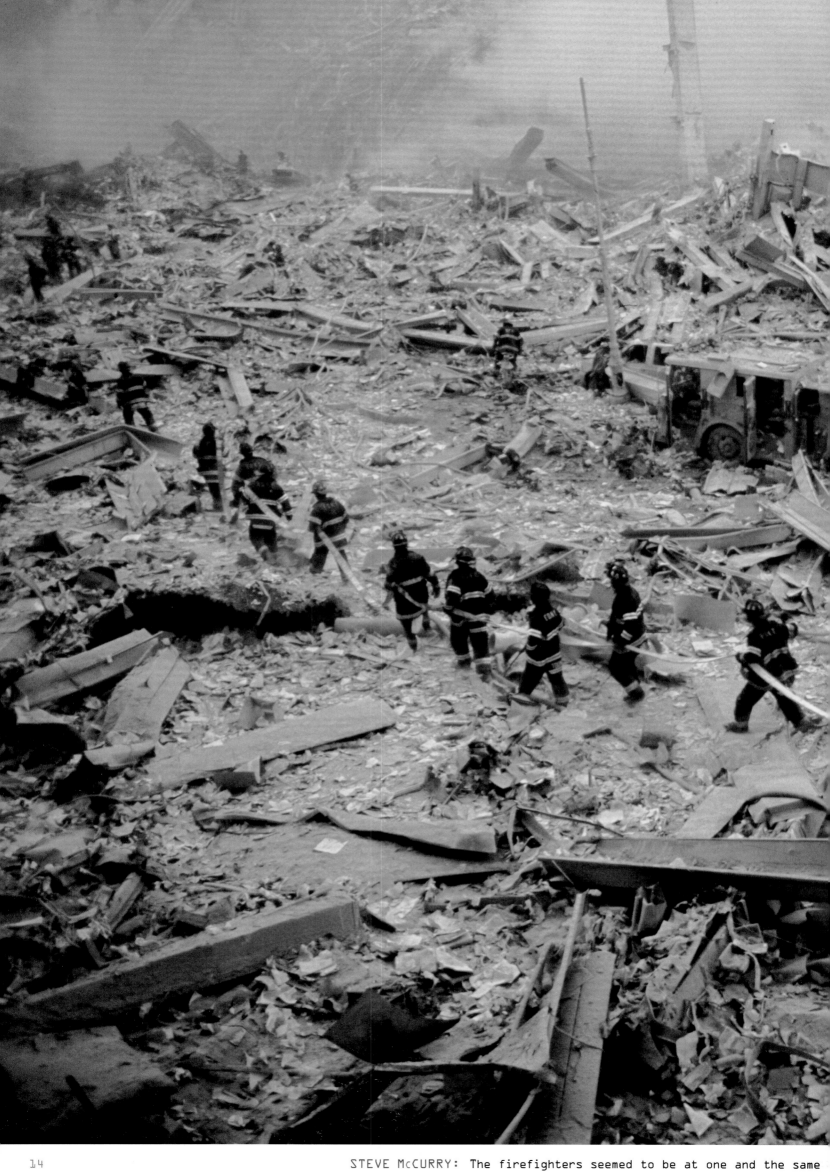

STEVE McCURRY: The firefighters seemed to be at one and the same

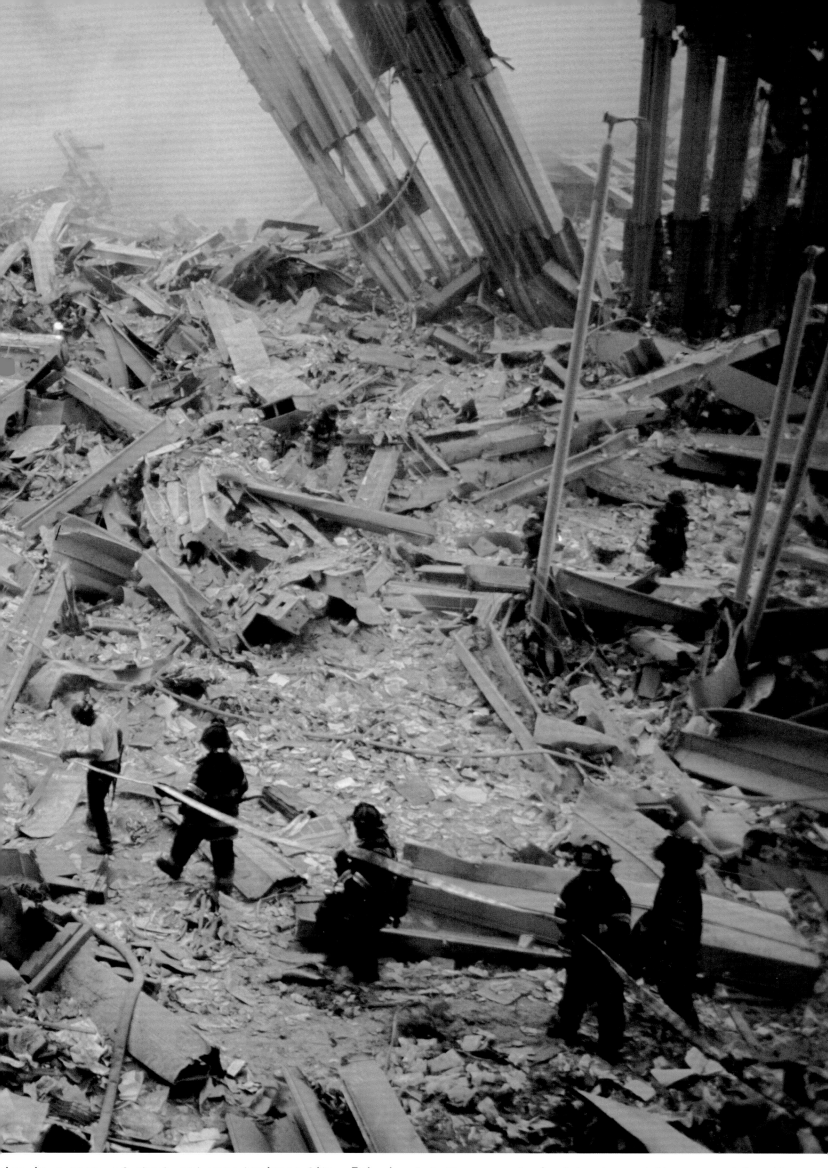

…ime in a state of shock and very business-like. This is what they were trained to do, and they were doing it.

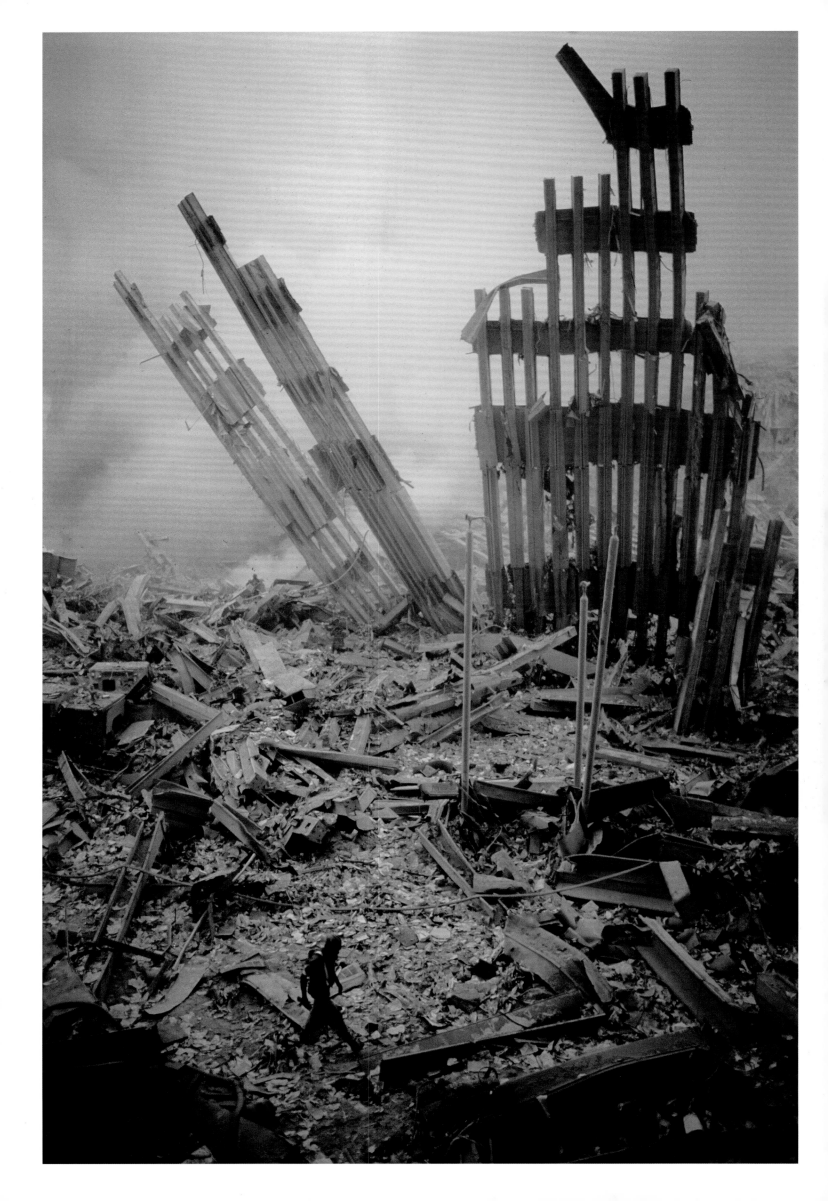

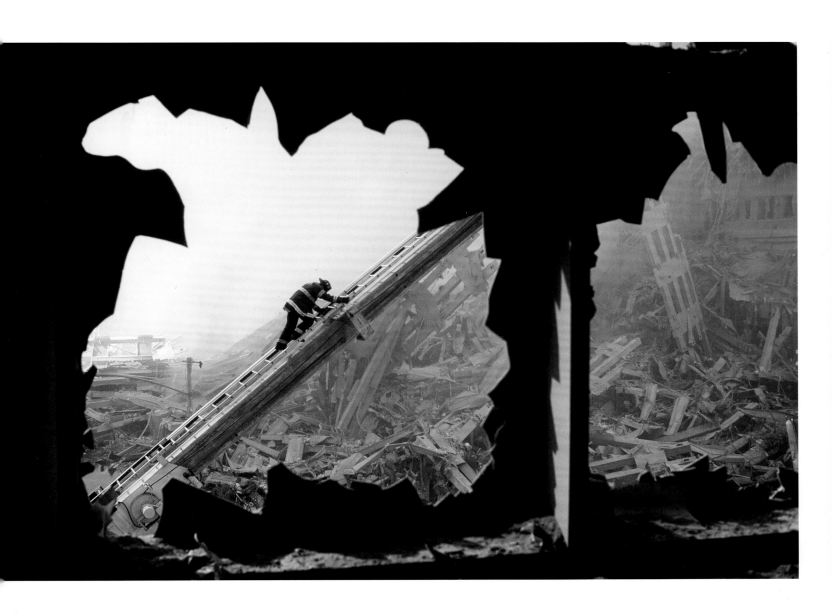

STEVE MCCURRY: The atmosphere was so heavy. Everybody knew
the weight of the situation. I was just trying to translate
into film what I was actually feeling—horror and loss.
This was a whole other level of evil.

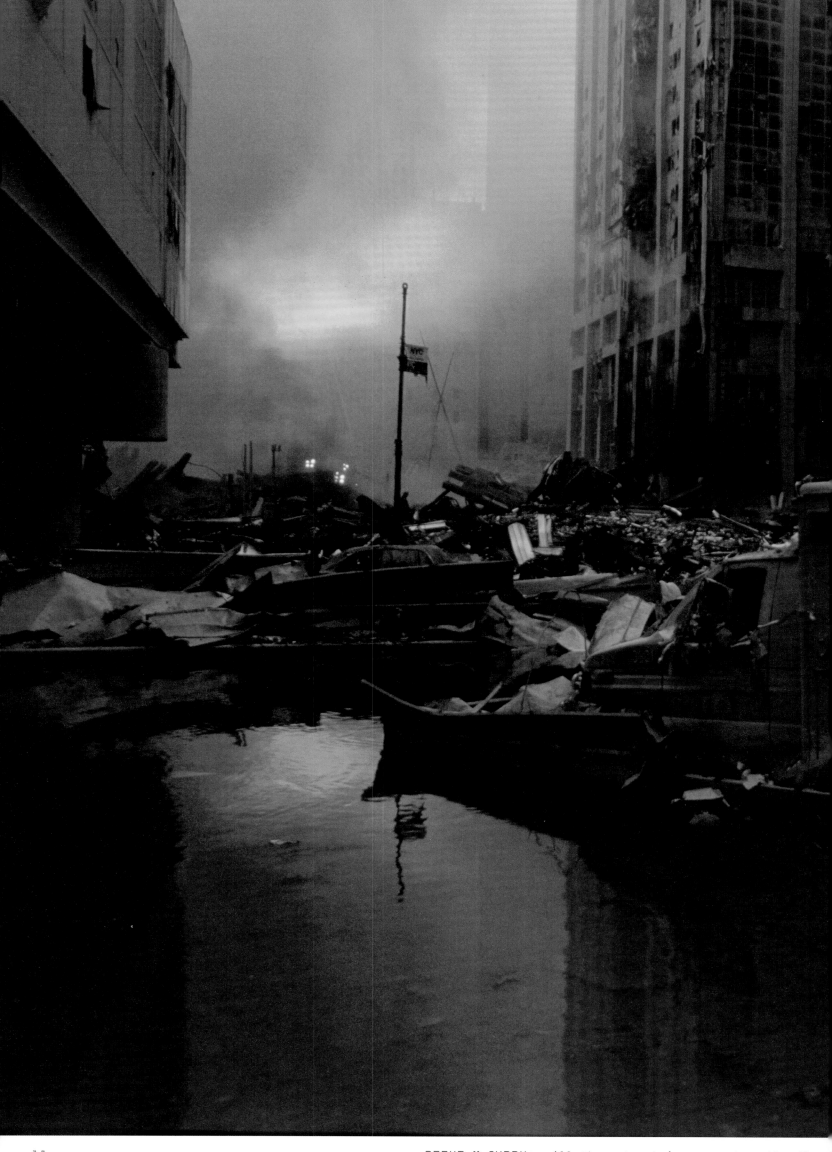

STEVE McCURRY: All the water being poured on the fires

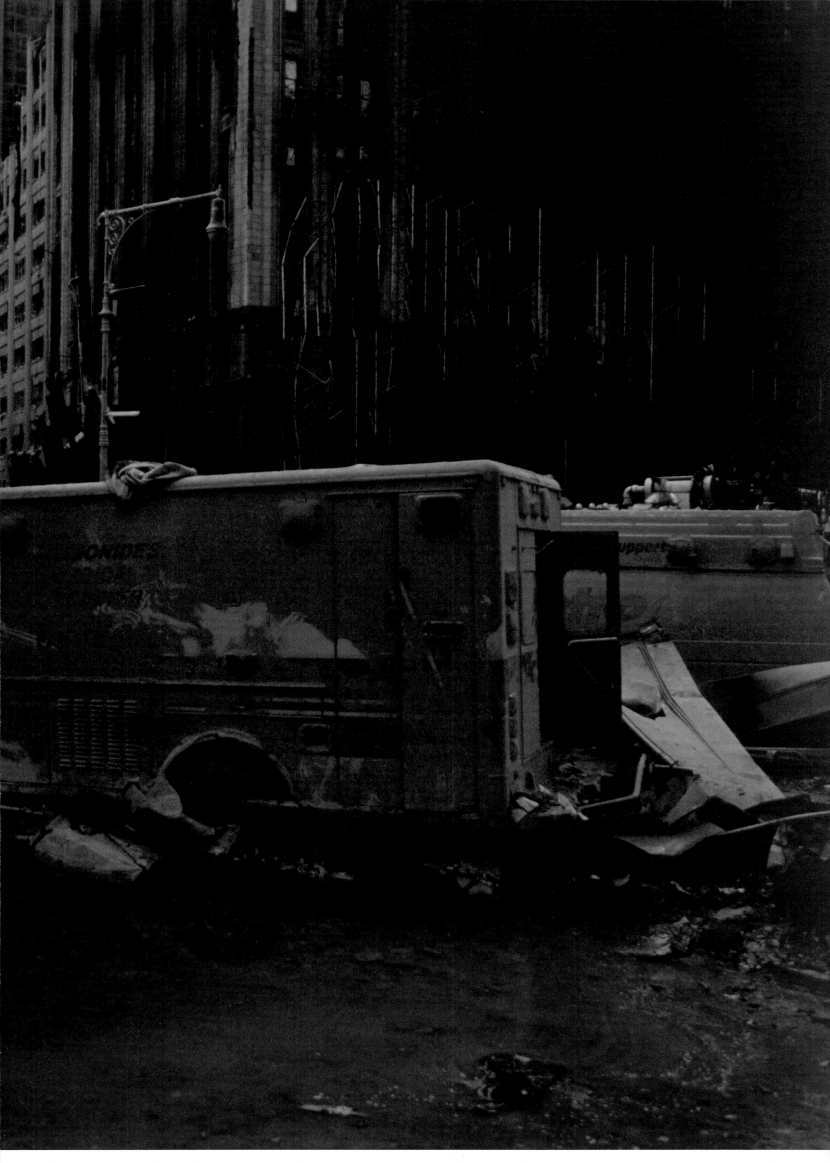

created small ponds. Most of the vehicles left behind were so badly damaged, you knew no one in them had survived.

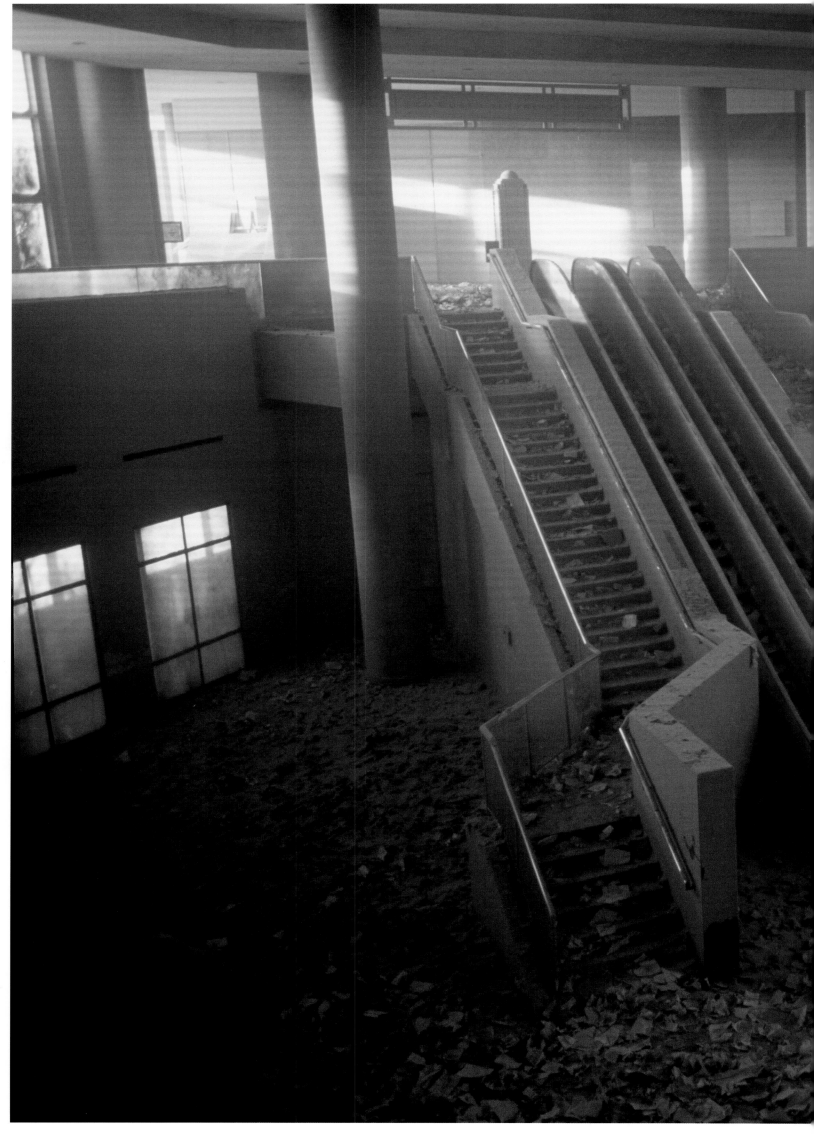

STEVE McCURRY: We walked through the lobby of 2 World

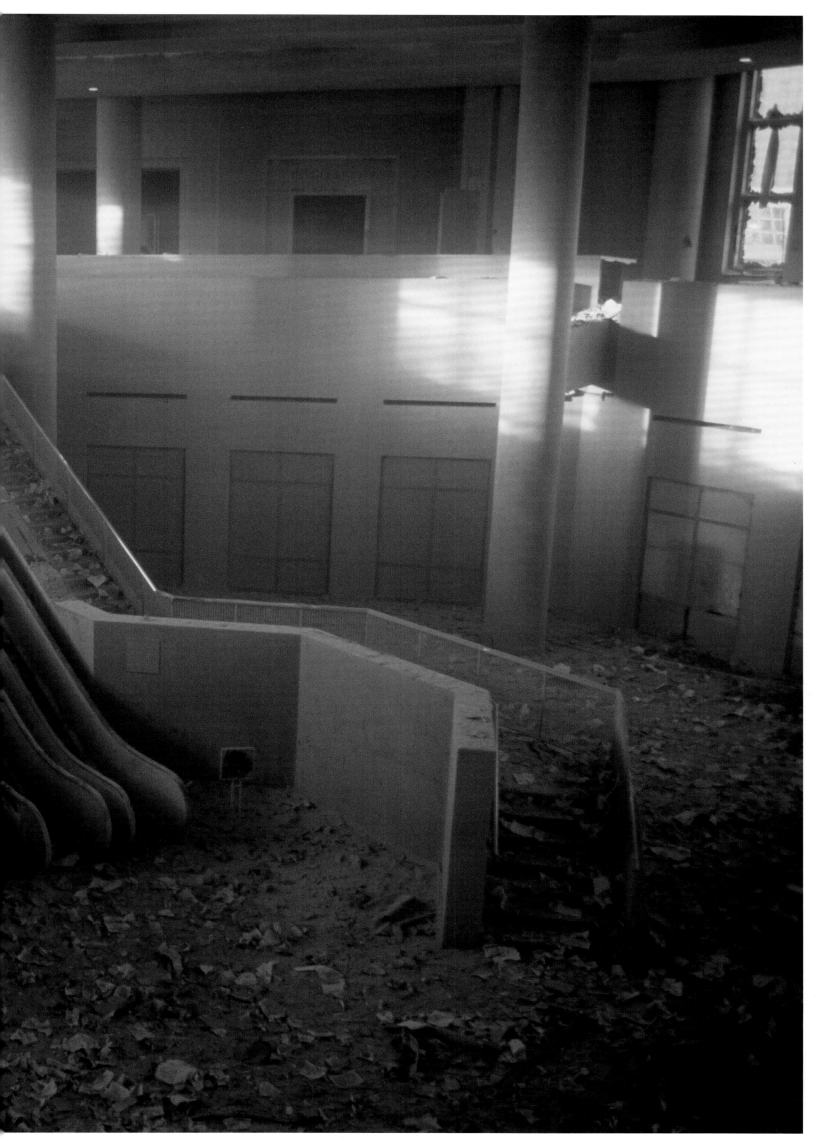

Financial Center, where you were used to seeing thousands of people rushing around, talking. It was utterly silent.

SUSAN MEISELAS

Tuesday morning I headed out to meet an old friend for breakfast.
Before I left, I heard a radio report about a plane hitting one
of the World Trade Center towers. I couldn't conceive of it, and
certainly had no sense of whether it was an accident or an
attack. When I arrived at the diner, I saw the first TV images of
the building in flames. I immediately ran back to my apartment on
Mott Street and grabbed two cameras and a few rolls of film—too
few, as it turned out. Got my bike, pumped up its tires, and
headed south.

As I raced down Broadway, crowds of people were walking quickly
uptown. Some corners were crowded with onlookers watching the towers
burn, but life seemed to go on. Messengers were still delivering
packages and traffic was still flowing. I headed west to get a
clearer view. The police were urging people to leave the area, but
I kept moving closer, weaving through alleys, as the flames became
billowing smoke.

Suddenly, one of the towers collapsed. People panicked and rushed
past me. I froze, and stayed. All I felt I could do was photograph.

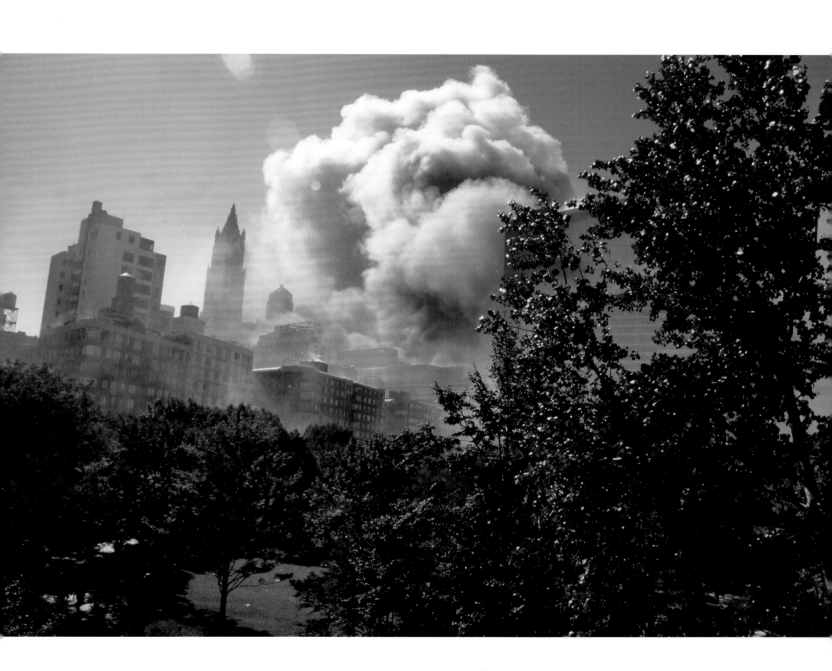

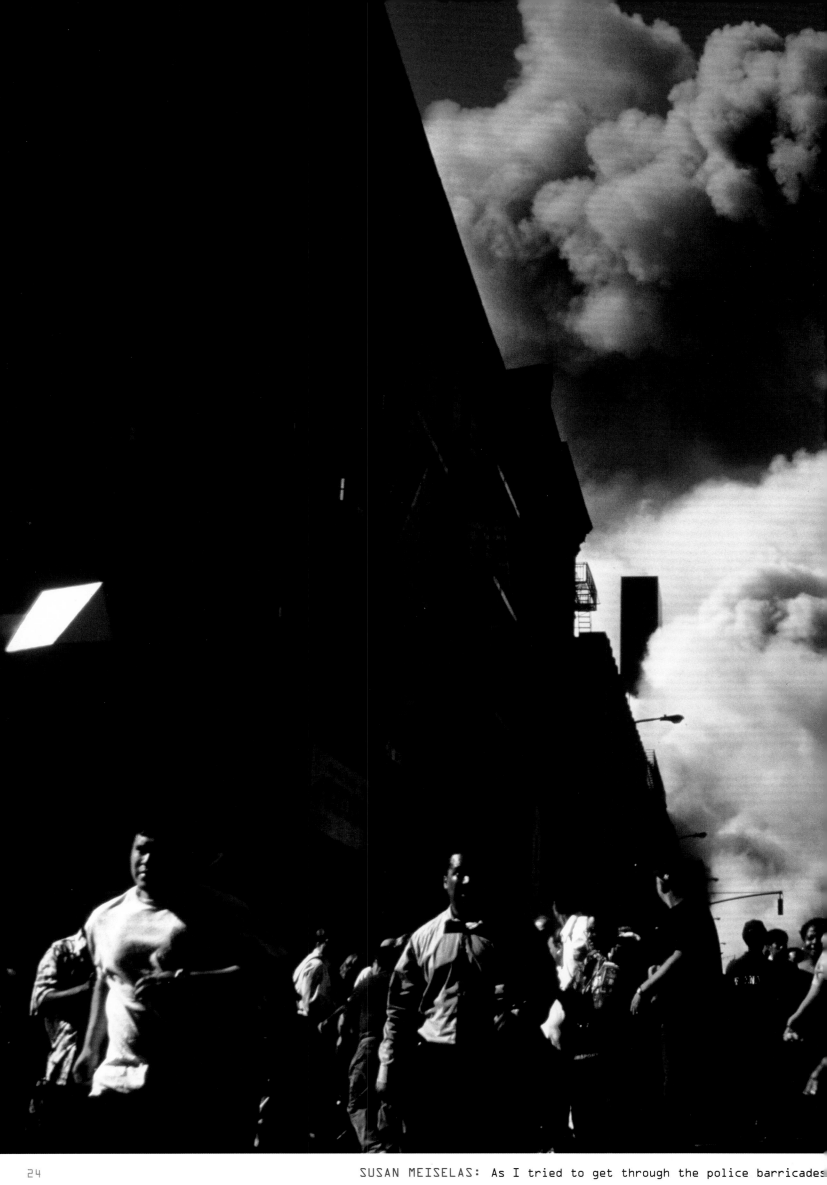

SUSAN MEISELAS: As I tried to get through the police barricades

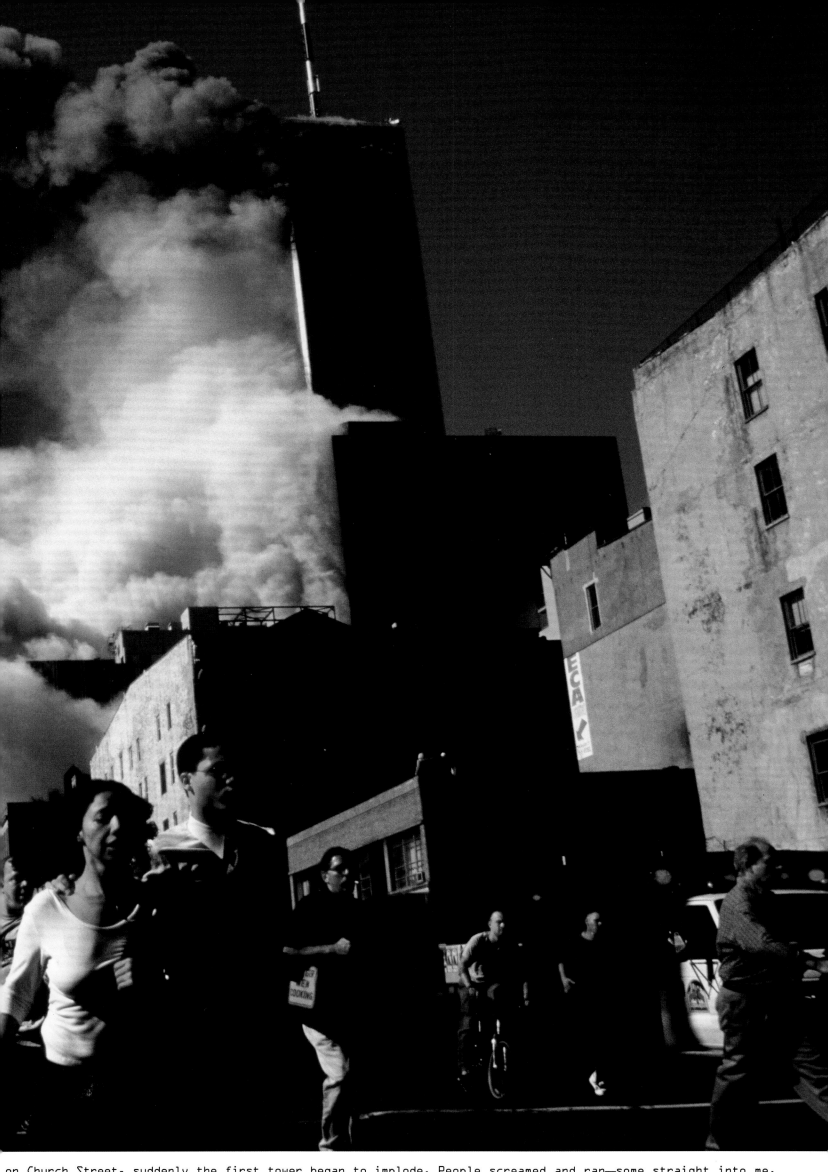

on Church Street, suddenly the first tower began to implode. People screamed and ran—some straight into me.

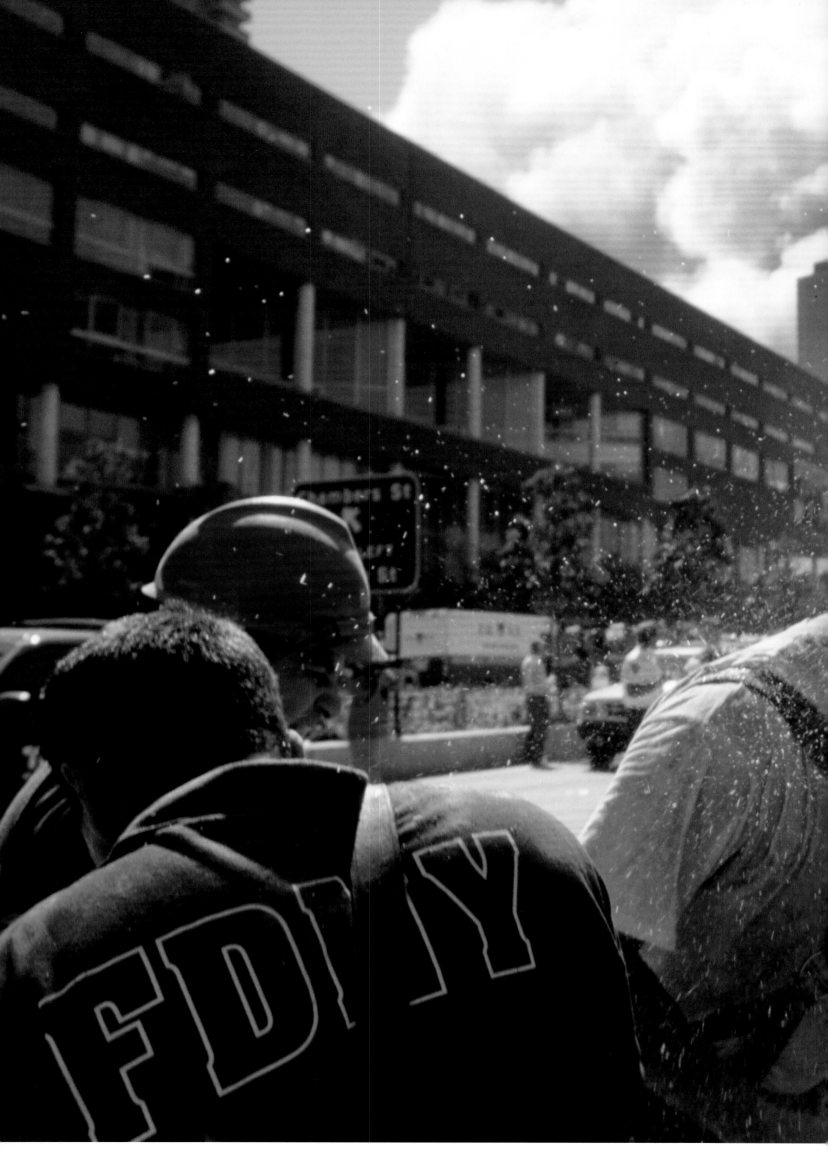

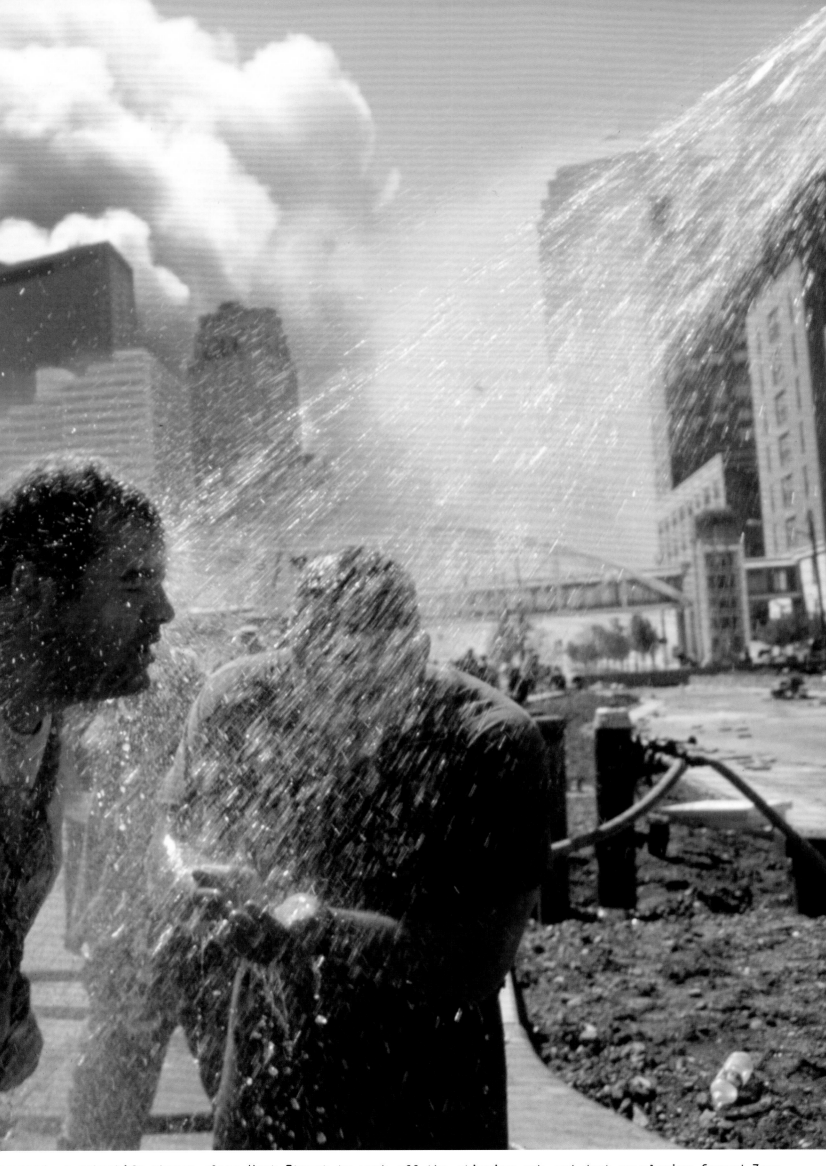

...reated a makeshift shower along West Street to wash off the stinging ash and dust enveloping Ground Zero.

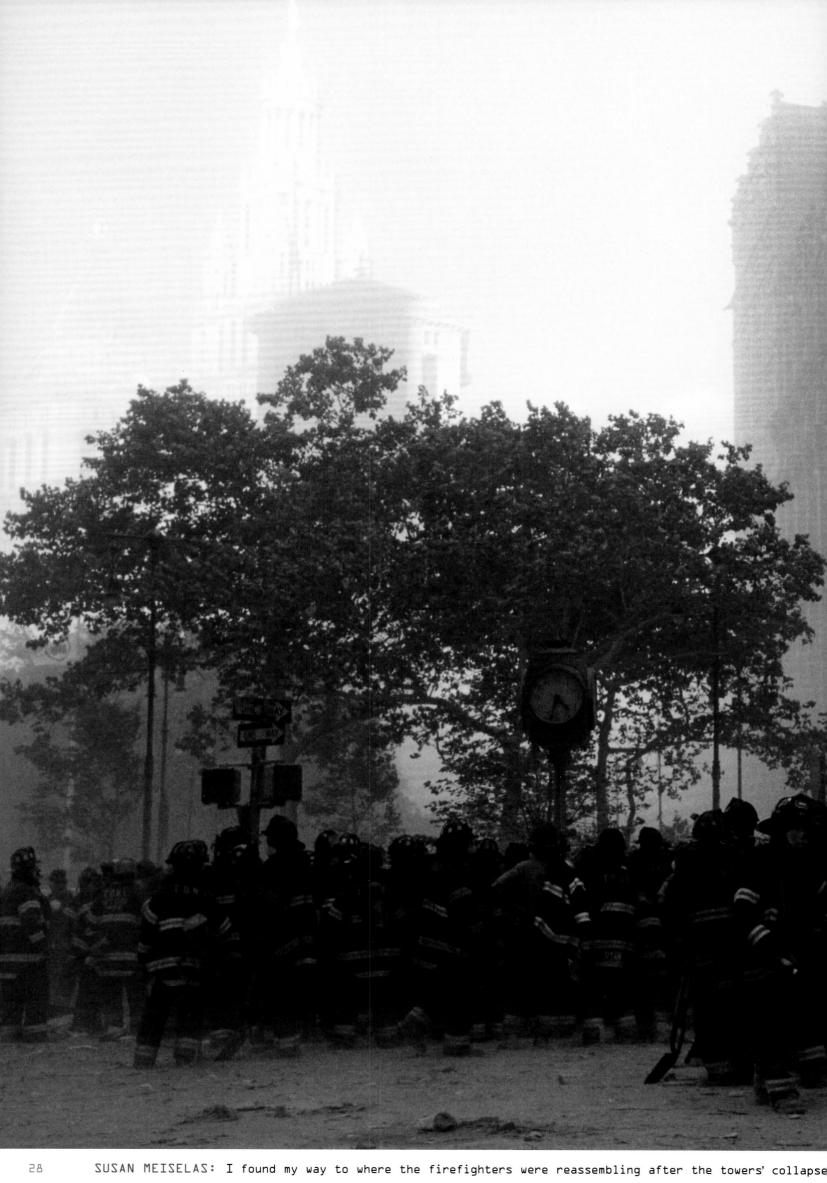

28 SUSAN MEISELAS: I found my way to where the firefighters were reassembling after the towers' collapse

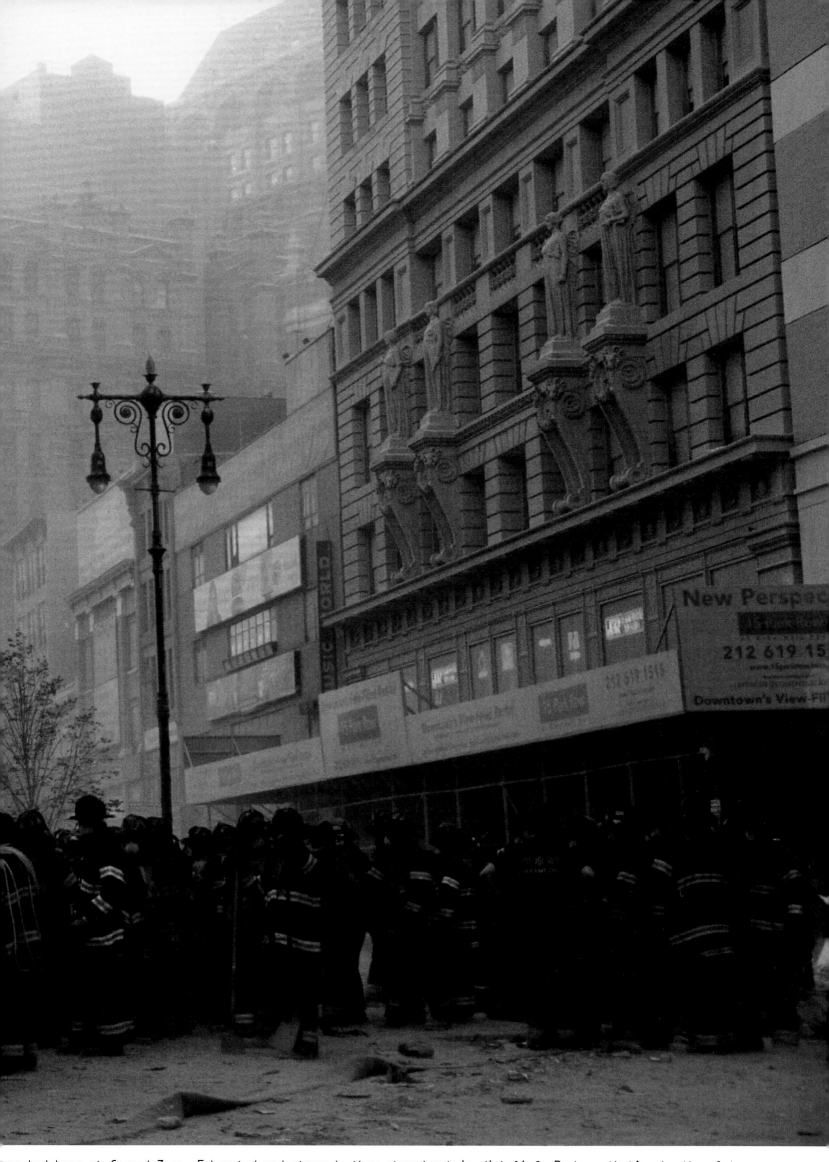

me had been at Ground Zero. Exhausted and stunned, they stared out in disbelief. Perhaps that's why they let me pass.

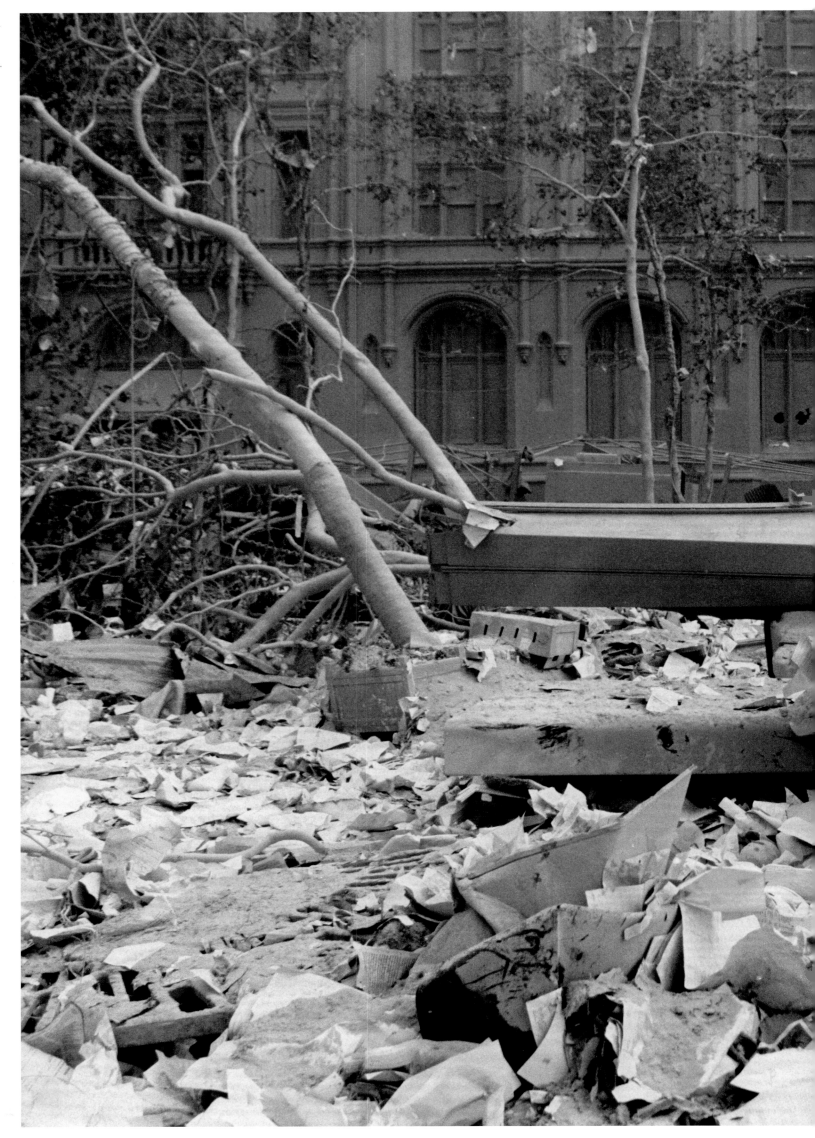

SUSAN MEISELAS: Late in the afternoon of that first terrible day, I came acros

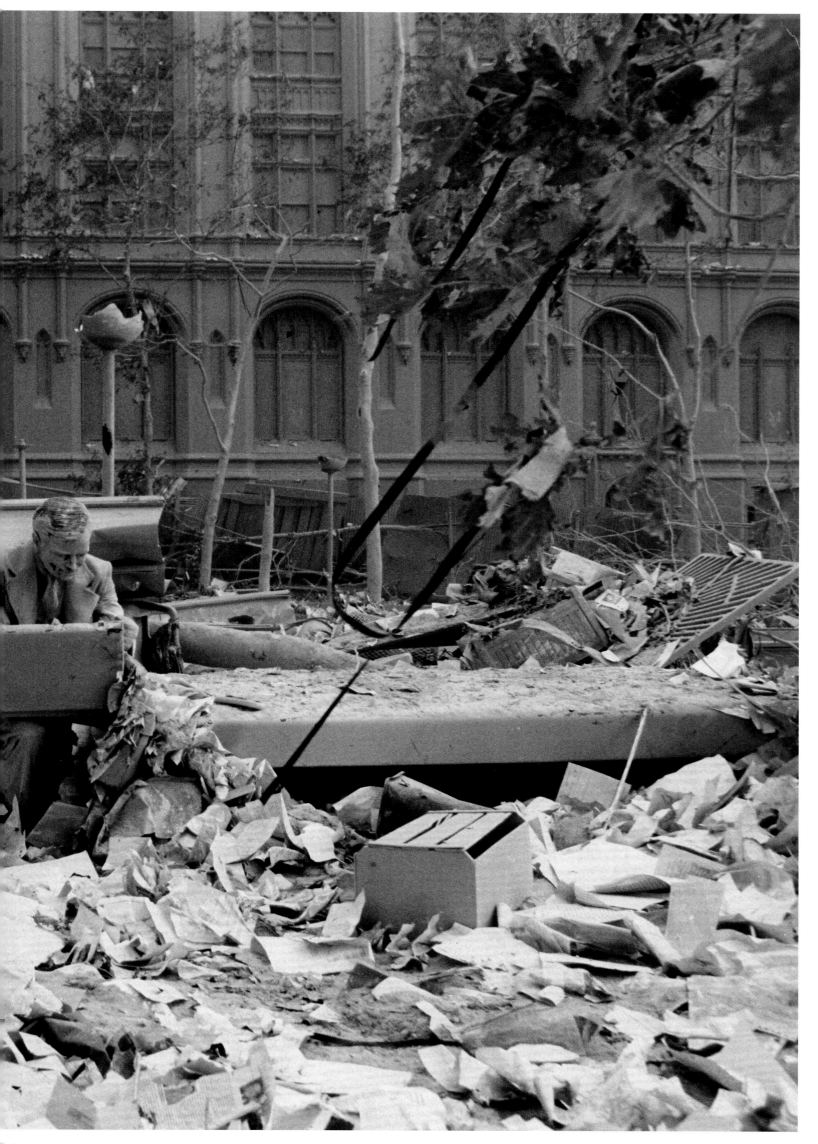

his sculpture near the World Trade Center. Frozen in place, it seemed to stand for all those who were gone.

LARRY TOWELL

I came to New York for a meeting at the Magnum office. I was staying down in SoHo with Susan Meiselas. At about ten in the morning on Tuesday, Susan stuck her head in the bedroom I was staying in and said, "Two airplanes, suicide bombers, just smacked into the World Trade Center." I raised my head from the pillow and said, "Where's the World Trade Center?" I'd never been there; cities and buildings are not my subjects. She said, "Follow the smoke, country boy."

I put on my sandals and went outside. People were moving quickly; they didn't know what was going on. There was a real sense of confusion. I stopped, took a couple of frames. I didn't have my regular equipment. I had one small, 35mm completely automatic camera. I lost a lot of frames. I was photographing the people. Had I seen the plane going into the building, I probably wouldn't have photographed it. My only interest is people. I photographed New Yorkers, people dressed well, coming up from the financial district, stopping, talking, pointing. I didn't see anything dramatic until I got closer.

Around Fulton Street I heard this rumbling. I thought it was another plane hitting the building. People started screaming. Someone screamed, "They're dropping bombs." And then everyone started running. When I got closer I saw people terrified for their lives.

Then the building came down. I was scared. Everybody was scared. I didn't see it come down, but I saw the smoke. A black, black cloud came rushing toward us. People obviously thought they were going to die. I just thought I'd get dirty. I tried to photograph. My camera didn't work. The green light was blinking, saying, "I don't know what to focus on."

Later I found firefighters regrouping. I went in with them to the epicenter and photographed there what I could. The police told me to leave, that I would be arrested. I saw no bodies, and I'm lucky I never saw anybody jump. I had the impression it would be a scene of carnage, but it wasn't. I stayed until almost dark, and then I walked back to the office.

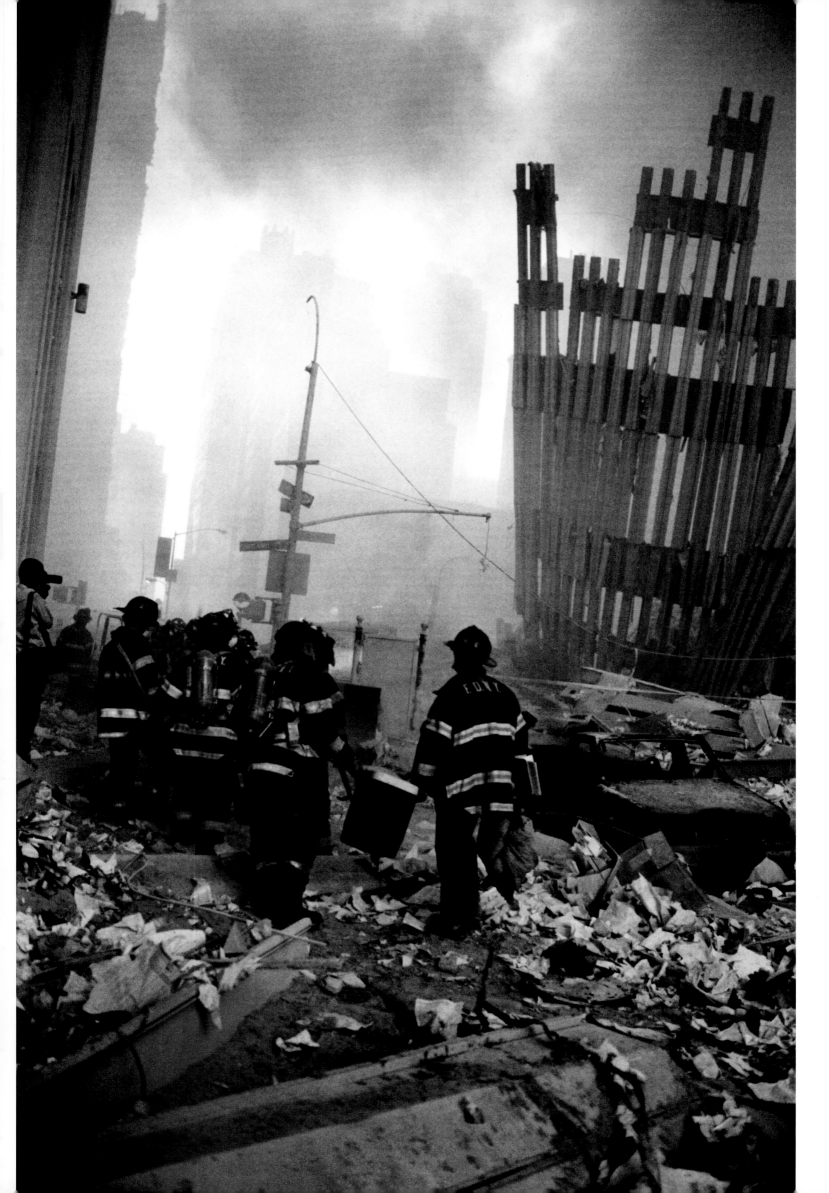

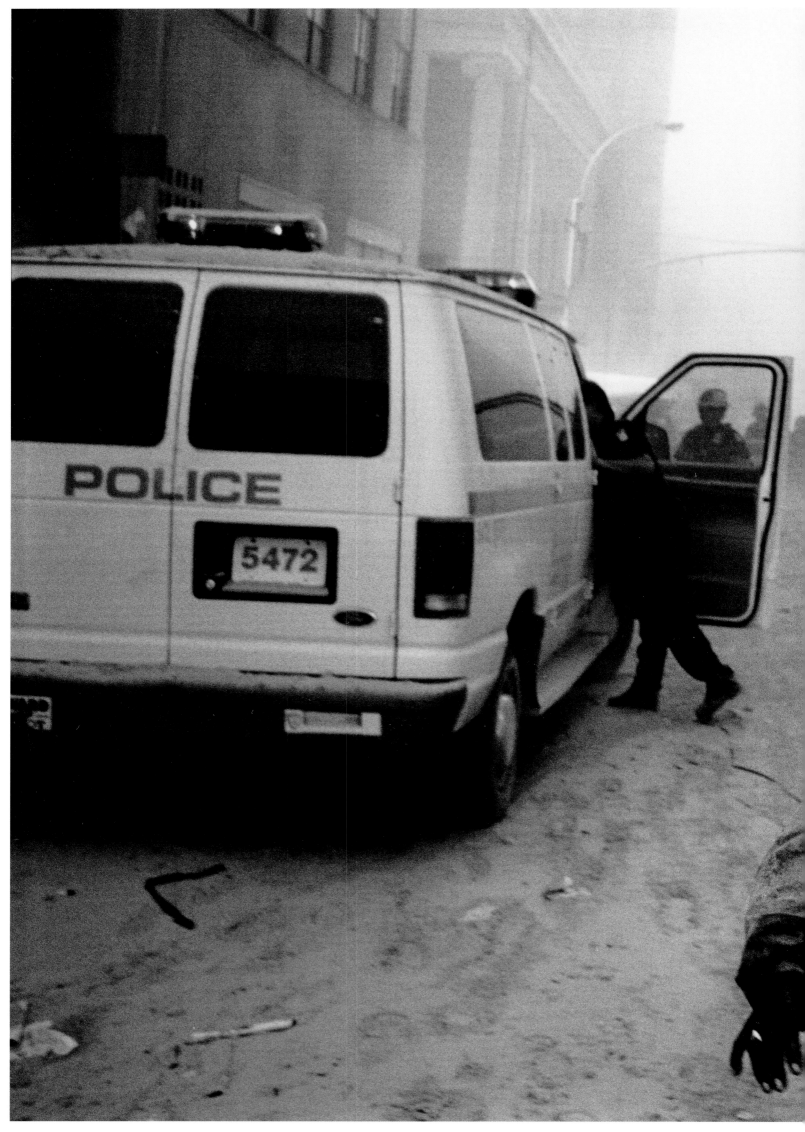

LARRY TOWELL: It looked like a tornado, like when you sit o

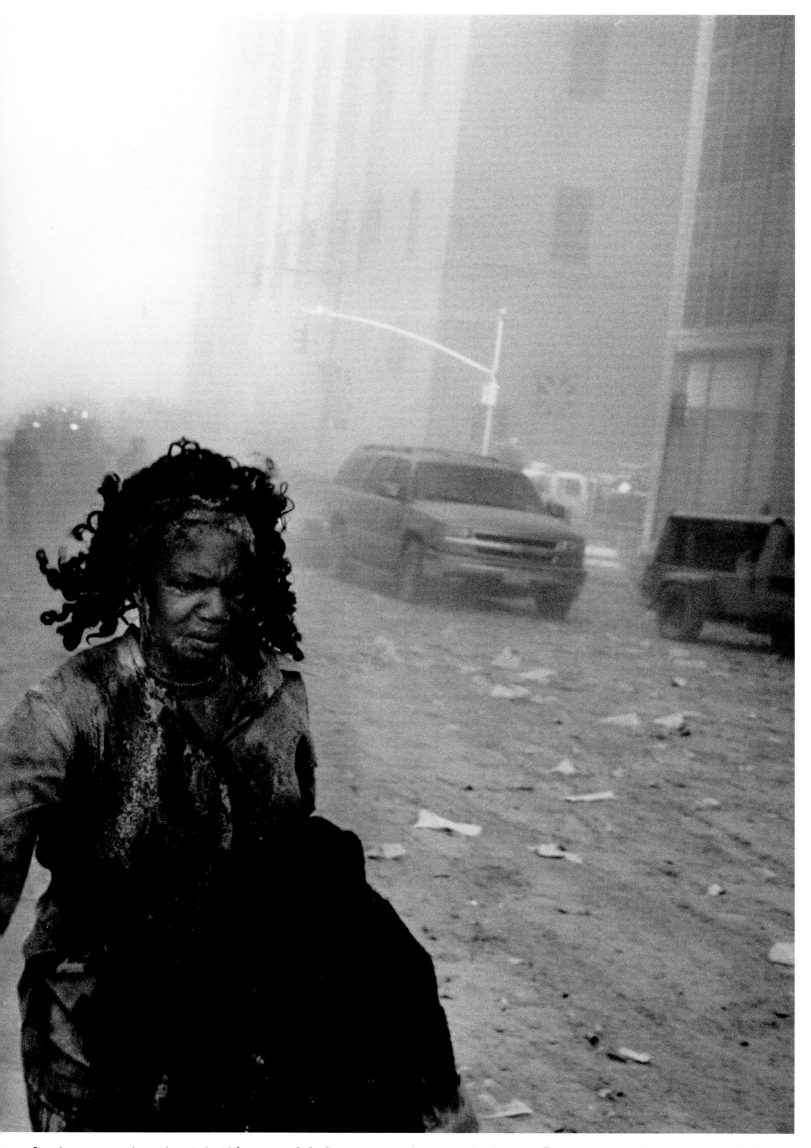

our farmhouse porch and watch this powerful force move closer and closer. Everyone raced to get ahead of it.

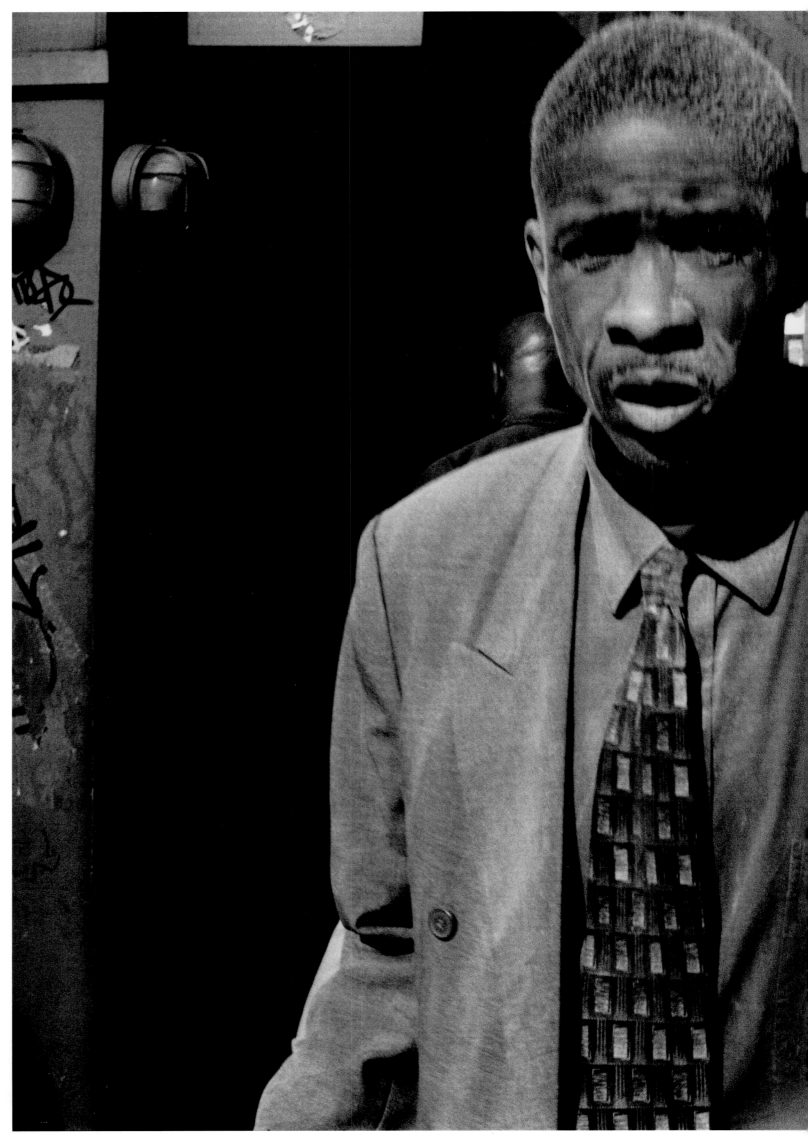

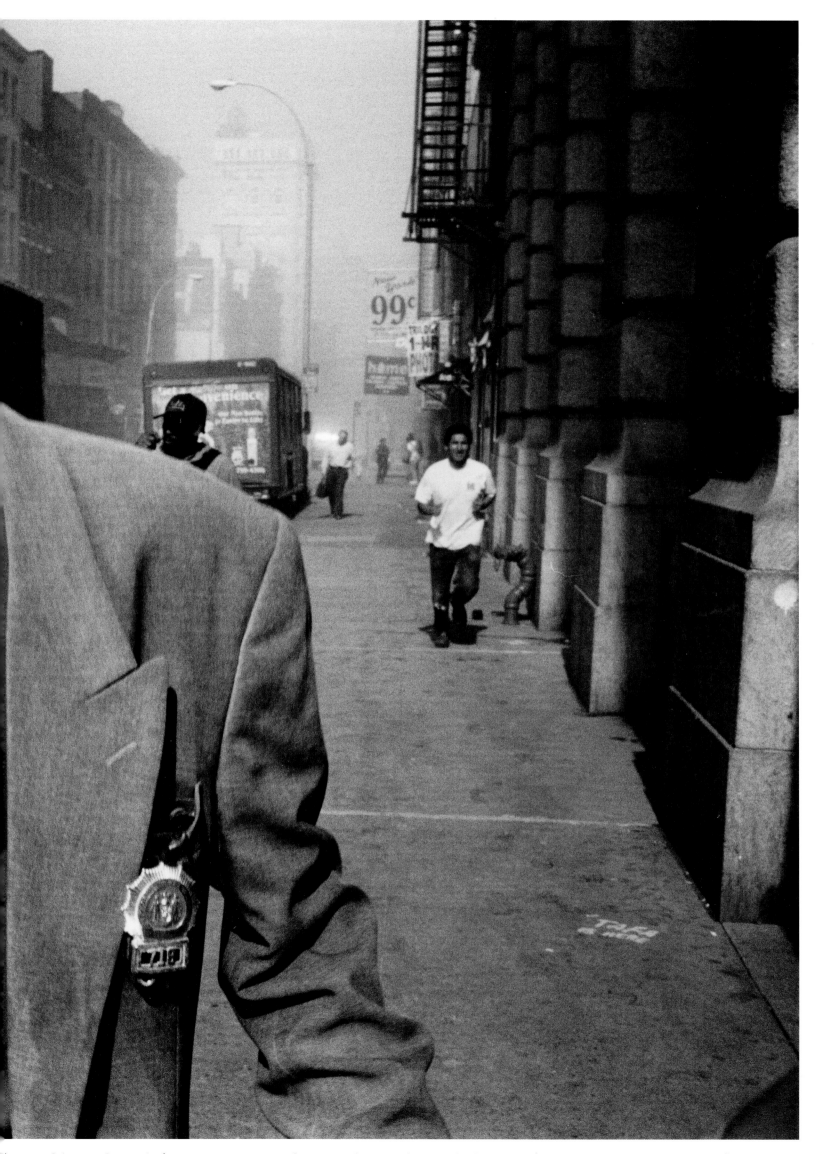

You could see from their eyes, some people seemed to understand the enormity of what had happened right away.

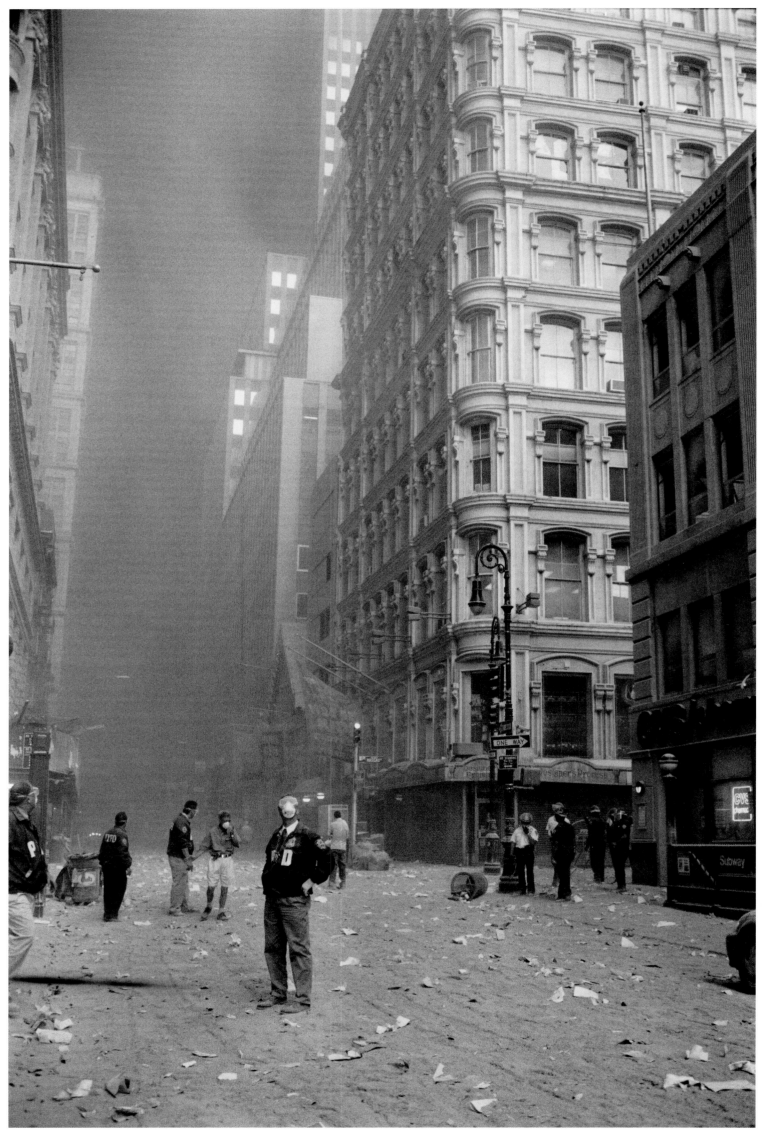

LARRY TOWELL: After Building 7 collapsed at mid-day, the

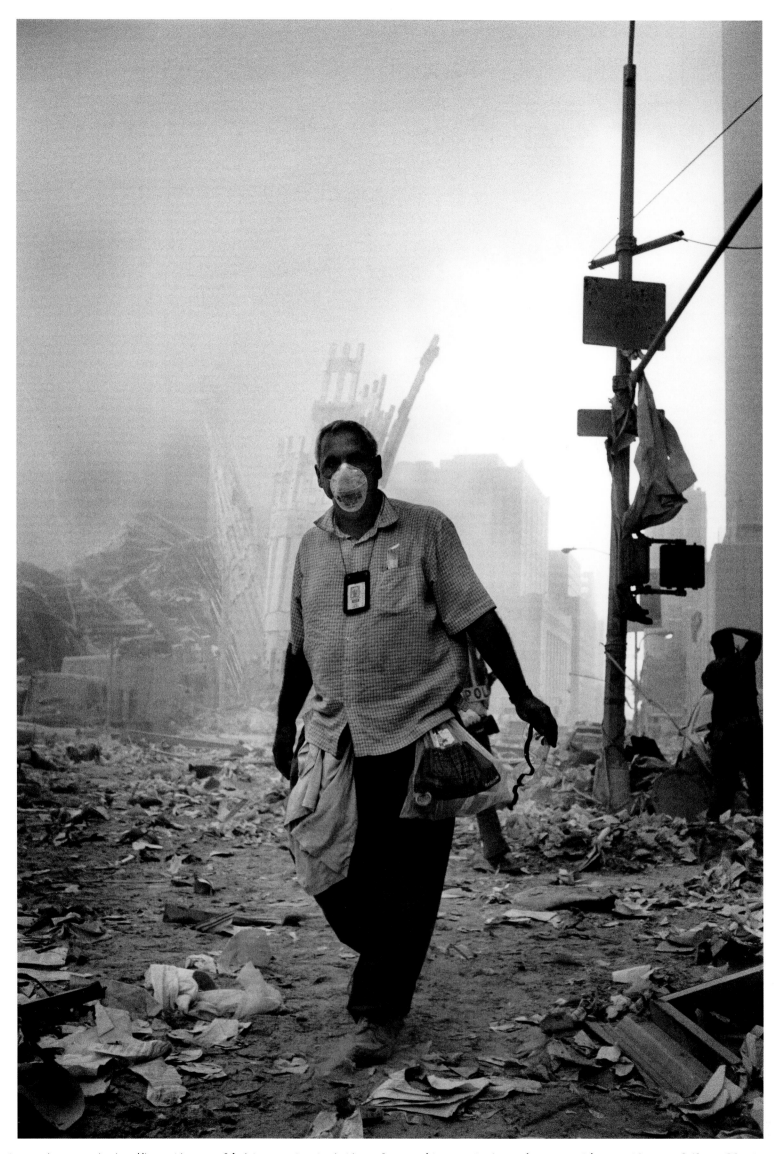

sky turned very dark. When the sunlight penetrated the gloom, it created eerie, sometimes otherworldly effects.

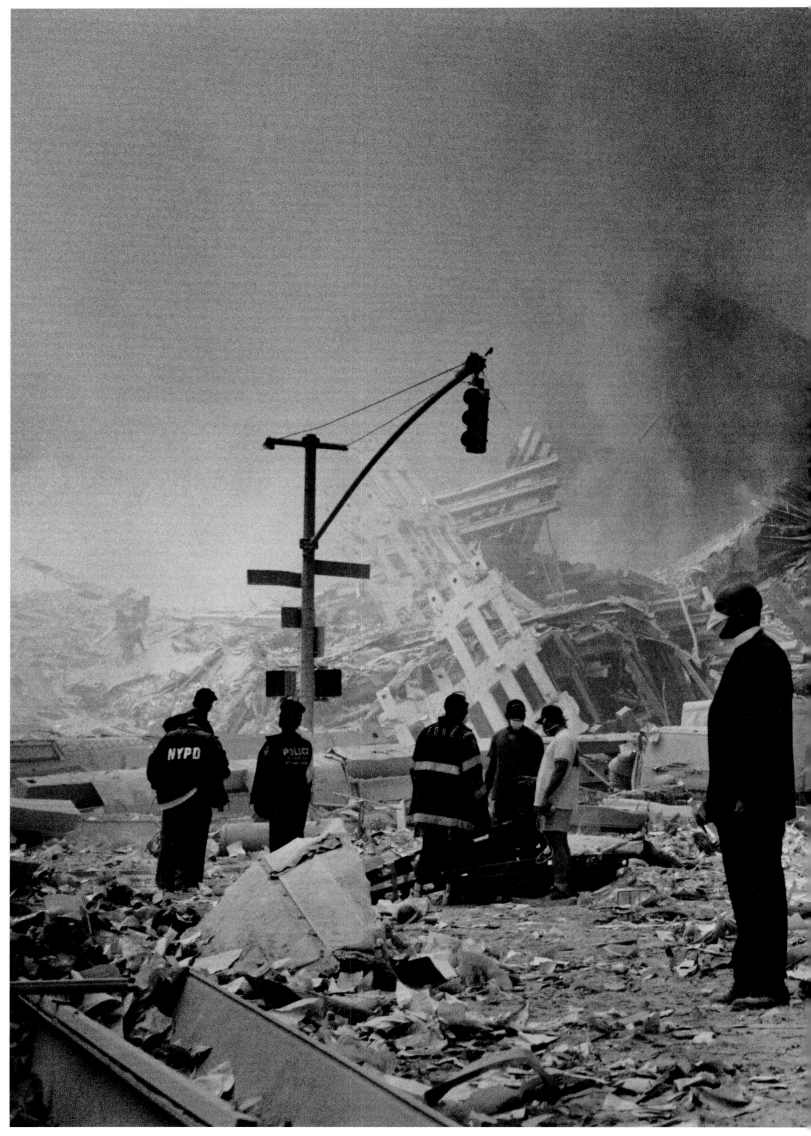

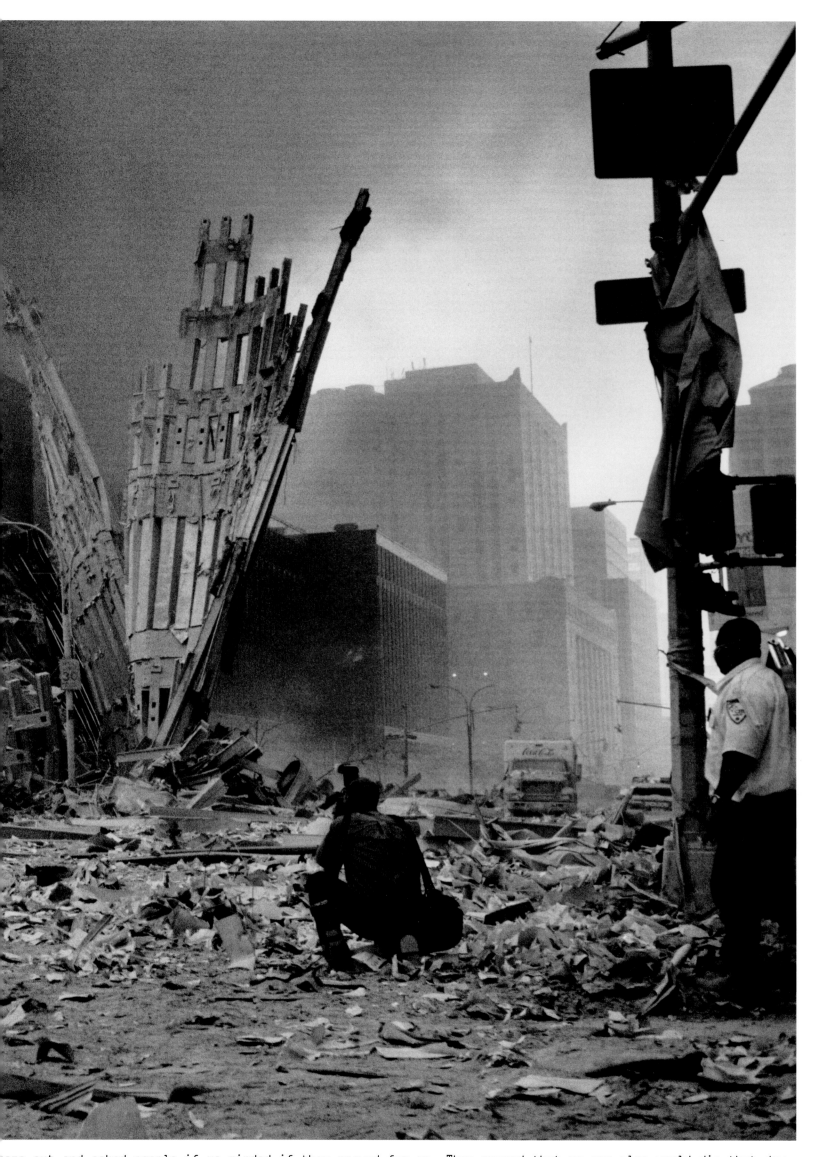

came out and asked people if we minded if they prayed for us. They prayed that no one else would die that day.

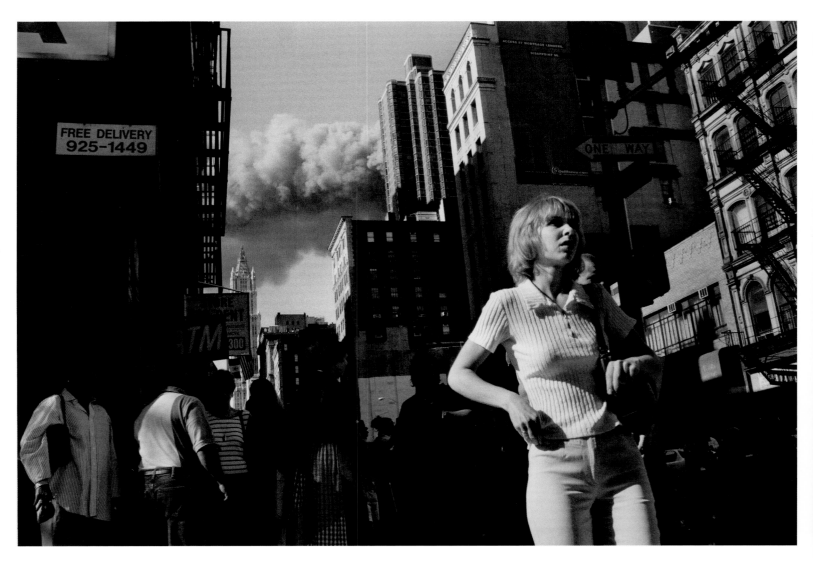

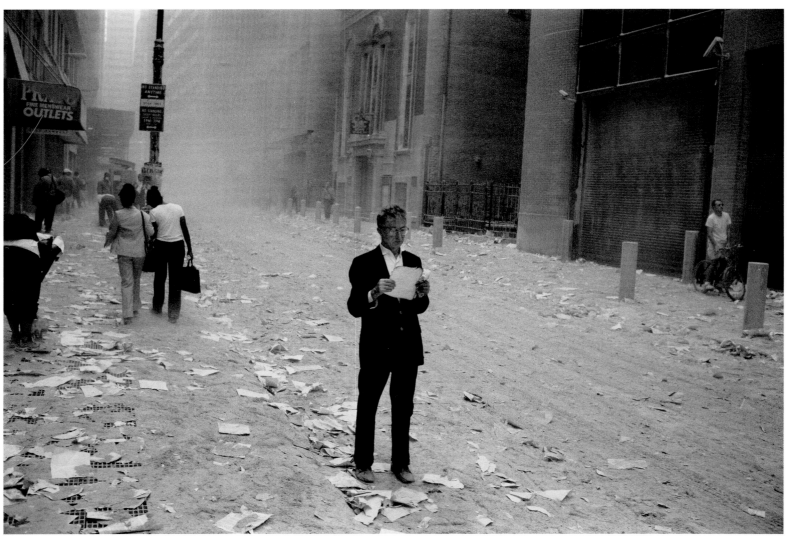

LARRY TOWELL: The police kept yelling out, "Get back. More buildings may collapse." But some people seemed dazed. They just stood and stared around; some sorted through the debris.

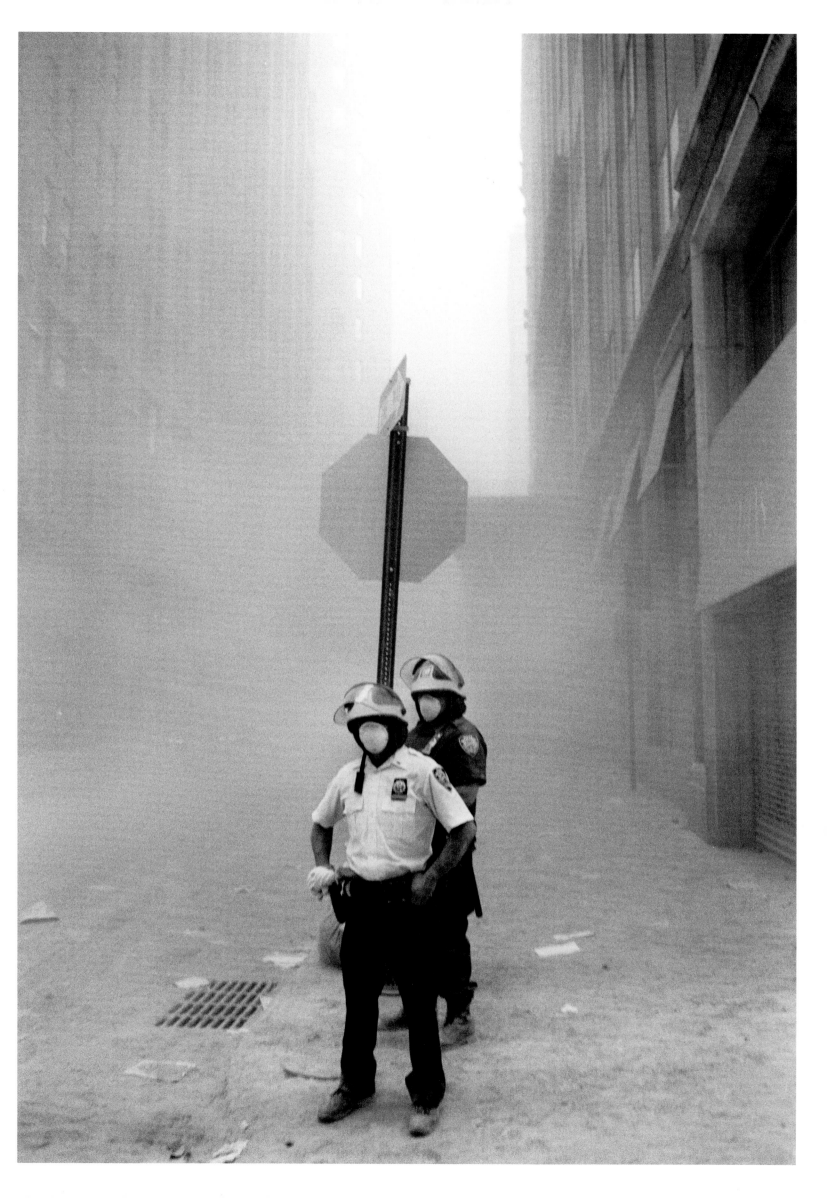

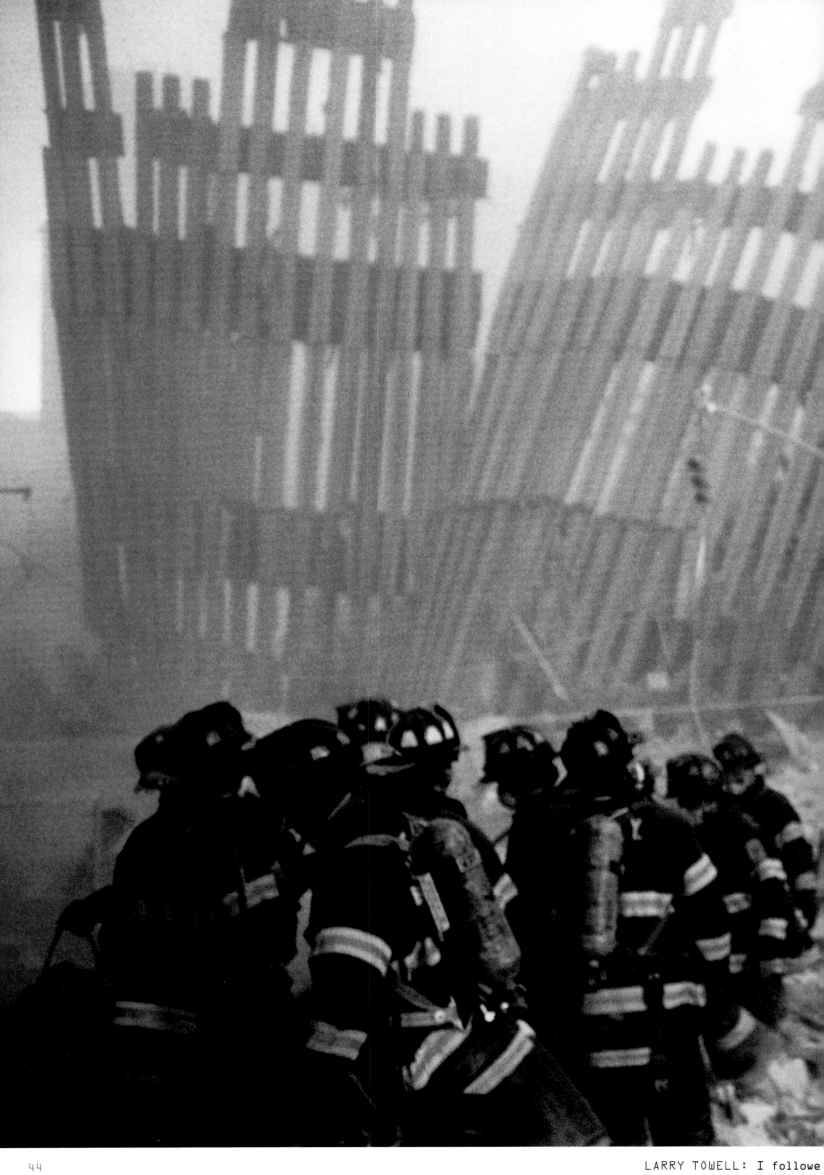

LARRY TOWELL: I followe

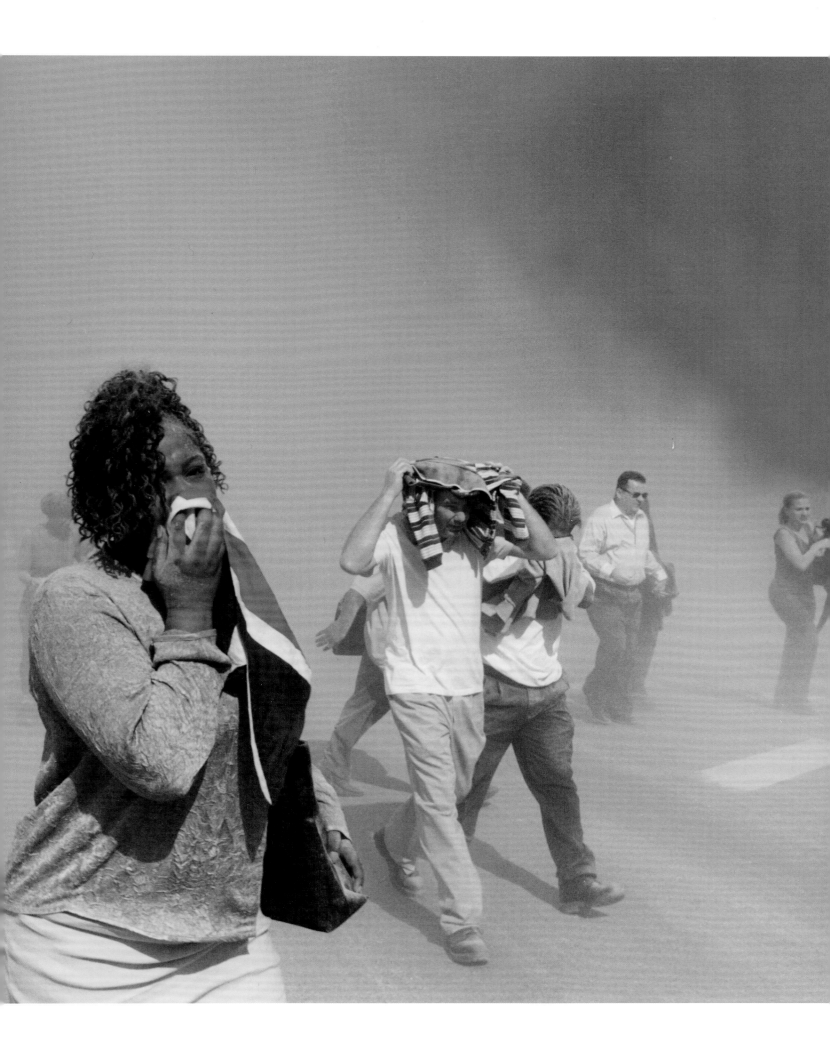

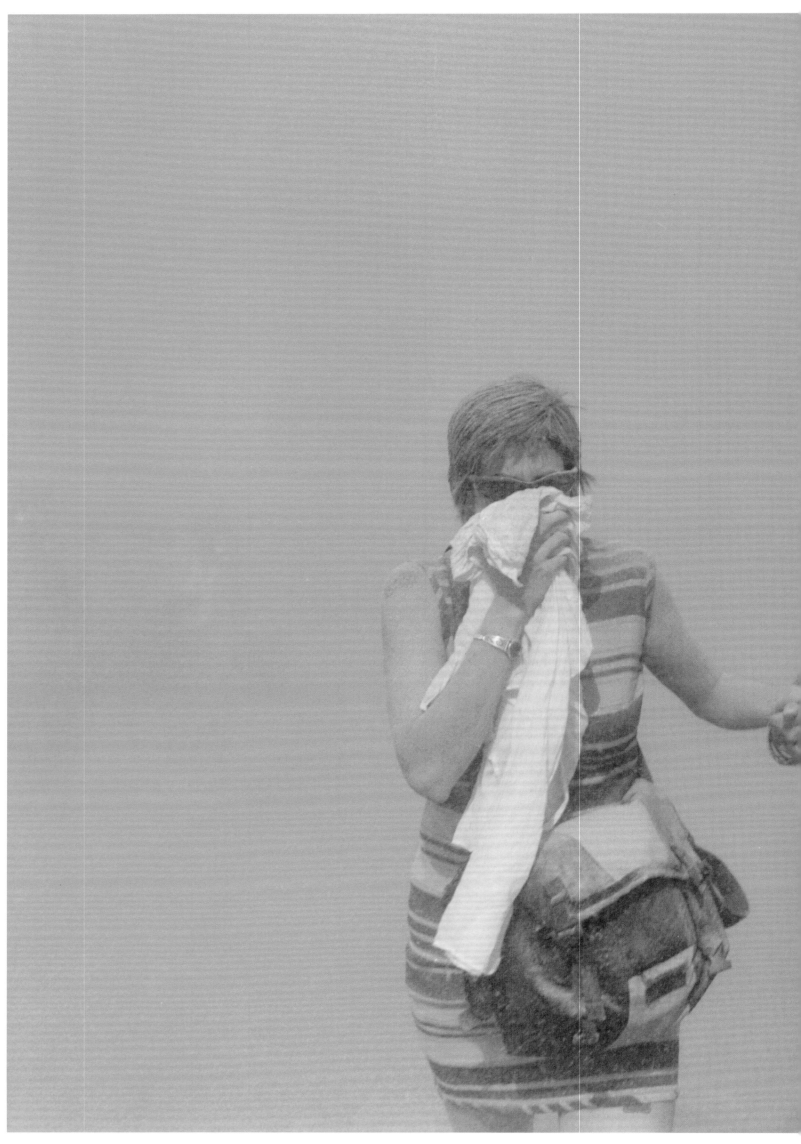

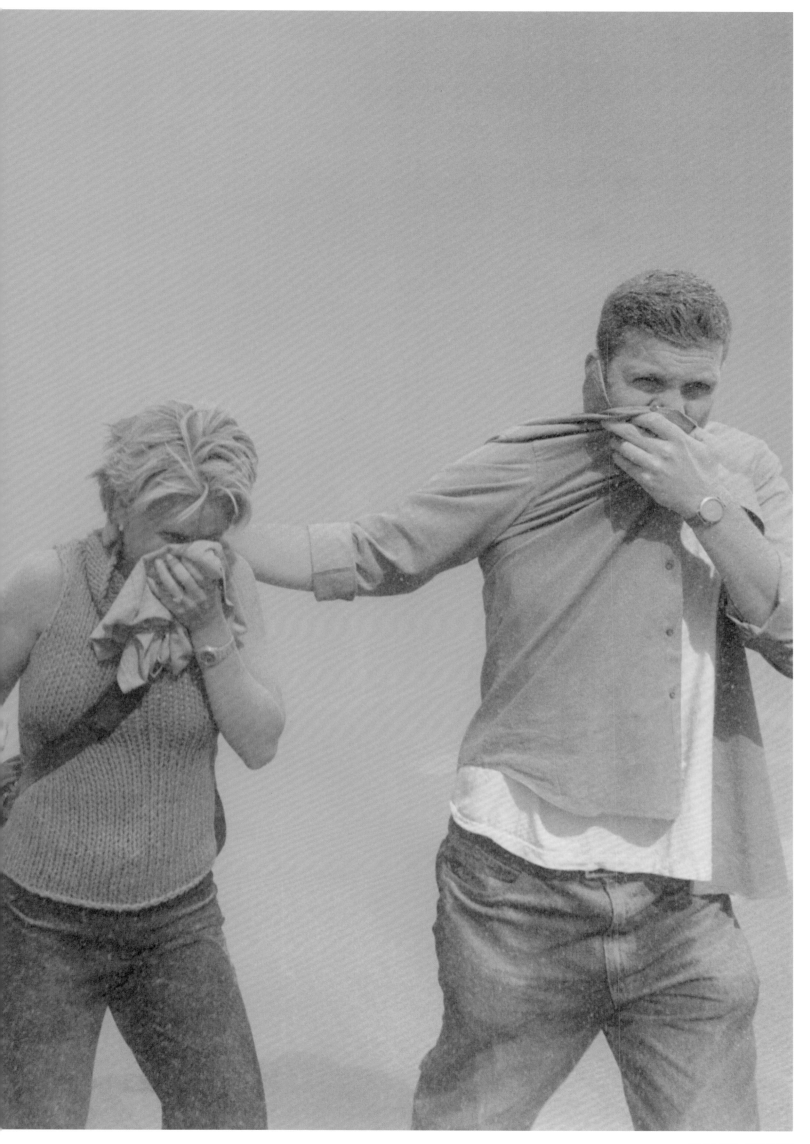

GILLES PERESS

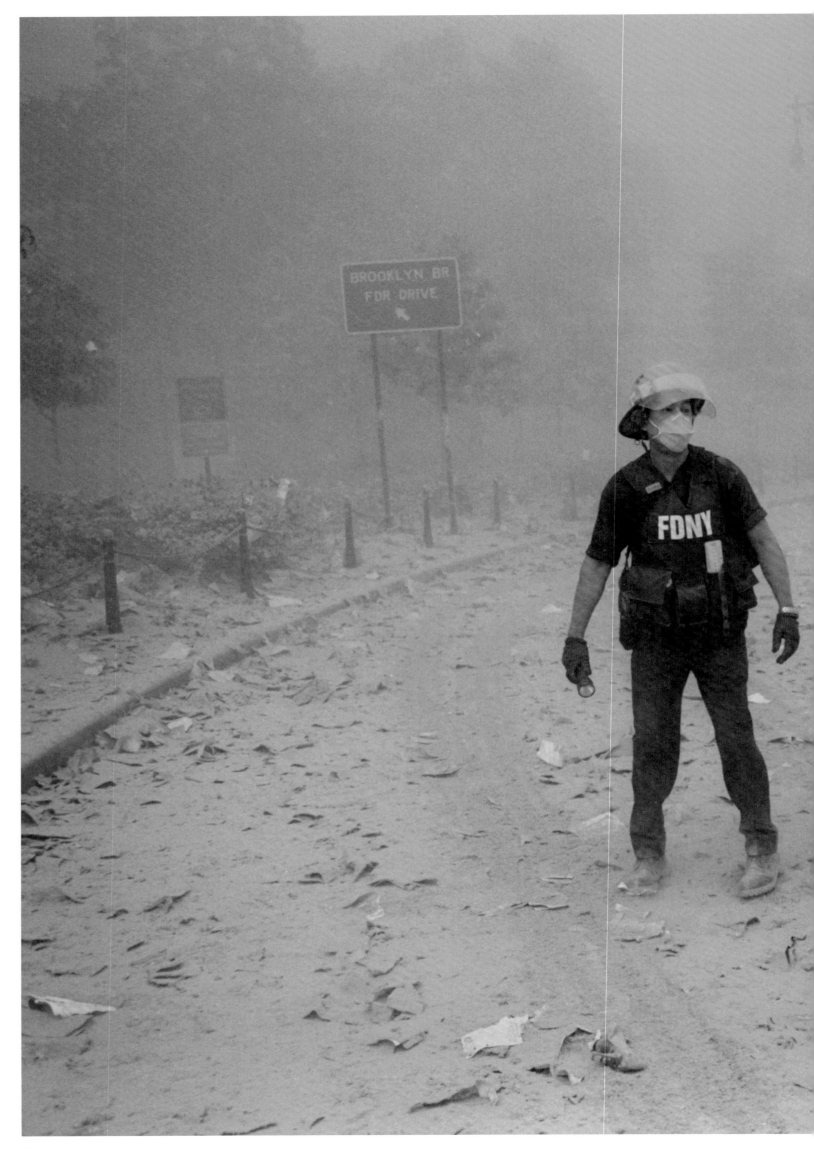

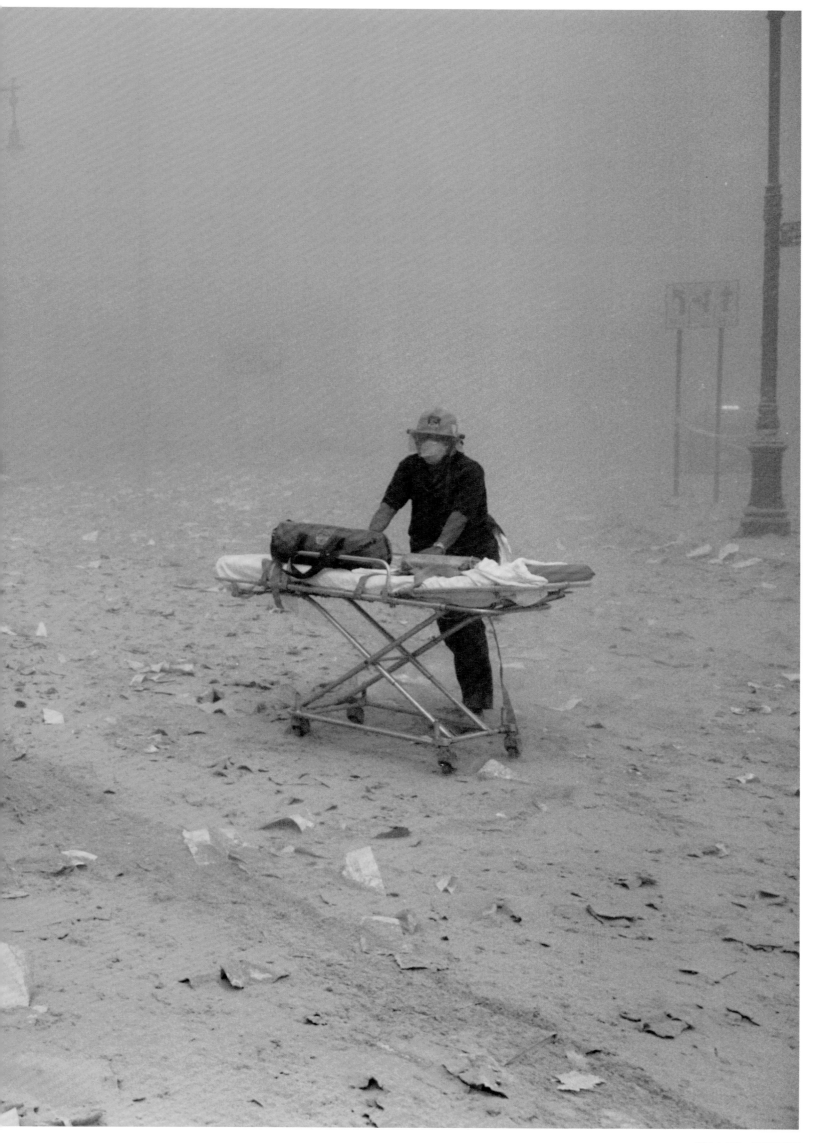

GILLES PERESS

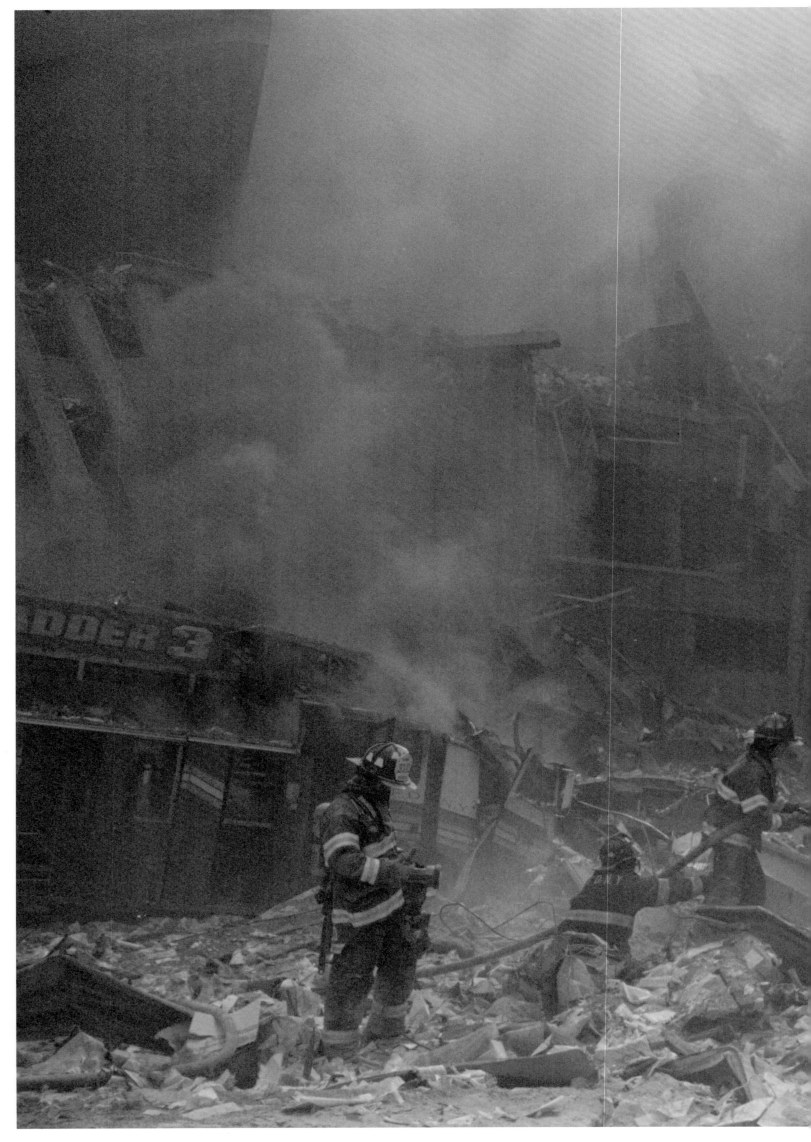

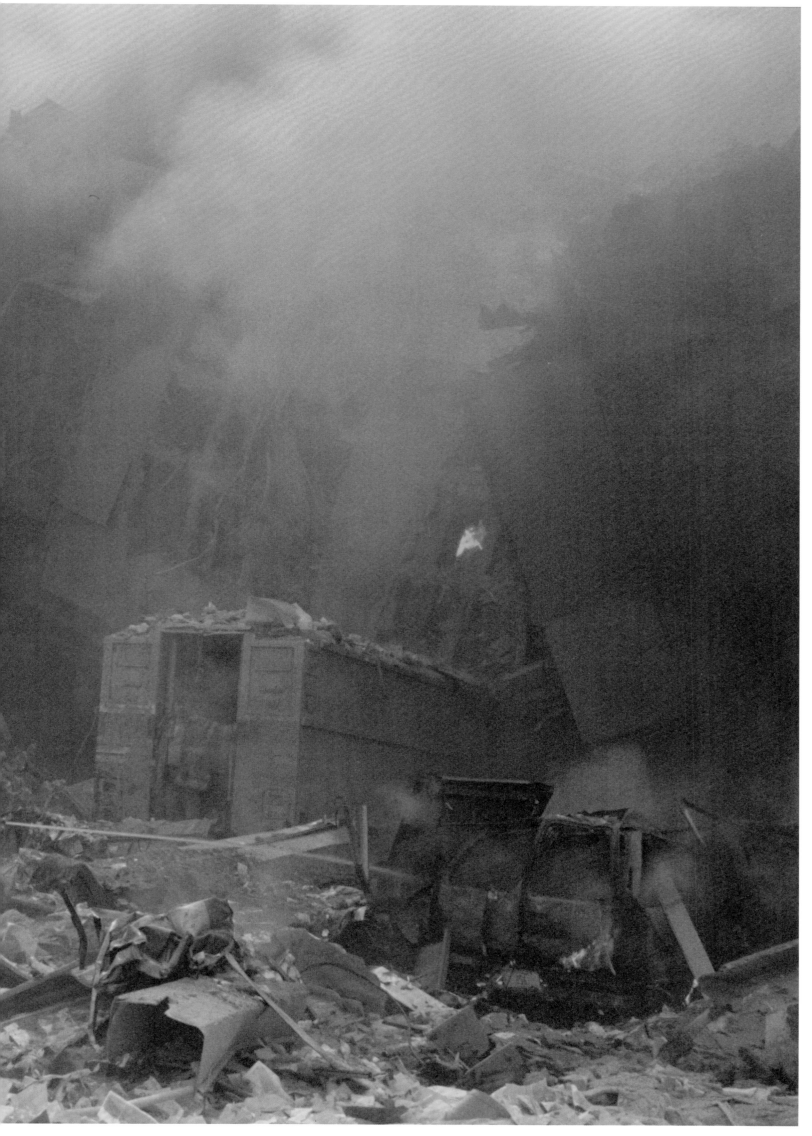

GILLES PERESS

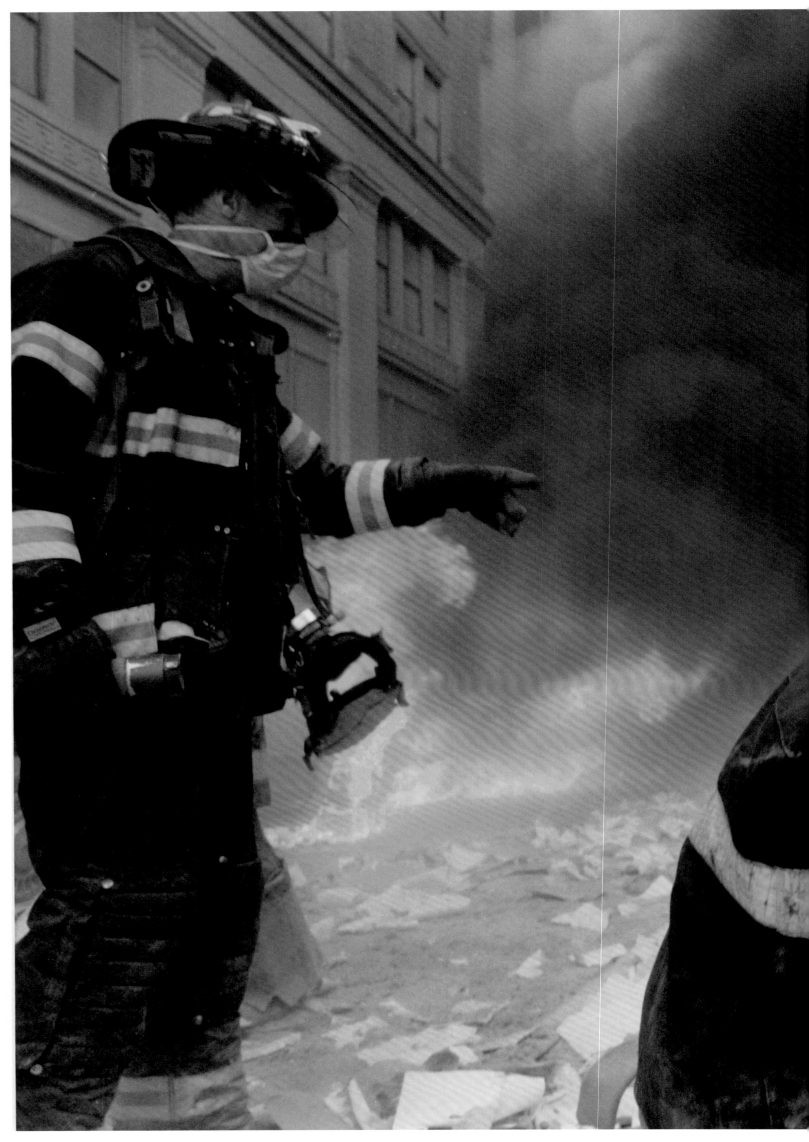

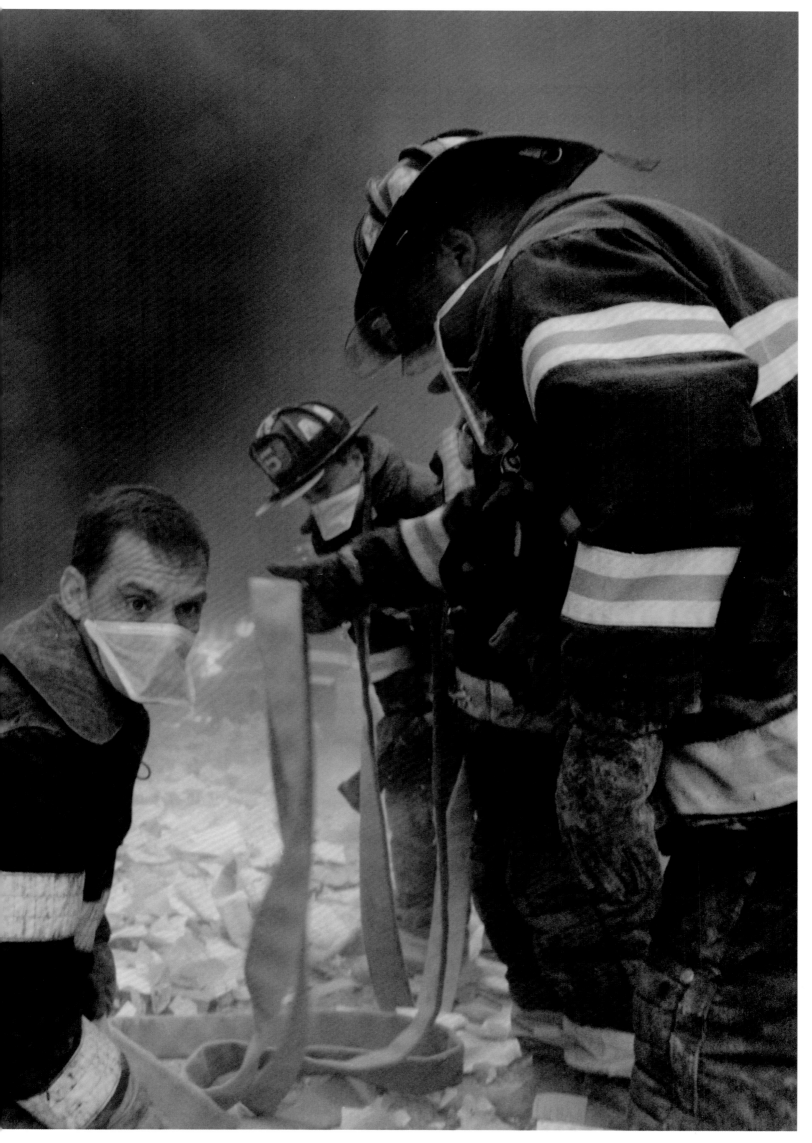

GILLES PERESS

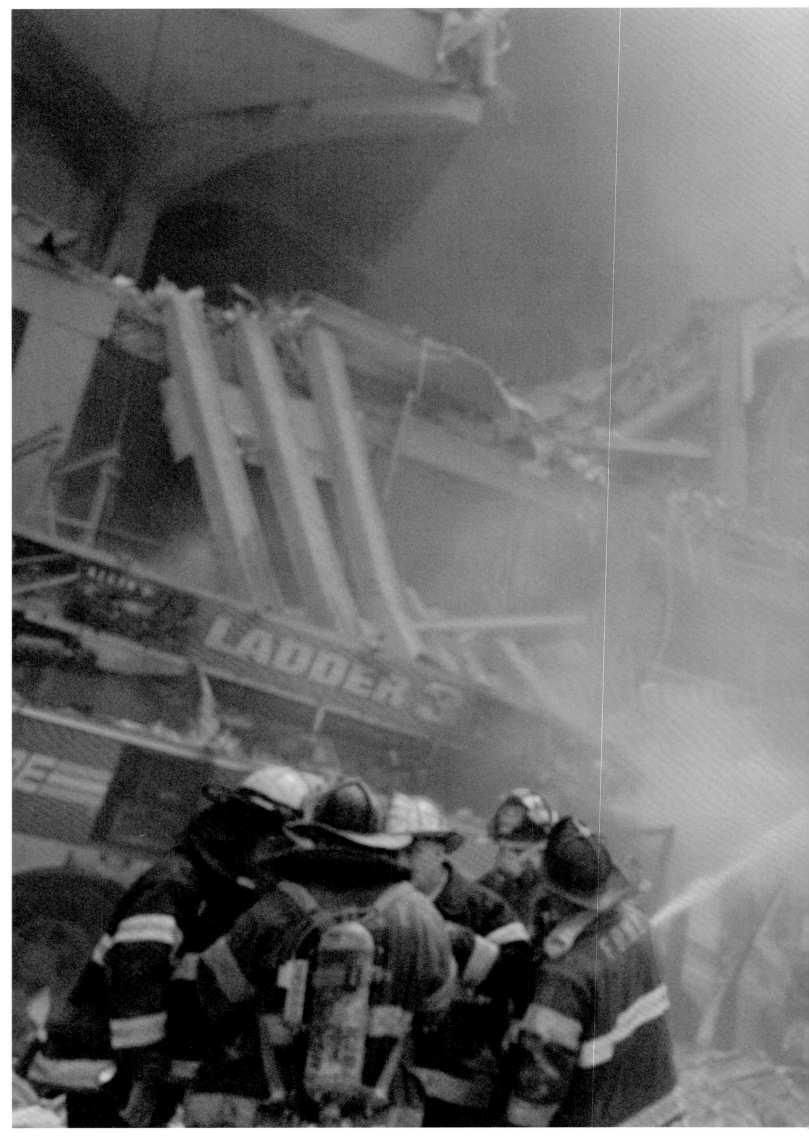

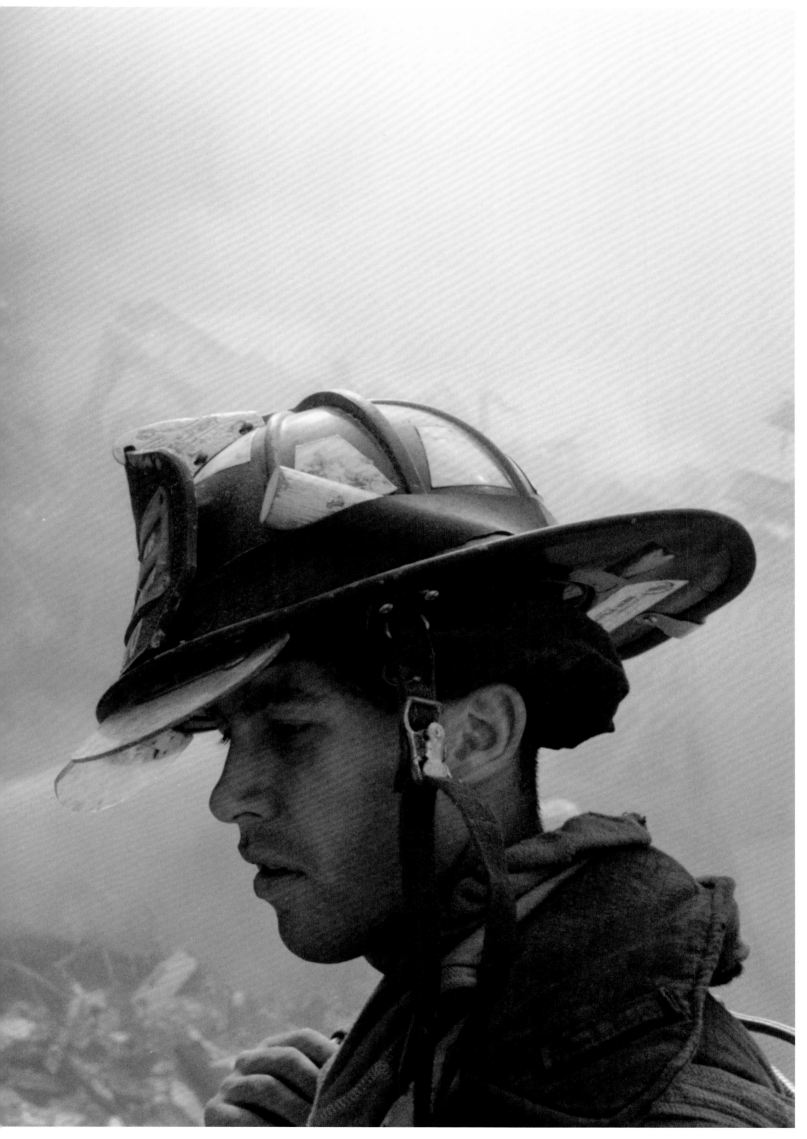

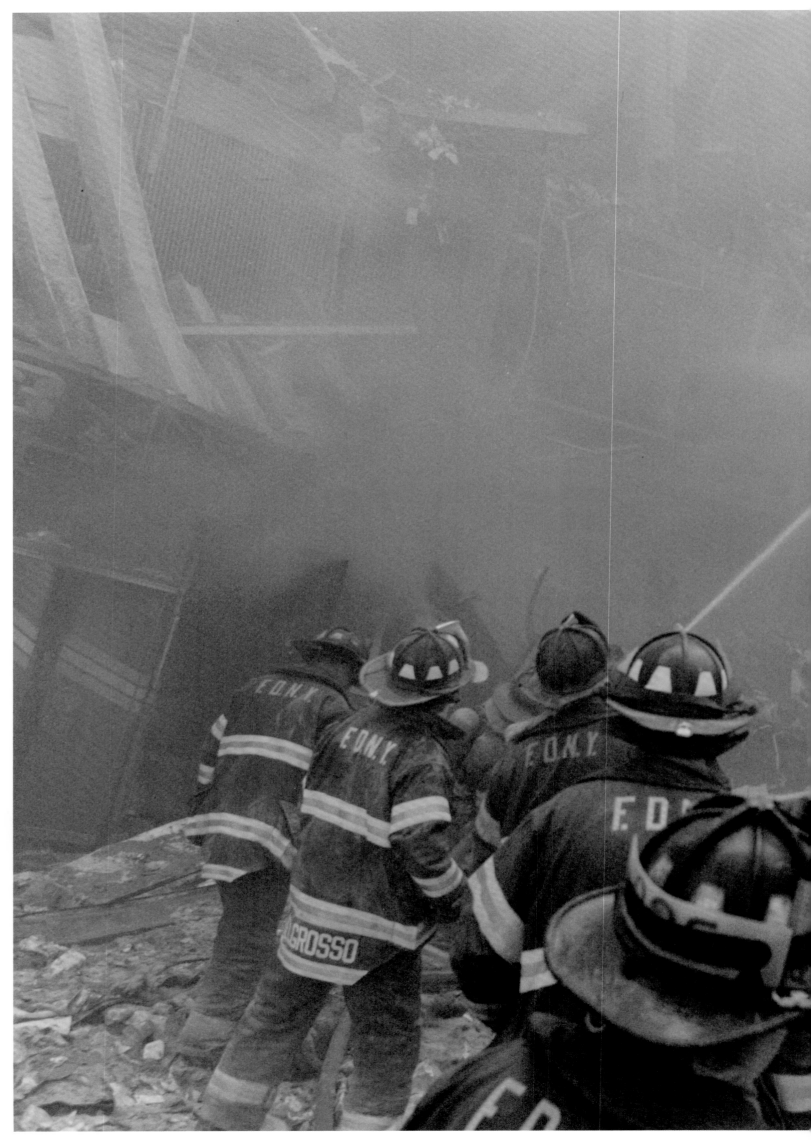

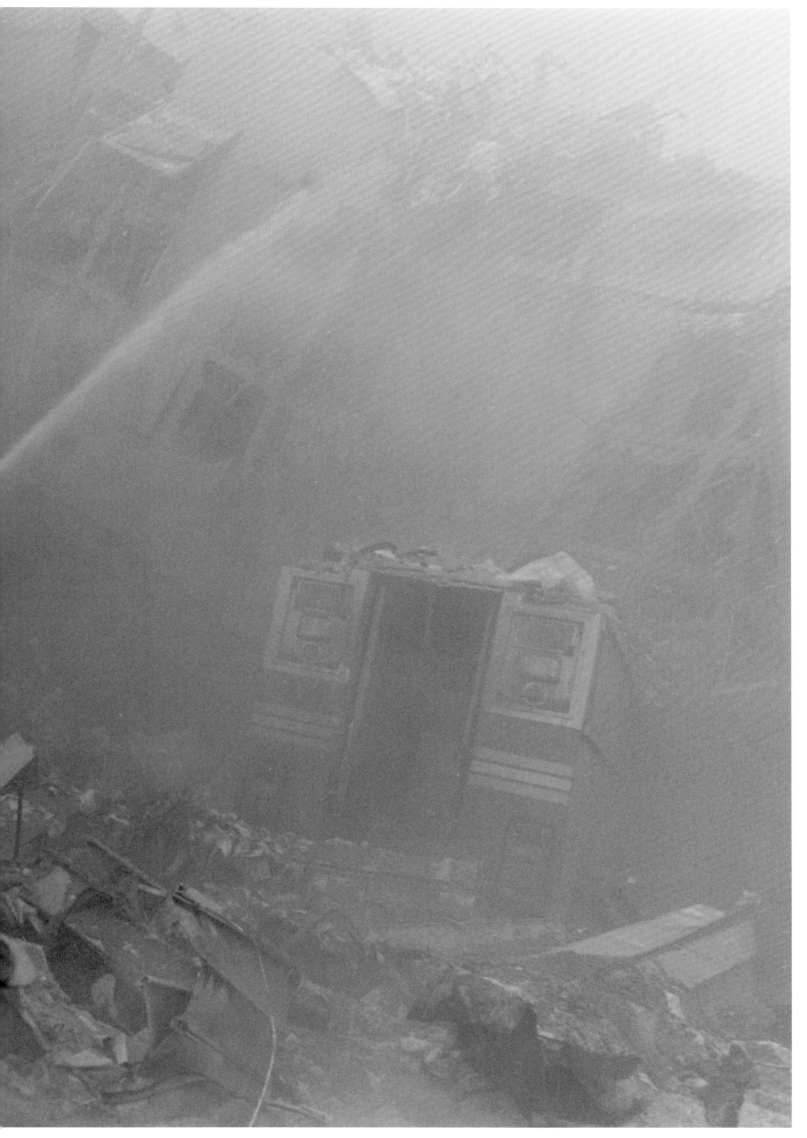

GILLES PERESS

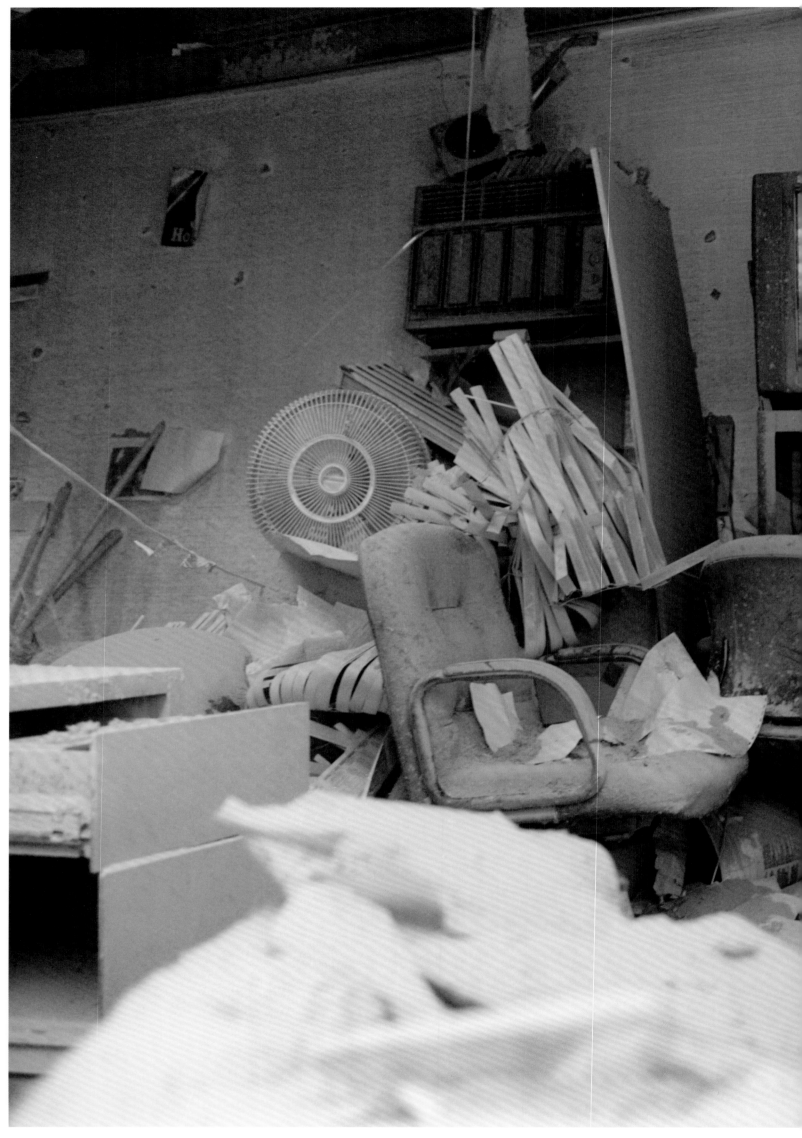

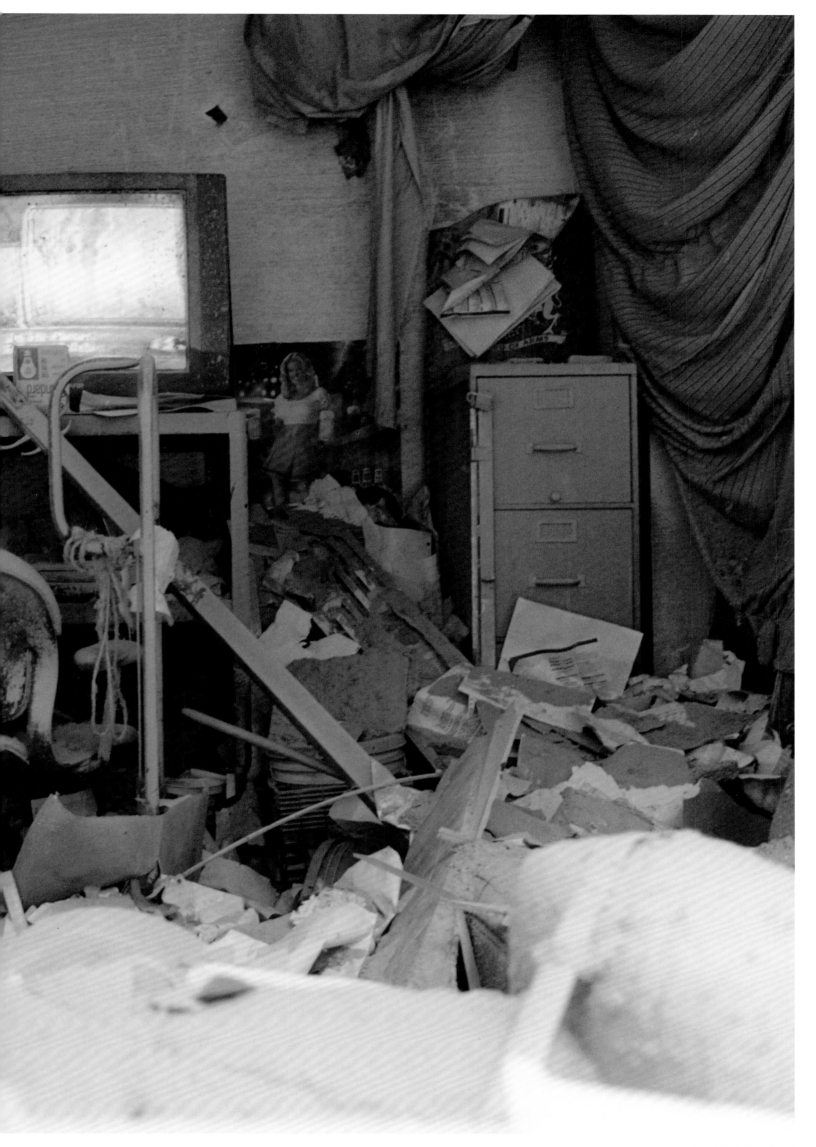

GILLES PERESS

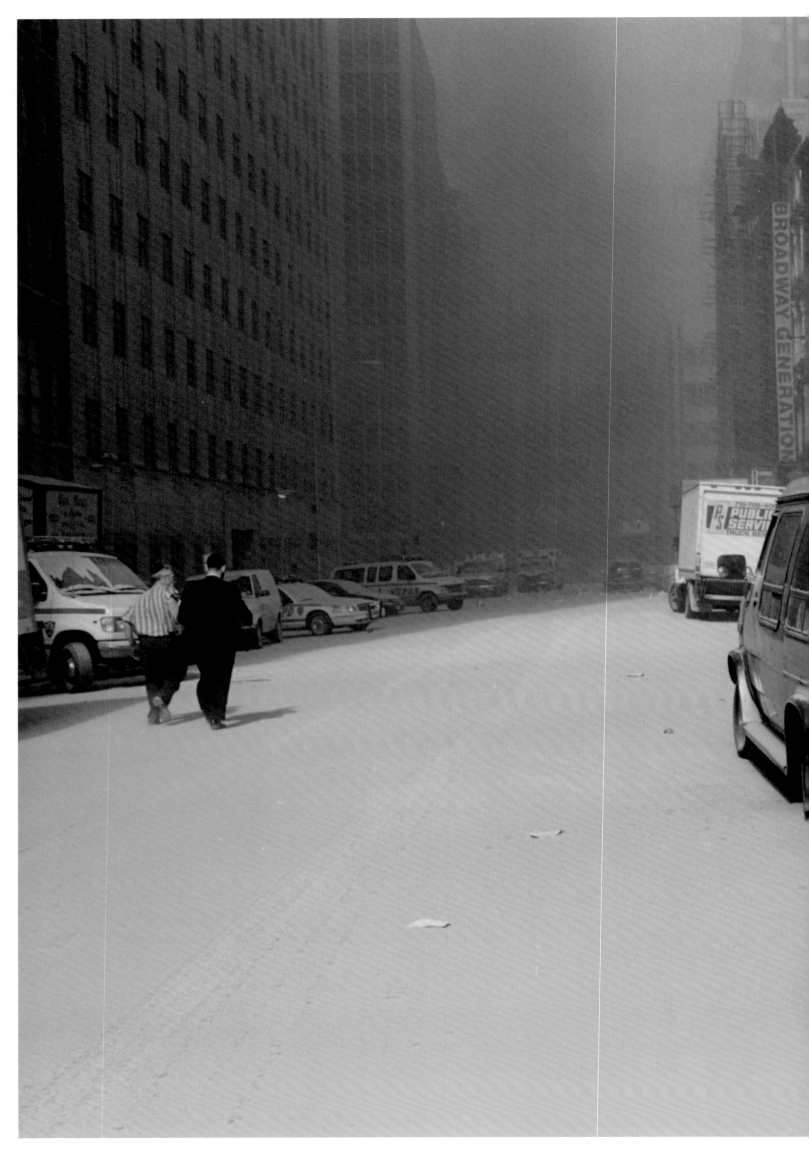

NOW SERVING
BREWED DECAF
COFFEE

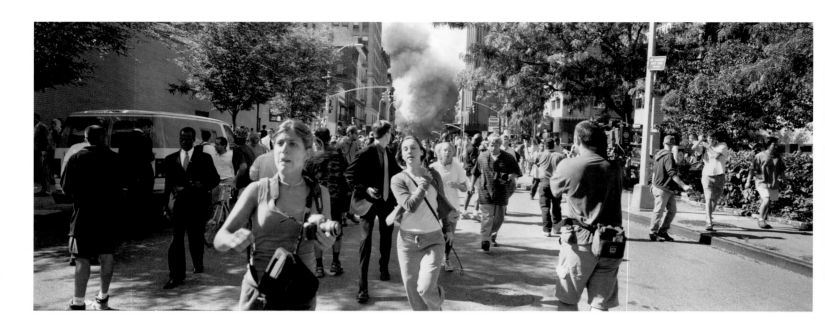

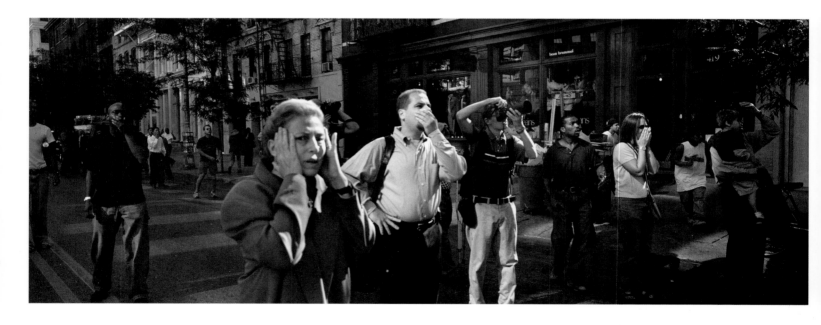

ADAM WISEMAN: I think the people who really realized what was happening
were the people who were quiet, who had their hands to their mouths.
Everyone else was standing there waiting for the second building
to fall. And when it fell, everyone panicked. It took them a couple
of seconds to run, and then everyone started running.

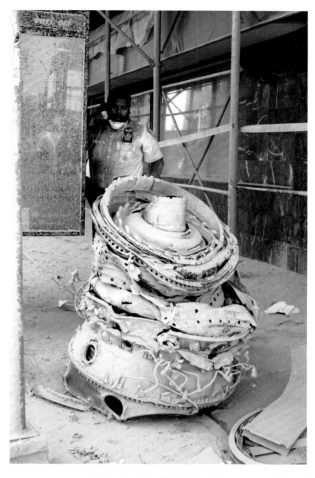

ANN-MARIE CONLON: Policeman behind
a fragment from one of the airplane engines.

(When the World Trade Center was attacked, several
Magnum staff members and interns went out to photo-
graph the events unfolding. Adam Wiseman works as a
printer in the darkroom, and Ann-Marie Conlon is an
intern visiting from Scunthorpe, North England.)

ADAM WISEMAN: I was late in getting started to get down there. When the first tower fell I was on
West Broadway, about a block or two north of Canal Street. Everyone was walking really slowly towards
it, almost as if it was pulling us. I ended up on Leonard Street and West Broadway in Tribeca, and
that's where I stopped.

At first, I wasn't really experiencing what was happening. I really feel I was hiding behind my camera.
It was my camera that was bearing witness. What made it come home to me was an English tourist, who came
up to me with camera in hand and asked me how close I thought they would let him get to the towers.
And I was baffled by that question, because one of the towers had just fallen. I turned to him and said,
"I really don't think it's a question of how close they will let us get. I think we shouldn't get much
closer than this, because I think the second tower is going to fall." And he turned around and looked,
and it was the first time he realized that the tower had collapsed, and he burst into tears.

I put my camera down and I was literally waiting for the second building to fall. And seeing people jump
to their deaths, one person after another after another. That was the most shocking thing of everything
for me. That's the one thing that keeps coming back in my mind.

It's funny the things that concern you at the time. I was concerned about calling Magnum to tell them
that I was going to be late for work. I had one hand on the redial button of my cell phone because I
couldn't get through. I was really concerned about that, pressing redial after redial after redial until
finally I did manage to get through. I said, "I'm sorry I'm going to be late. I've been shooting downtown
and there's no public transportation and I'm going to have to walk back to the office." And I hung up.
The forty blocks I walked back to the office were the longest distance I have ever walked. And when I
got back to Magnum I completely broke down. A couple of people there brought me to the back and made
me a cup of tea—and took my film.

THOMAS HOEPKER

I came to live in New York twenty-five years ago, from Germany, on assignment
for Stern magazine. I feel if you come to this city as a foreigner you're even
more intense about it. You don't take it for granted. I like the intensity, the
speed of the city. I like the professionalism, what we see on this project.
How in a few days you can gather together in a room a group of top-notch
professionals, enthusiastic, who can get a project like this book done fast.

I found out about the World Trade Center very early. I had just sat down for break-
fast and the phone rang. Magnum's editorial director, Rebecca Ames, was calling, about
five minutes after the first plane hit. She lives in Brooklyn and had just seen
smoke coming from the World Trade Center from her window. She was totally shaken. In
a way, I didn't really believe what she said. It took a while to sink in. Then I
switched on the TV, and only when I saw the pictures did it become a reality. That
is typical for our day and age, isn't it? If it's not on TV, it has not happened.

I saw the second plane hit the building on the
screen, and for a moment I was totally helpless.
I didn't know what to do. I just sat there in shock
for a moment thinking, What do I do now? What's the
right thing to do?

All these things run through your mind. I even thought, It's probably
not right to go and take pictures. It's so horrific, it's not decent to
photograph that. Of course then you begin to think professionally. You have
to do something. You simply have to go out and take pictures.

I heard that the subway wasn't running. I felt the only way to get anywhere
was by car. When I got onto Second Avenue, I realized the traffic was so
heavy I couldn't go downtown. Then I decided to cross Queensboro Bridge.
That turned out to be a mistake. Already, there were many, many people in
cars, in trucks. It looked like an exodus—people fleeing a doomed city.

There was such a contradiction in the beauty of this day and the real
horror downtown. It was like a Hitchcock movie that is shot in bright
daylight, where something horrible is looming but you don't know what. It
was a lovely, sunny, late-summer day. And this horror descended on a day
like this.

Then I found out I was trapped on the other side of the East River and couldn't
drive back into Manhattan. So I shot most of my pictures from Brooklyn and by
walking over the Manhattan Bridge. Then I called the Magnum office and asked,
"What should I do now?" And they told me to bring my film in so I could get it
to the lab immediately.

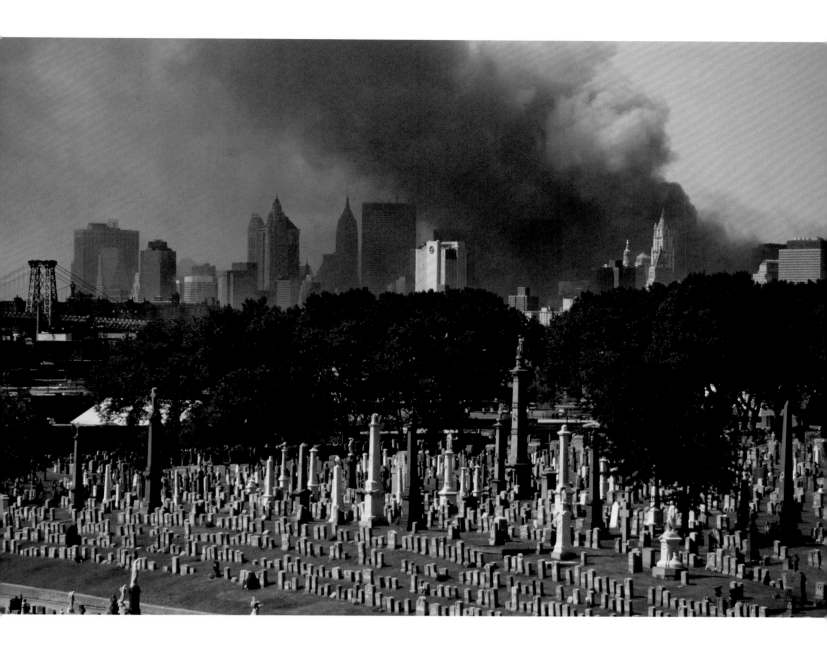

Magnum was founded as a group of documentary photographers. That is our tradition. With a terrible event like this, we understand all over again the importance of that heritage. I think that today, through all the new digital technology, through a loss of "visual integrity," people are faking images left and right. They're changing what's in the pictures. So the public has lost the sense that a photo is proof and a document. They see it as an illustration, as entertainment. We have lost our innocence, and we have lost our sense of what's morally right with photographs.

I strongly believe in documentary photography, in taking pictures of real life. When I looked at the pictures from our photographers, there were some that were wonderful or clever compositions, but they emphasized the artistry in photography rather than telling the story. We didn't put those pictures in this book. I don't think they belong in this book because they do not serve its purpose, which is to bear witness. In a moment like this you must be very humble. When something like this happens, nothing you do can adequately respond to the monstrosity of the event.

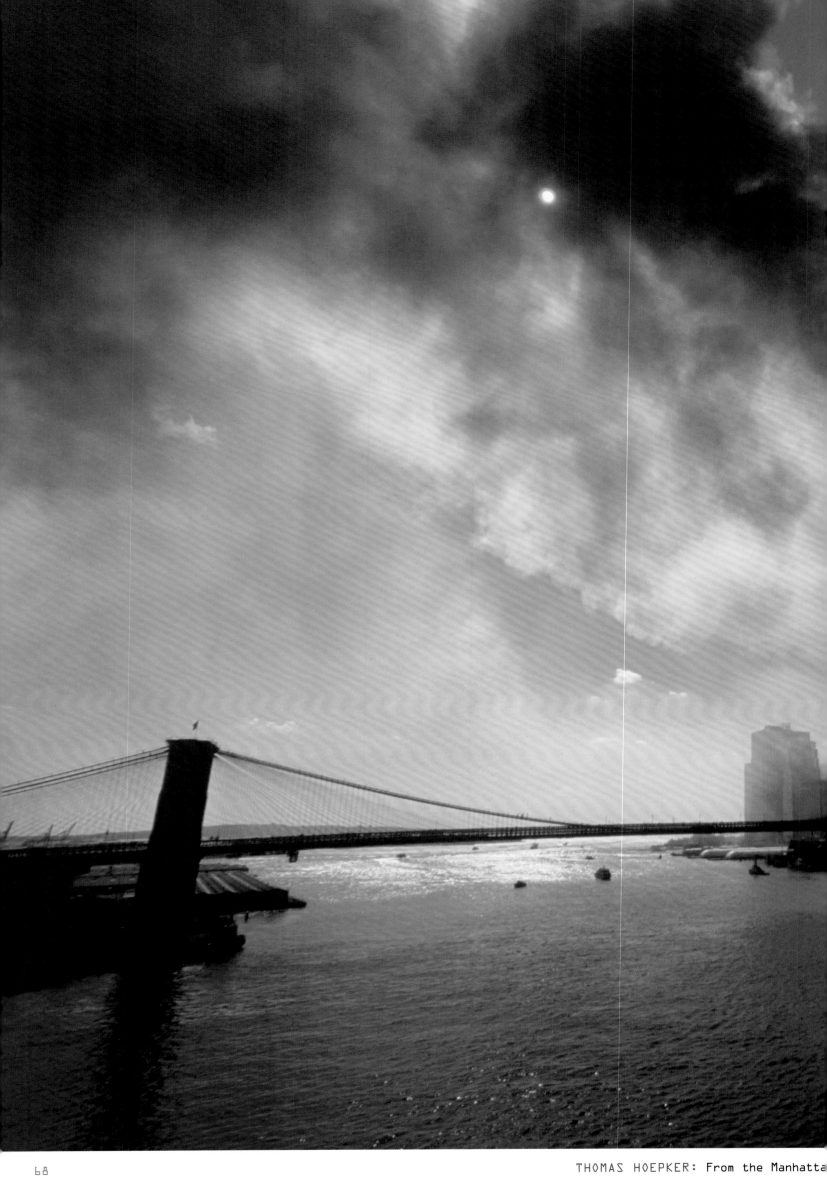

THOMAS HOEPKER: From the Manhatta

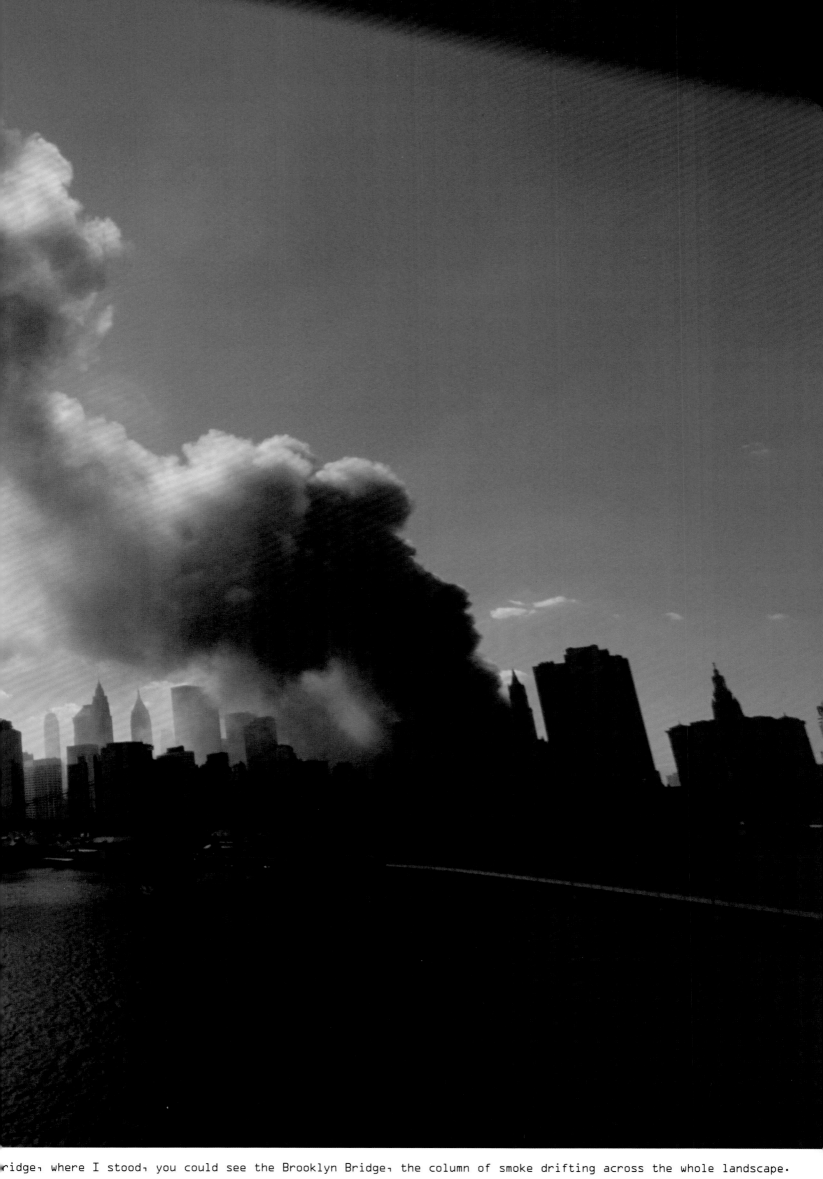

ridge, where I stood, you could see the Brooklyn Bridge, the column of smoke drifting across the whole landscape.

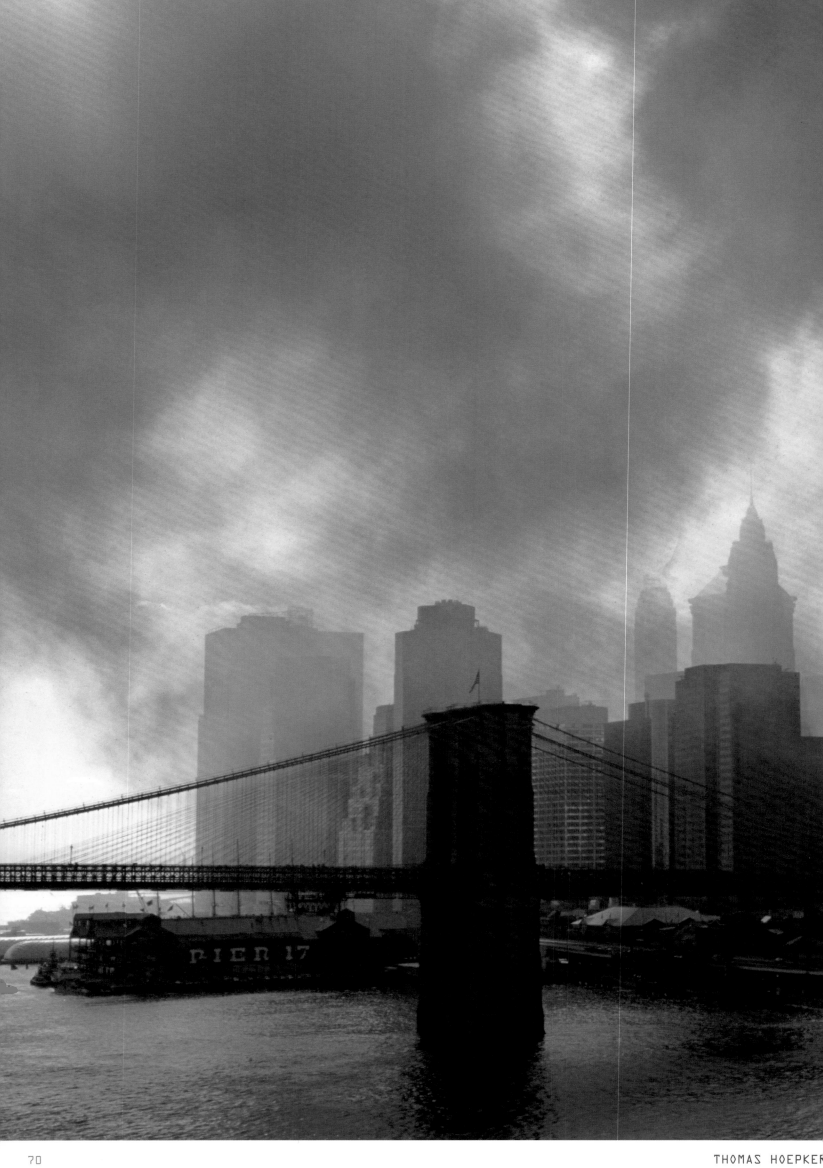

THOMAS HOEPKER

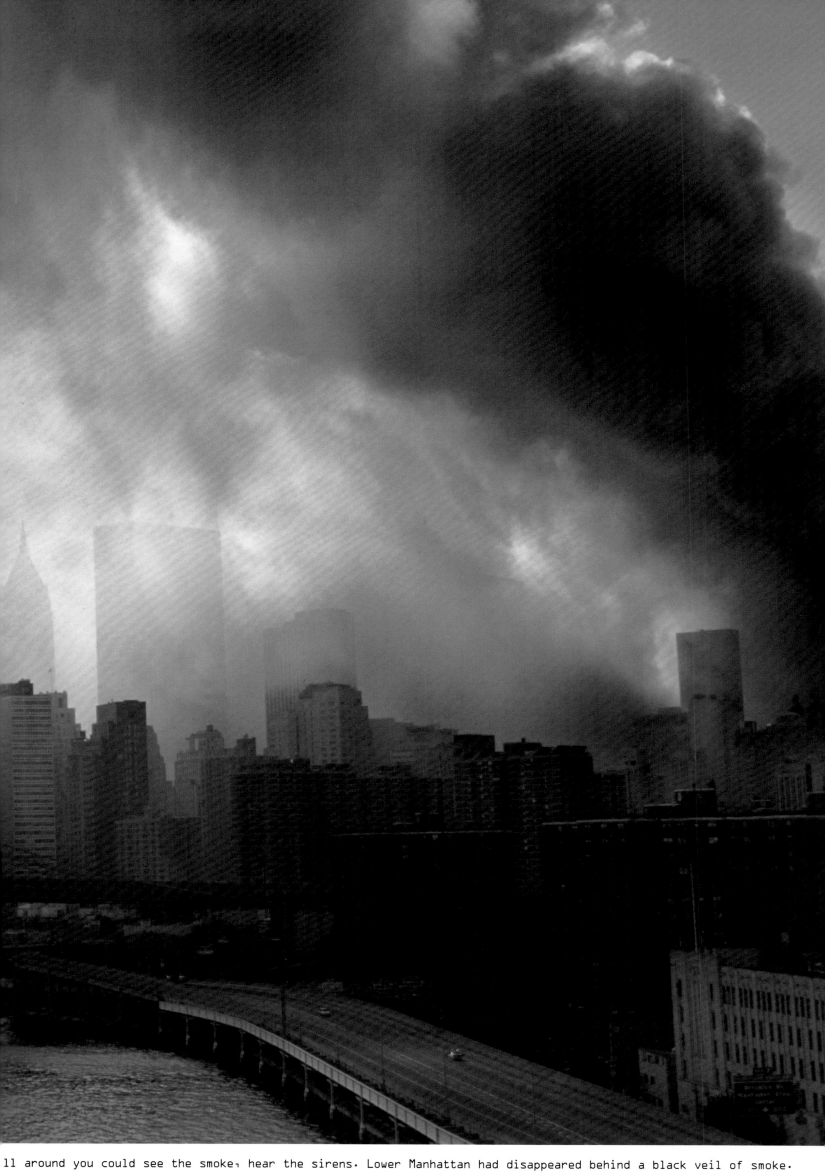

ll around you could see the smoke, hear the sirens. Lower Manhattan had disappeared behind a black veil of smoke.

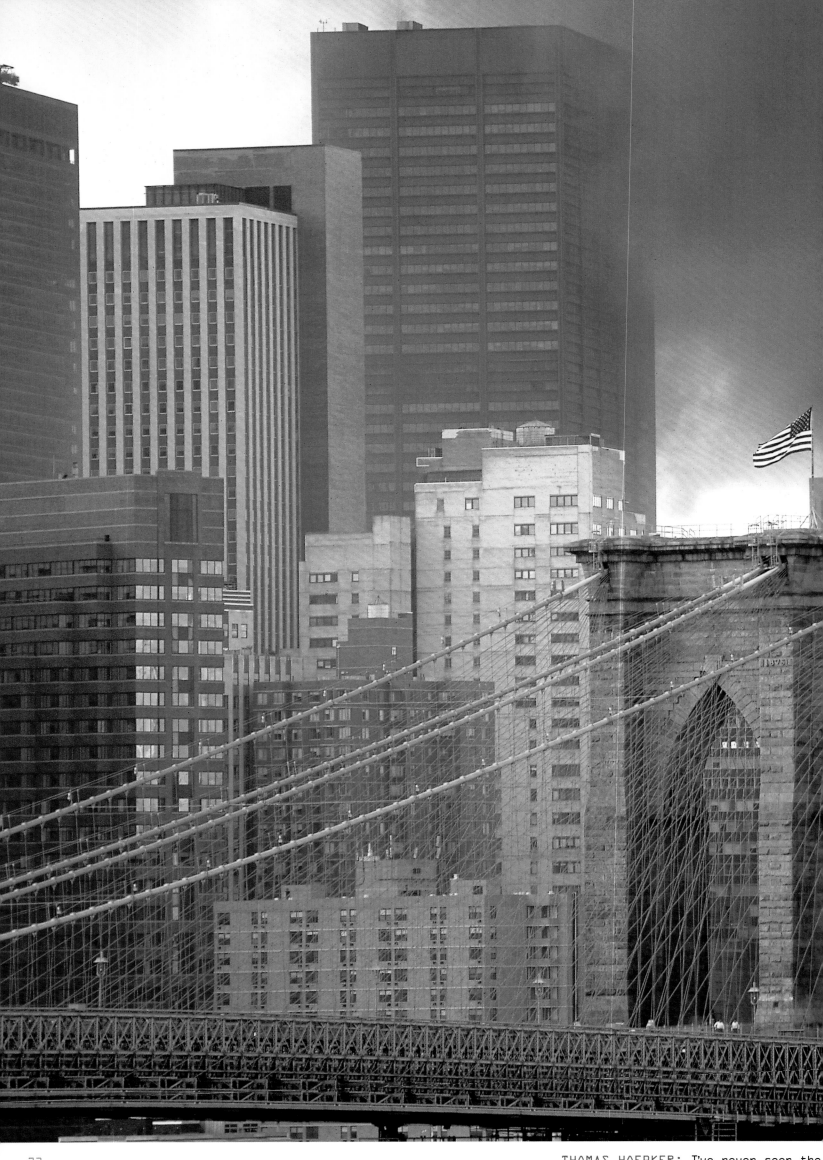

THOMAS HOEPKER: I've never seen the

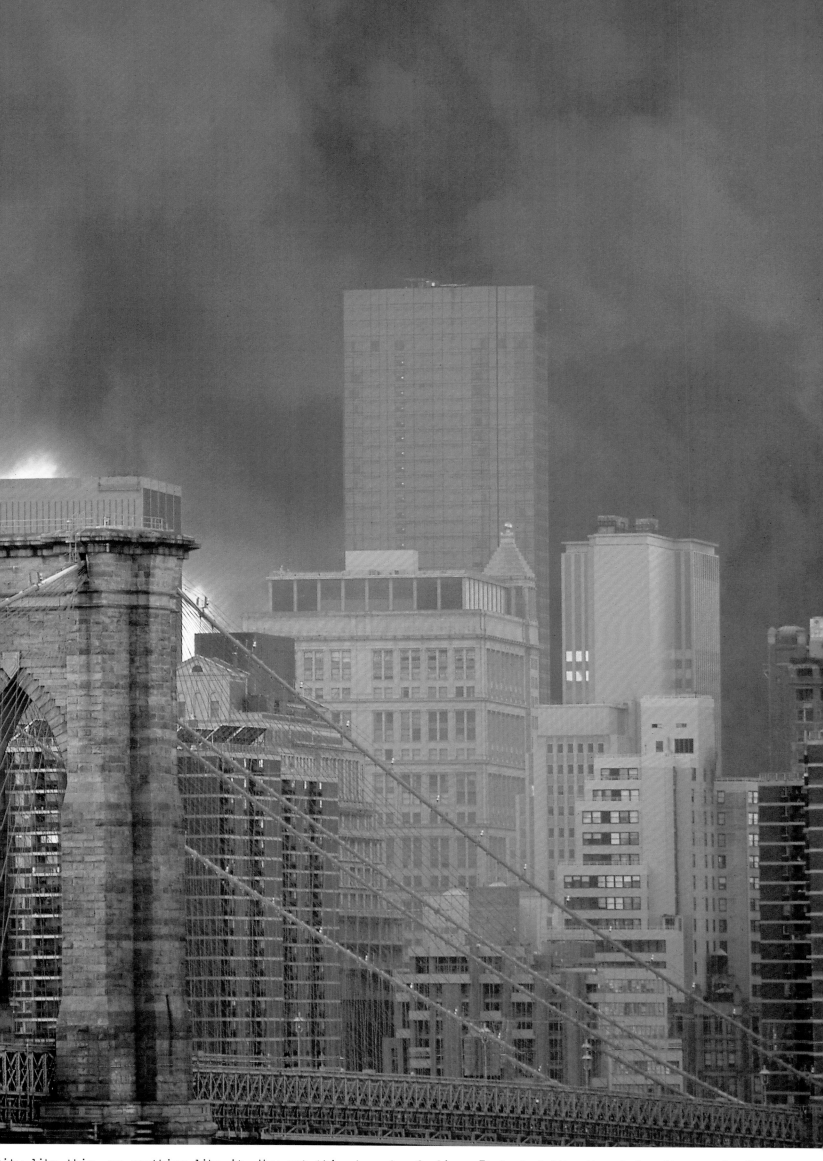

city like this, or anything like it. You got this doomsday feeling. It looked like the whole city was in flames.

ALEX WEBB

My wife Becky and I held one another and watched, horrified, as the second plane crashed on television. As I began to gather up my cameras, I felt weighted down by unfamiliar feelings. In the past, wars, civil strife, or natural disasters that I've photographed happened far from home. This was different. Terrorists had attacked my city. Thousands of people were probably dead. I felt I had to photograph, yet I hesitated. Becky, herself a photographer, wanted to go with me. Despite my worries about her safety, I reluctantly agreed, realizing that she, like me, needed to respond somehow to this tragedy.

We live in Park Slope, Brooklyn, some three miles from
Manhattan. The subways and local car services were not running.
To save time, we rented a car a few blocks from our apartment and
drove toward Manhattan, abandoning the car near the East River
and proceeding on foot, eventually crossing the Manhattan Bridge
and heading downtown.

A handkerchief across my face, I meandered through the powder-filled
streets of the financial district: a strange, whited-out, monochromatic
scene. At one point Becky turned and said that the fine, white dust
blowing around us might well contain the ashes of thousands of victims.
When Building 7 collapsed the sky turned a dark ochre. People became
dusty silhouettes, the sun a dim fireball.

Arriving late, I never witnessed the terror and the agony of the tragedy downtown. I never saw the pain or the panic. I just saw the desolation of the aftermath as the city slowly came back to life. A few hours after the attack, I saw a man pushing a nine-month pregnant woman down the sidewalk in an office chair, joking with her to keep her spirits buoyed. I photographed a bicyclist collecting powder from the explosion in a plastic glove. I asked a woman, whom I didn't photograph, what she was looking for amongst a pile of blowing papers. She told me that she wanted to see what people had been investing in. And I met a woman who was in the World Trade Center at the time of the attack. She was videotaping near the ruins, she told me, as a way of coming to terms with the experience.

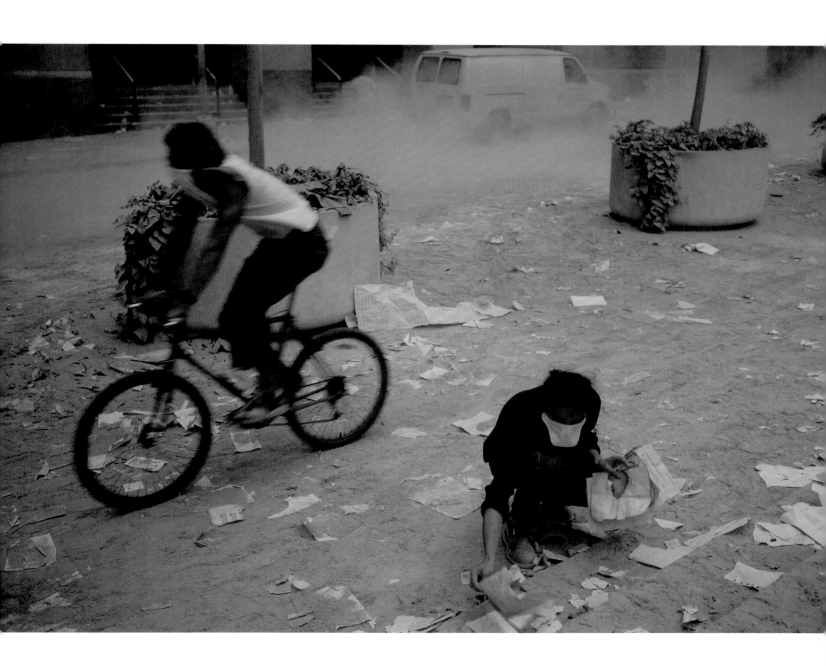

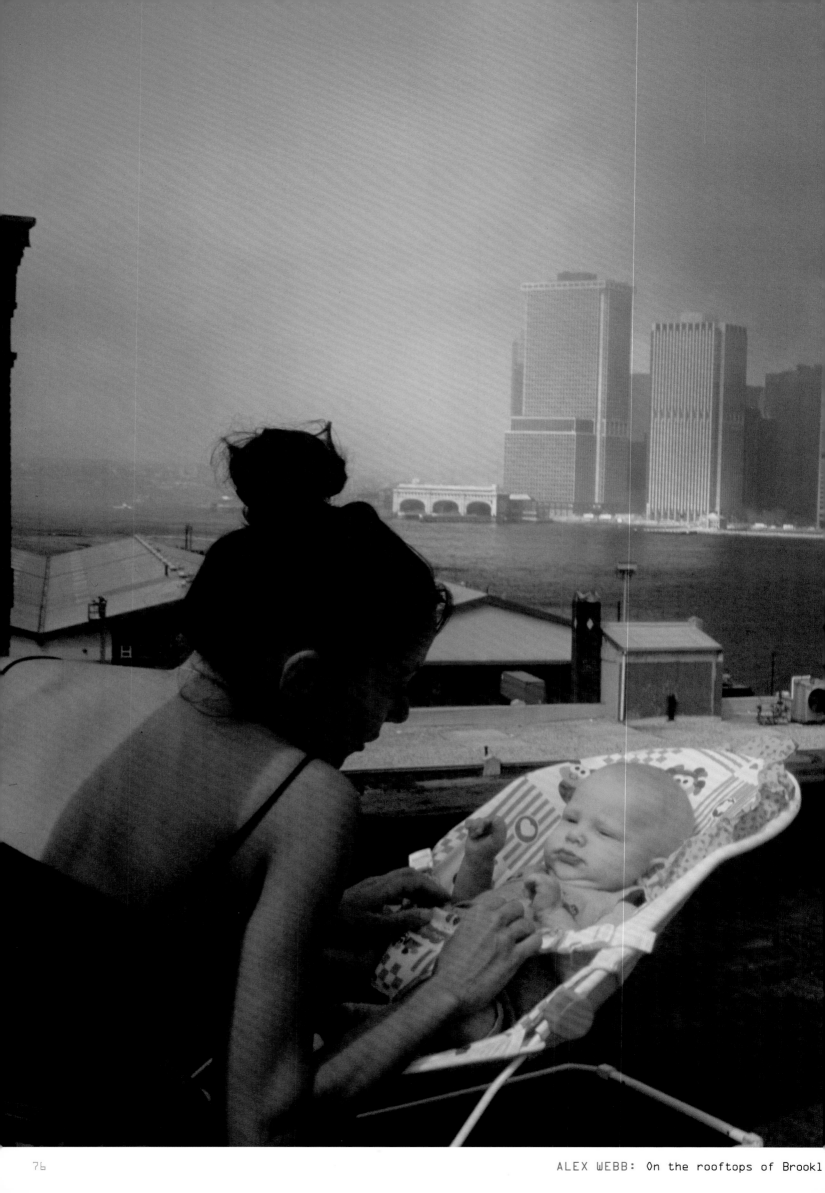

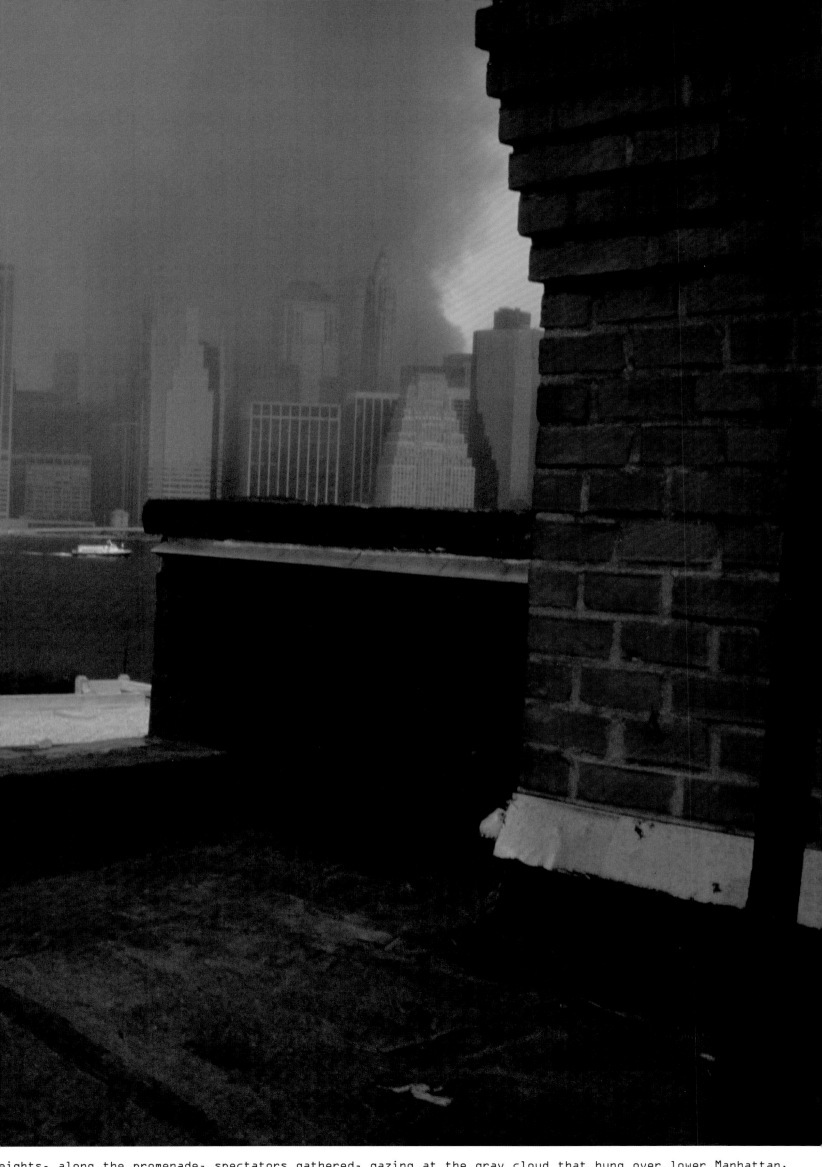

eights, along the promenade, spectators gathered, gazing at the gray cloud that hung over lower Manhattan.

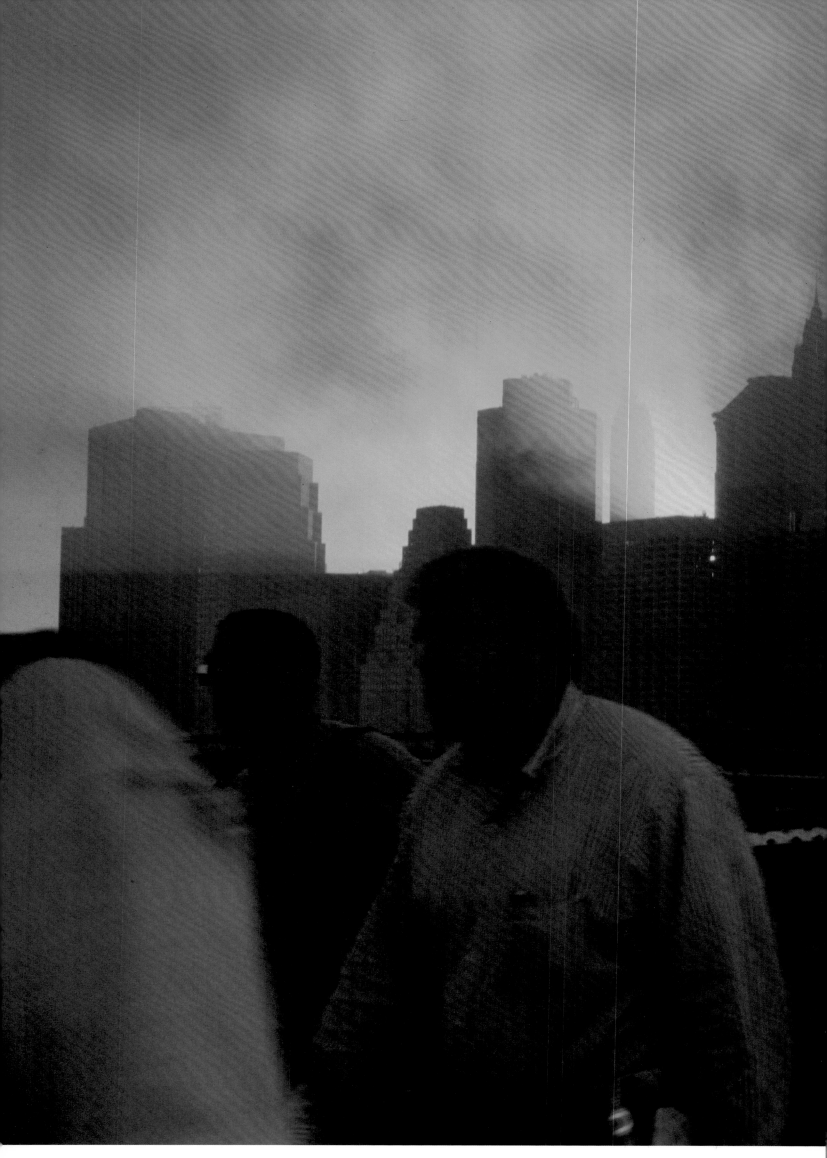

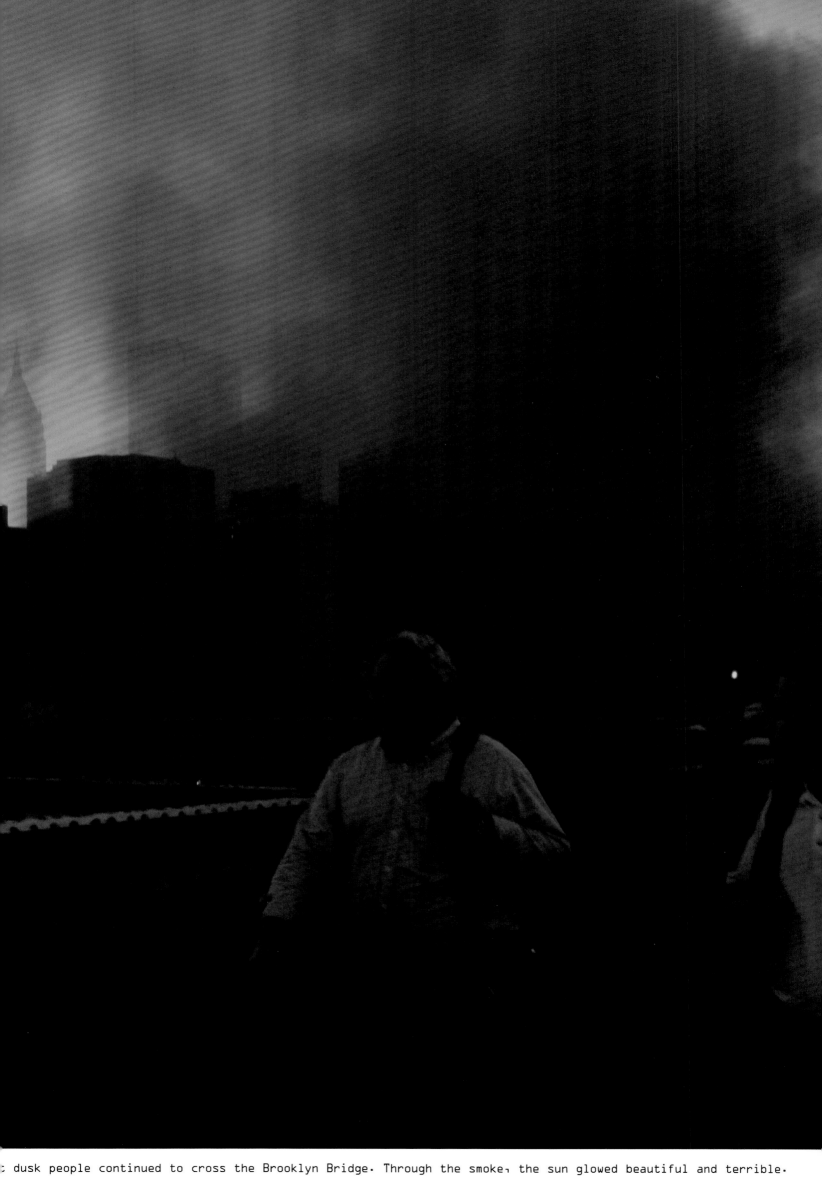

dusk people continued to cross the Brooklyn Bridge. Through the smoke, the sun glowed beautiful and terrible.

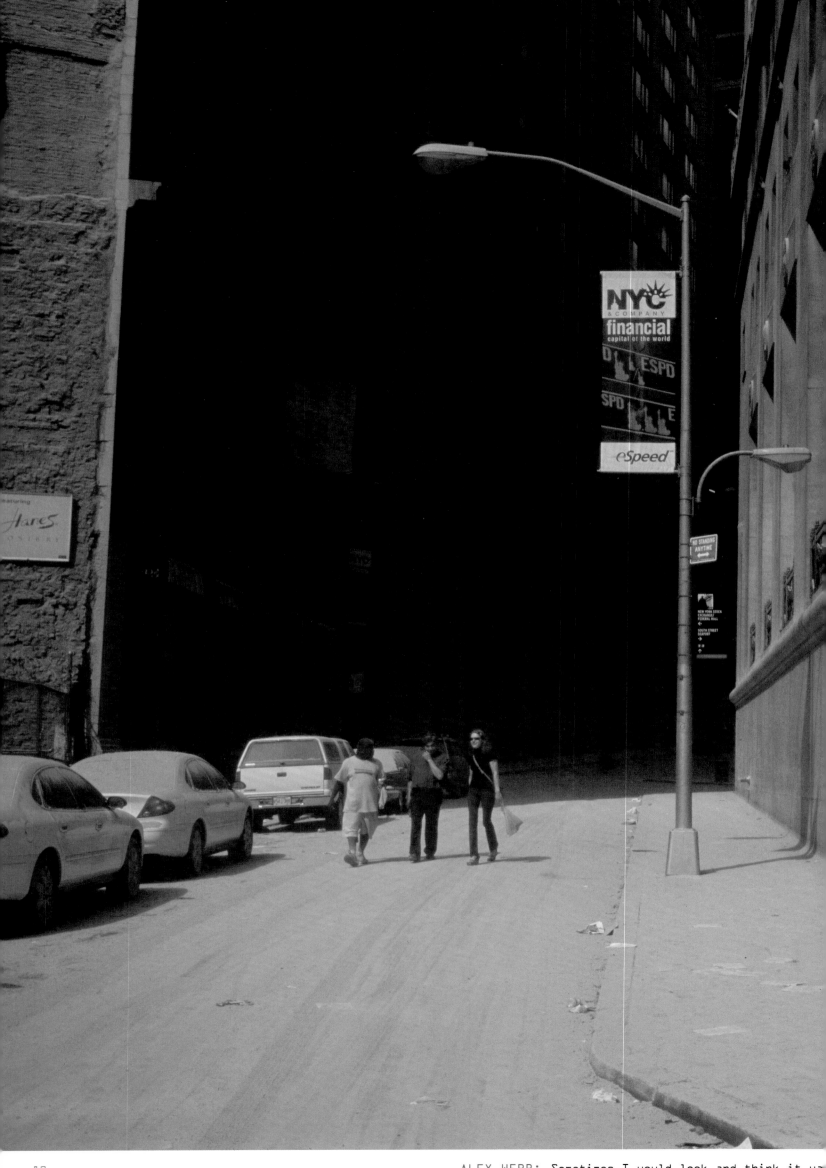

ALEX WEBB: Sometimes I would look and think it wa

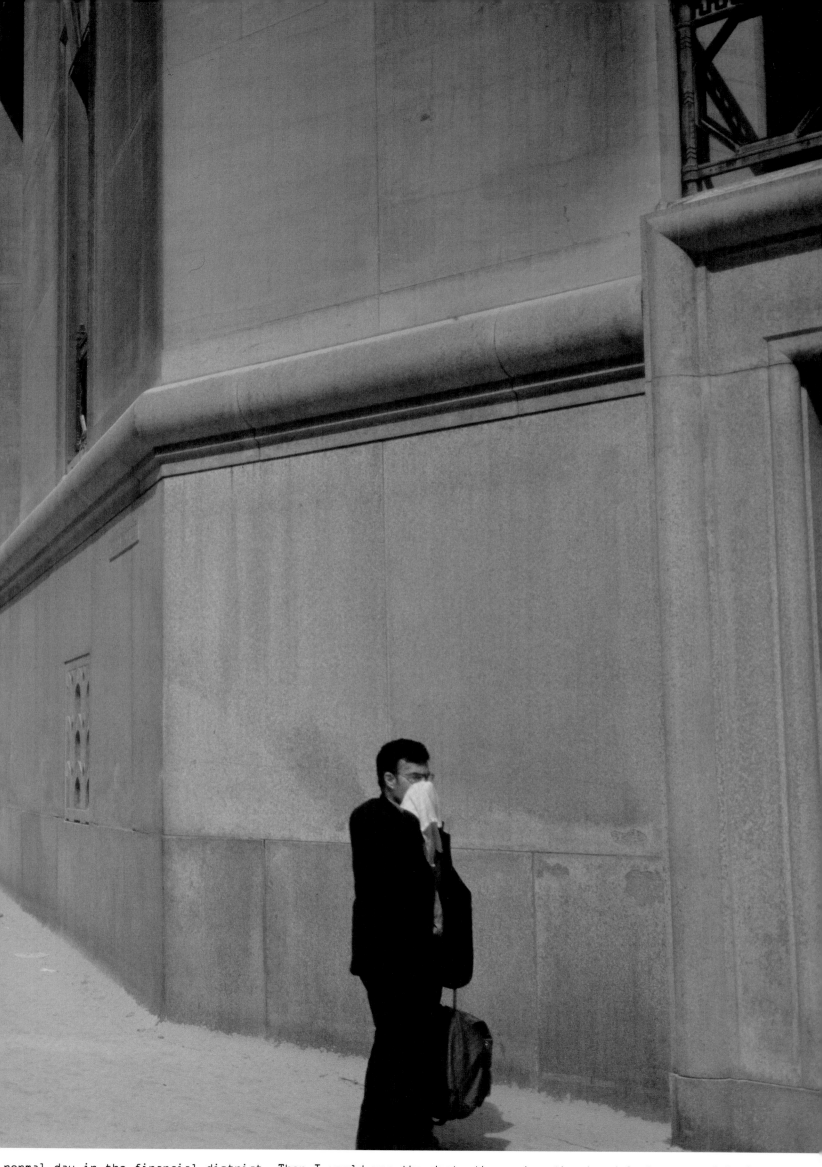

normal day in the financial district. Then I would see the dust, the masks, the dazed look on people's faces.

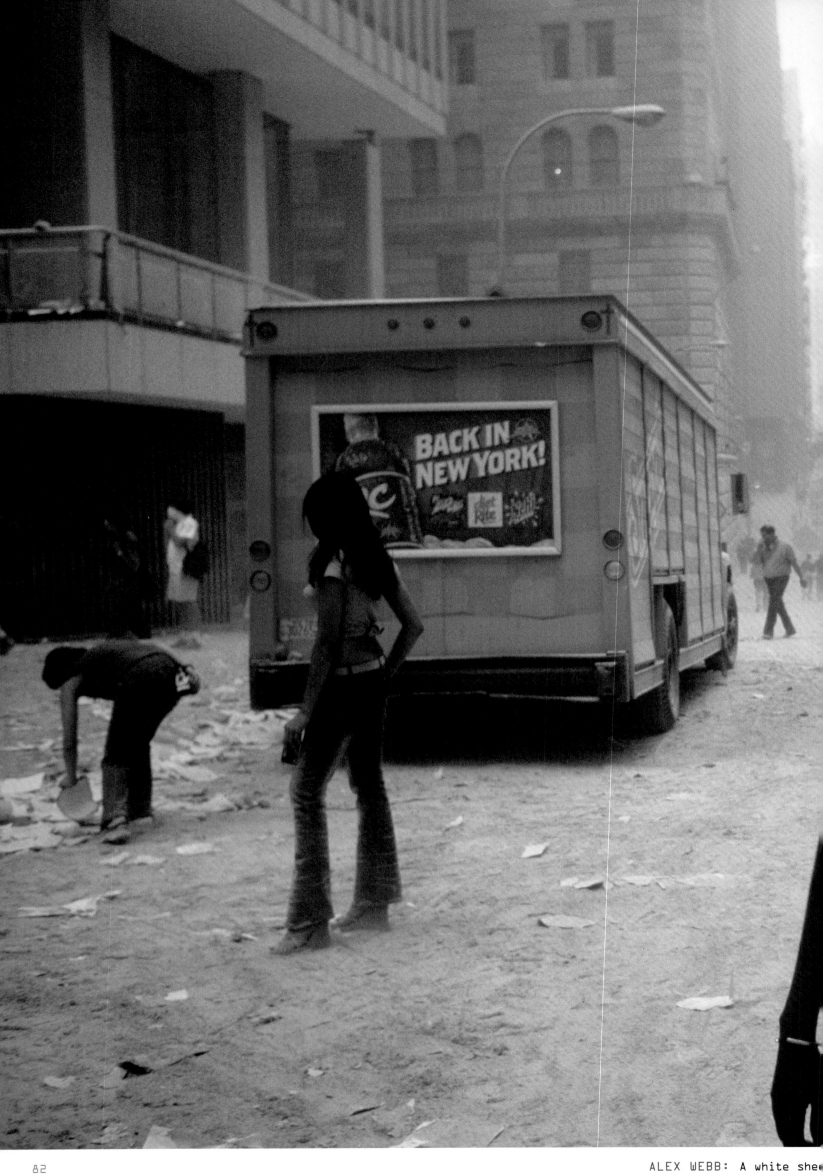

ALEX WEBB: A white she

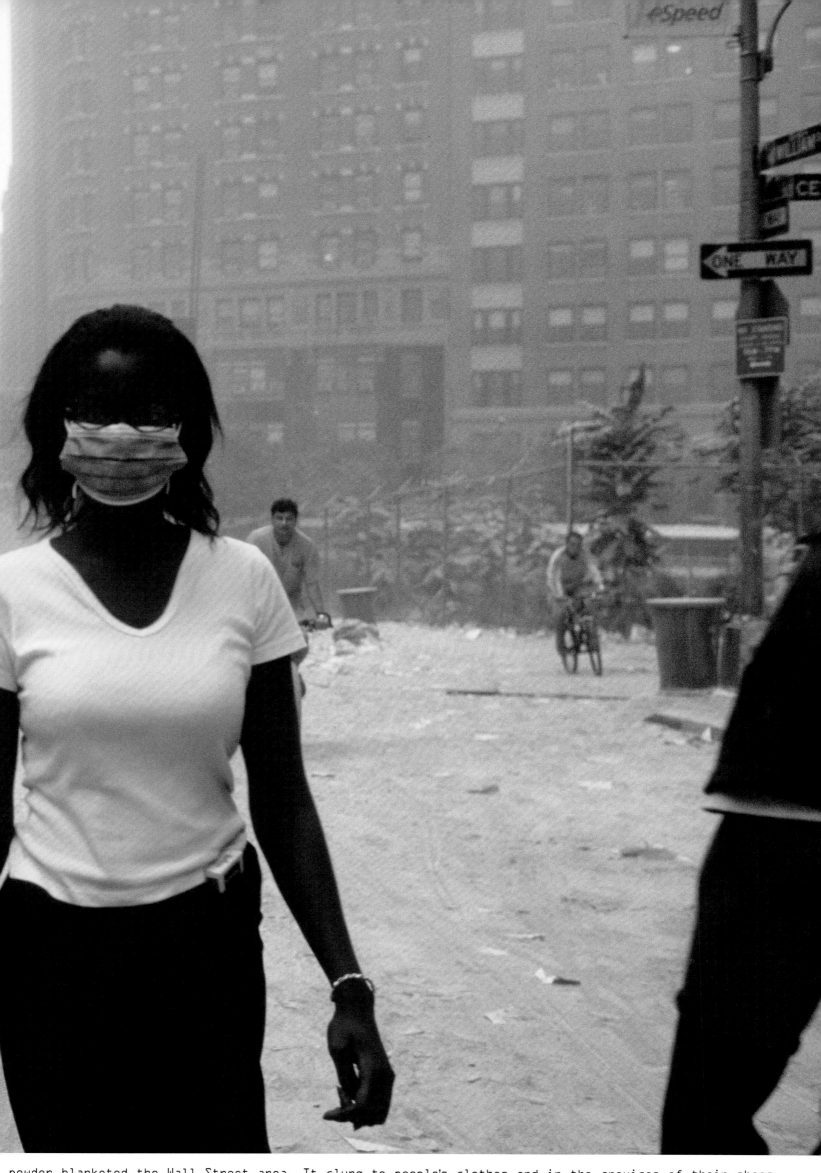

powder blanketed the Wall Street area. It clung to people's clothes and in the crevices of their shoes.

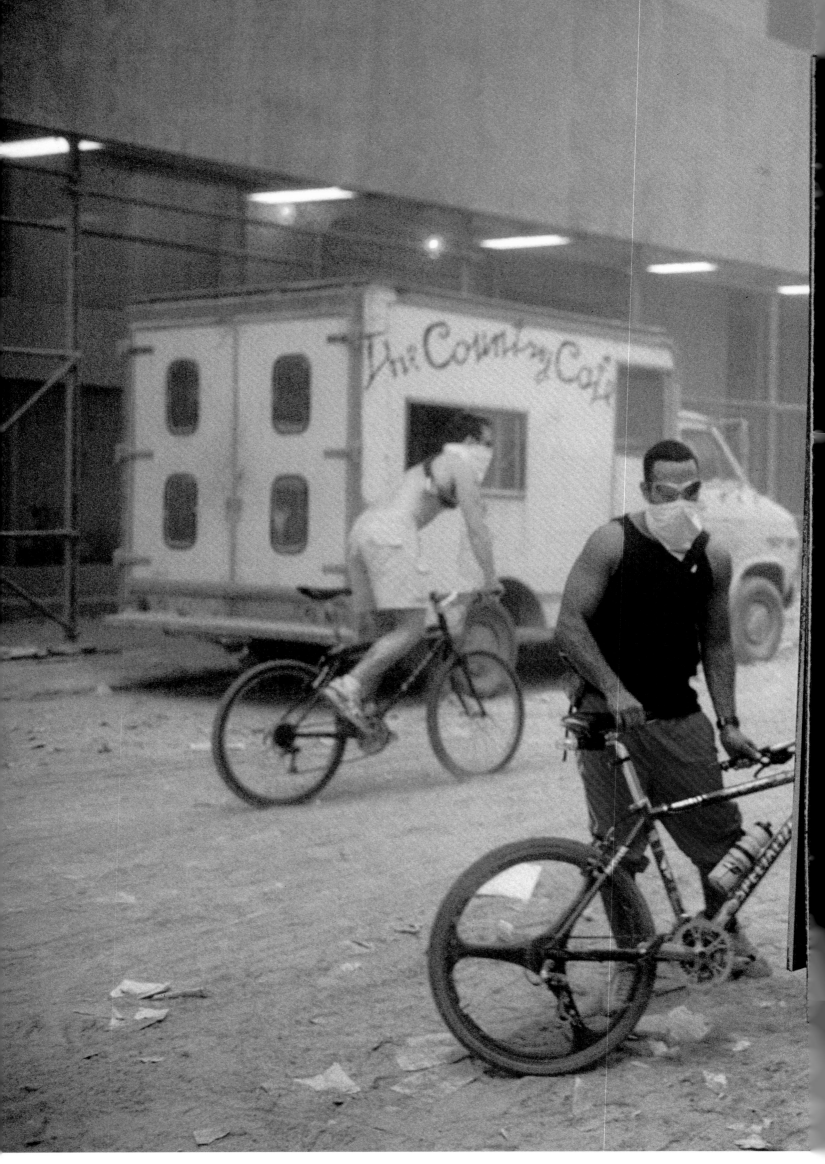

ALEX WEBB: The wind blew clouds of fine, white powder through the streets.

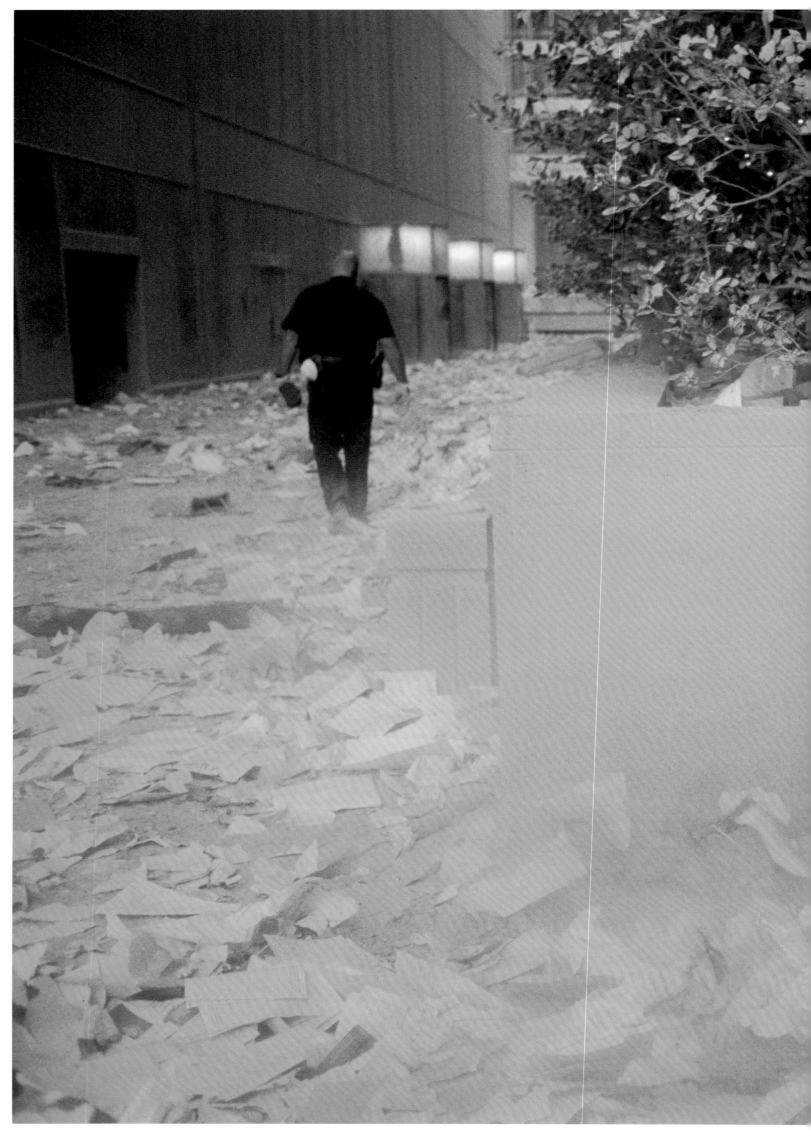

ALEX WEBB: Police searching for clues across from the

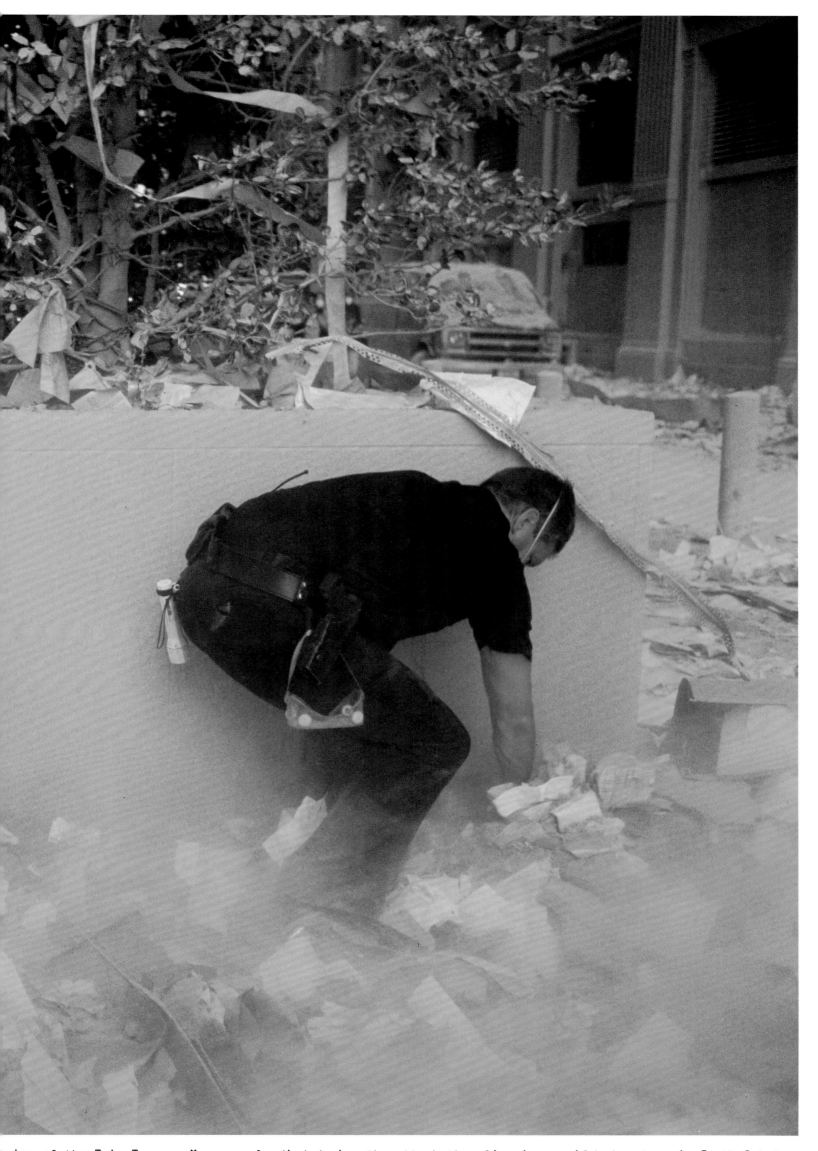

uins of the Twin Towers. More people died during the attack than live in my wife's hometown in South Dakota.

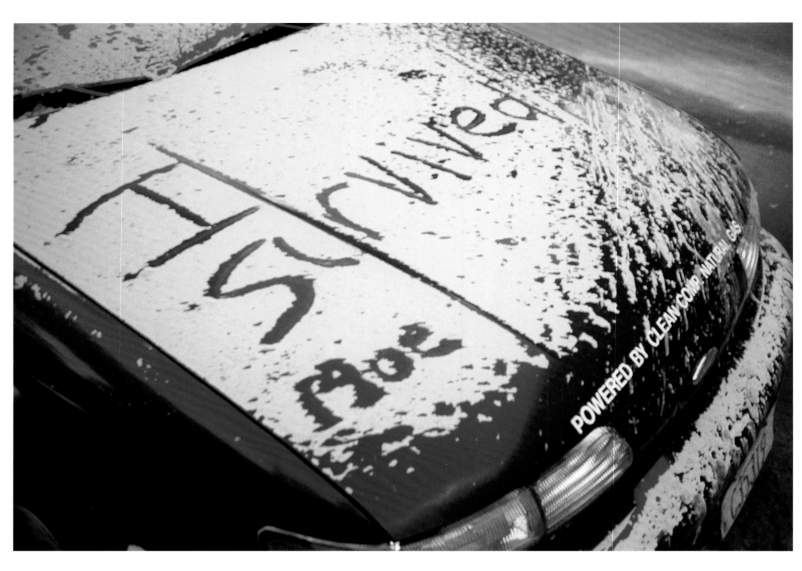

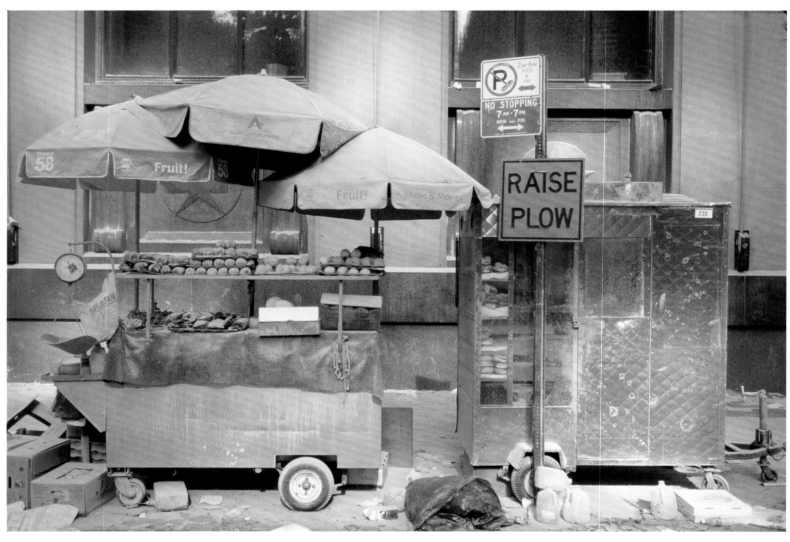

ALEX WEBB: At times downtown appeared to be dusted with snow. Other times it brought to mind nightmares of nuclear winter.

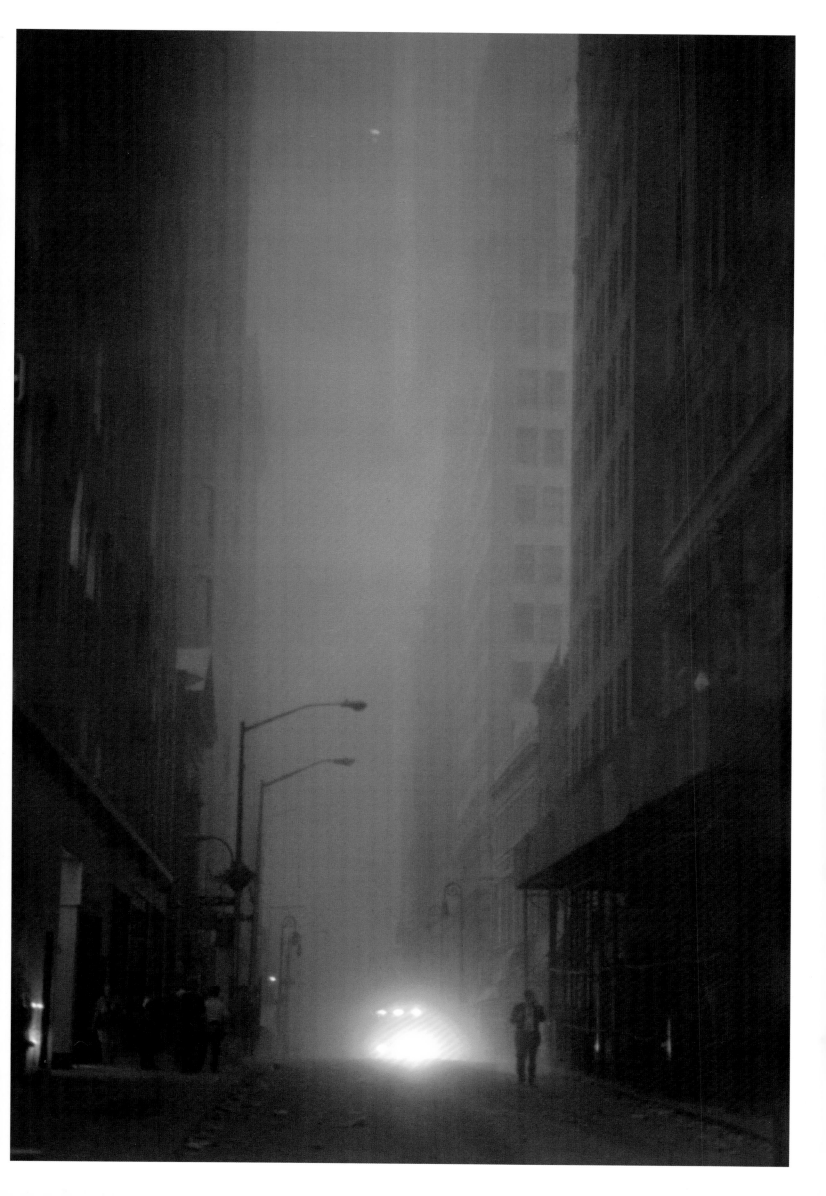

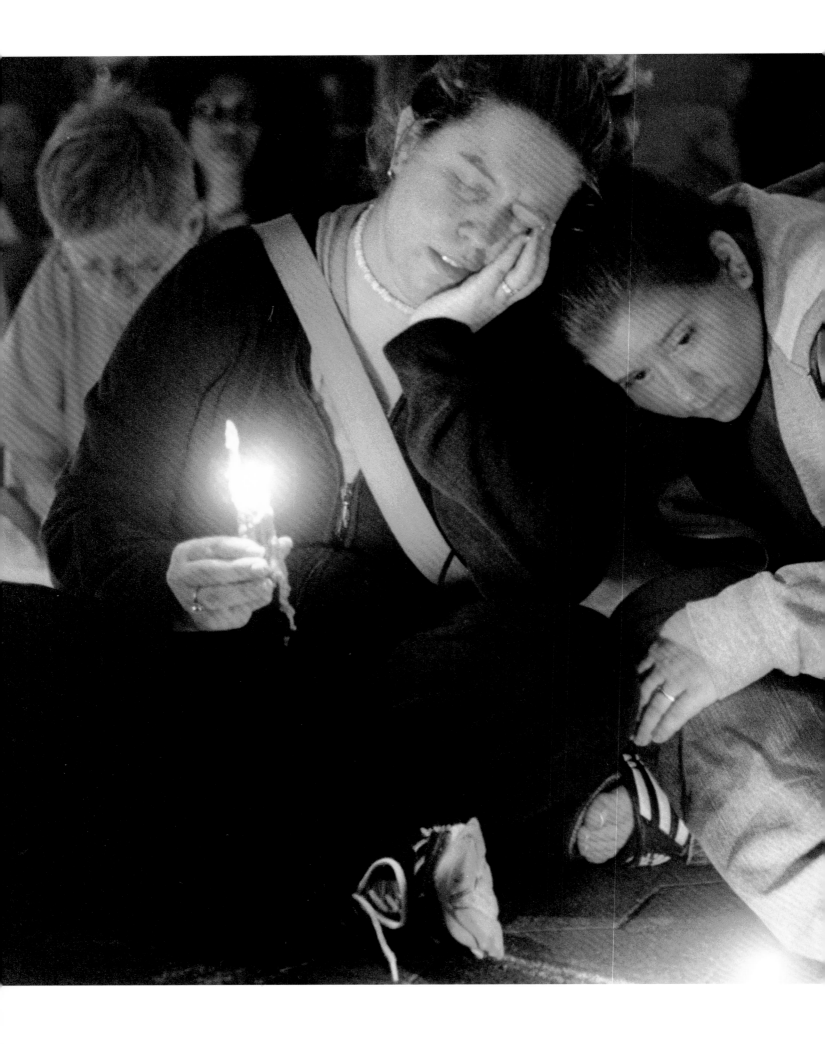

A CITY MOURNS

THOMAS HOEPKER: The grief and mourning that set in right away was deep and strong and painful. These feelings found many means of expression.

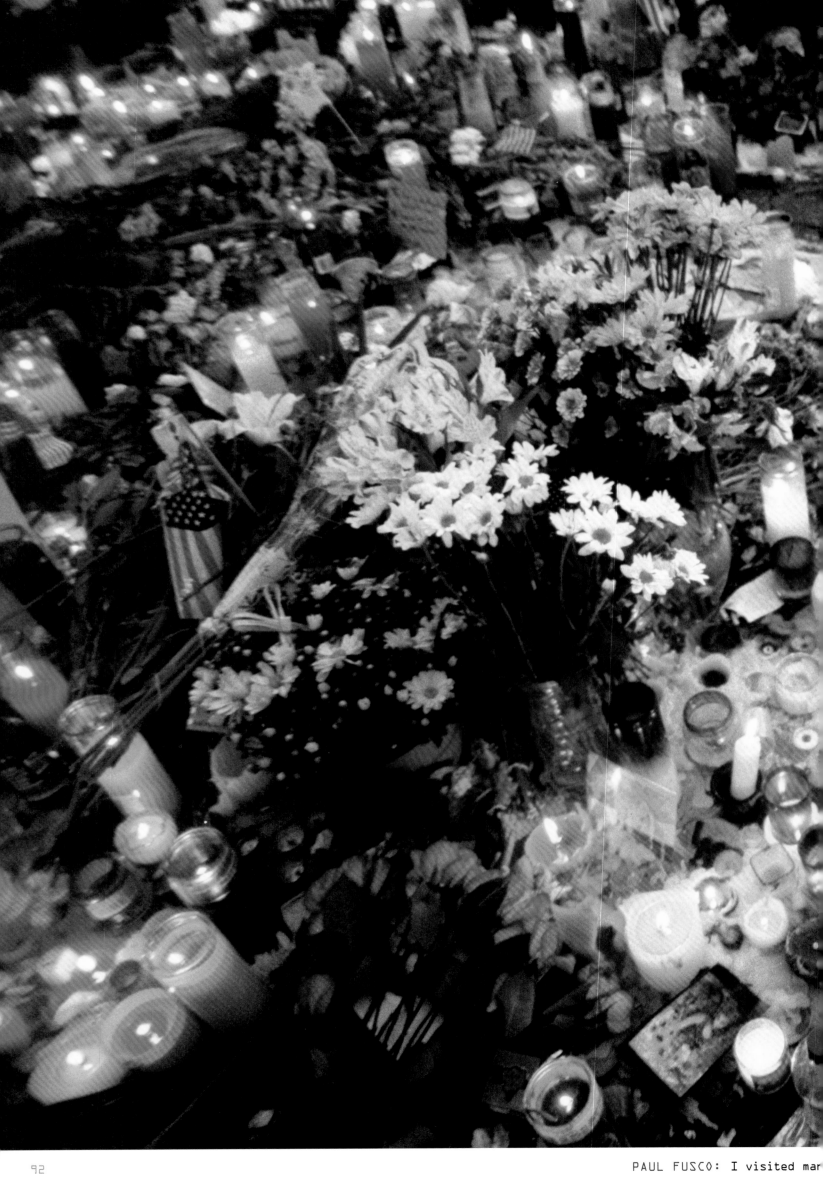

PAUL FUSCO: I visited mar

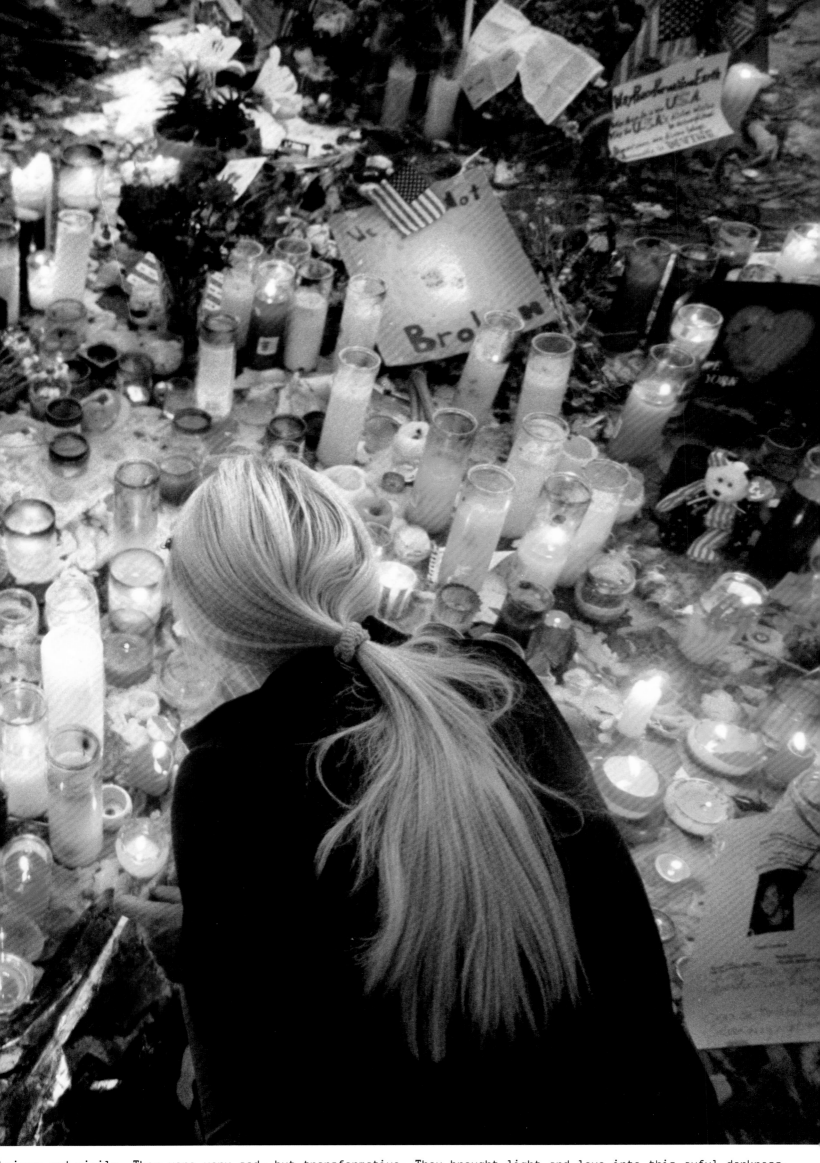

hrines and vigils. They were very sad, but transformative. They brought light and love into this awful darkness.

PAUL FUSCO

My photography is all about real people, doing real things, living real lives. I'm nosy.
I've always been interested in examining, commenting on the daily life of human beings.
What does that mean? That means everything people do—how they live, how they die.

I don't want to impose anything on what I'm shooting. Am I objective? No. None of us is
objective. We're all very subjective. That's who we are: we respond subjectively and emotionally
to the world. And that's where I live, in the emotional response to what I see.

On the morning the World Trade Center was hit, I was in the VA hospital in New
Jersey for some routine tests. The TV was on, and this all happened while I was
being examined. I drove home, got my cameras, and tried to get into the city. But
I couldn't get in. So I had two very frustrating days of prowling around, trying to
work. They had everything blocked off. All streets with access to the river were
blocked. It drove me crazy.

After I got into Manhattan on Thursday, I went to the Armory on
26th and Lexington, which had become a center for missing persons
information. Access was very restricted. Hundreds and hundreds
of people were trying to find out about people they cared about who
were missing, but you couldn't get to any of them. If you tried,
you were pounced on by cops.

I tried to get to Ground Zero without any success. I couldn't get through to
the police. I had two phone numbers that were supposed to connect me to police
information for the press, but they connected me to answering machines, and the
outgoing message was giving information on how to get tickets to the Jets game.

Mostly, I photographed people's reactions to what happened. I think people were in a
state of shock. They were very preoccupied. You could almost hear them thinking,
"What does this mean? What do I do now?"

I feel I was very fortunate to be able to work during this. I photograph because I think
we know and understand one another and the world best through stories, and photographs
tell stories. That's why we do everything, isn't it? It's why we make music and films;
it's why we dance; it's why we write novels and poetry.

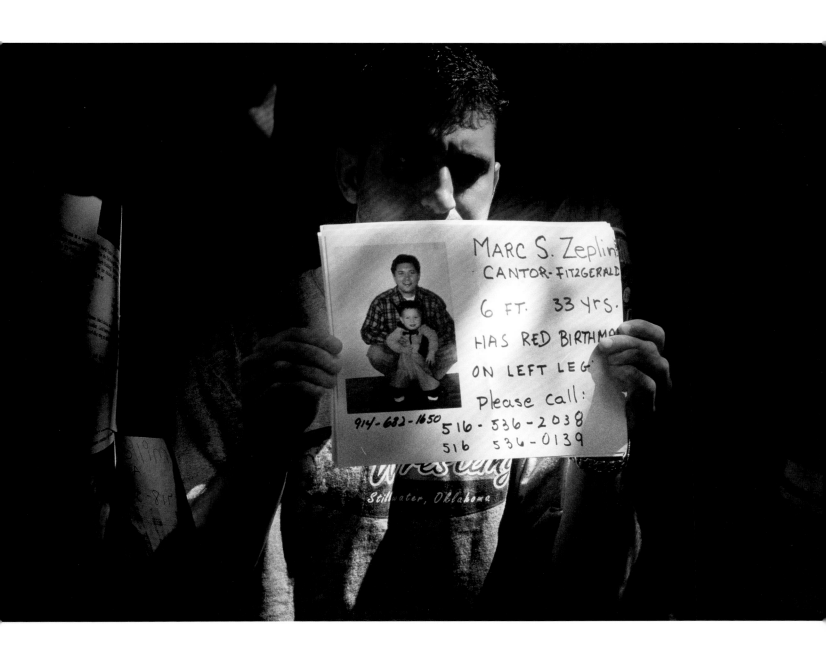

I believe that the first thing human beings said to one another when we came out of
the water, or wherever we came from, was, "You know what I just saw? Let me tell you a story
about it."

What do these pictures tell the story of? I don't know. I don't think anyone knows yet
what this story really is about. I do know that in its darkness and cruelty, it is the most
horrible story I've ever covered.

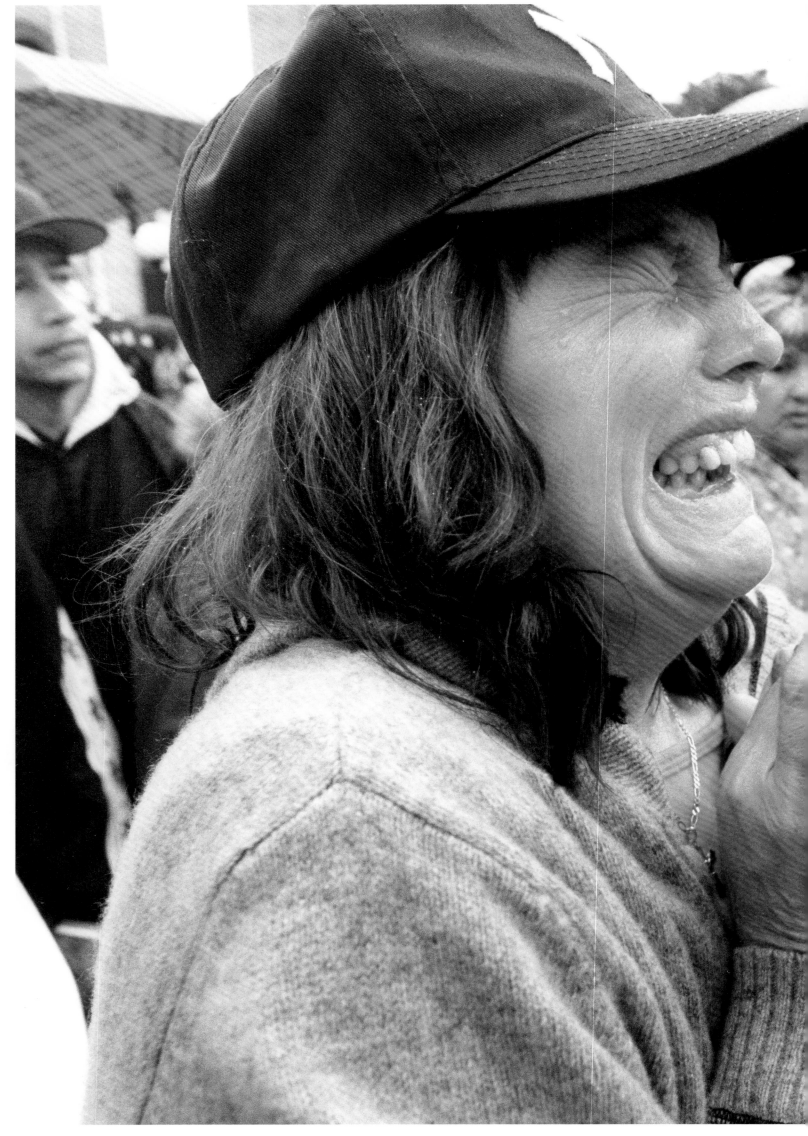

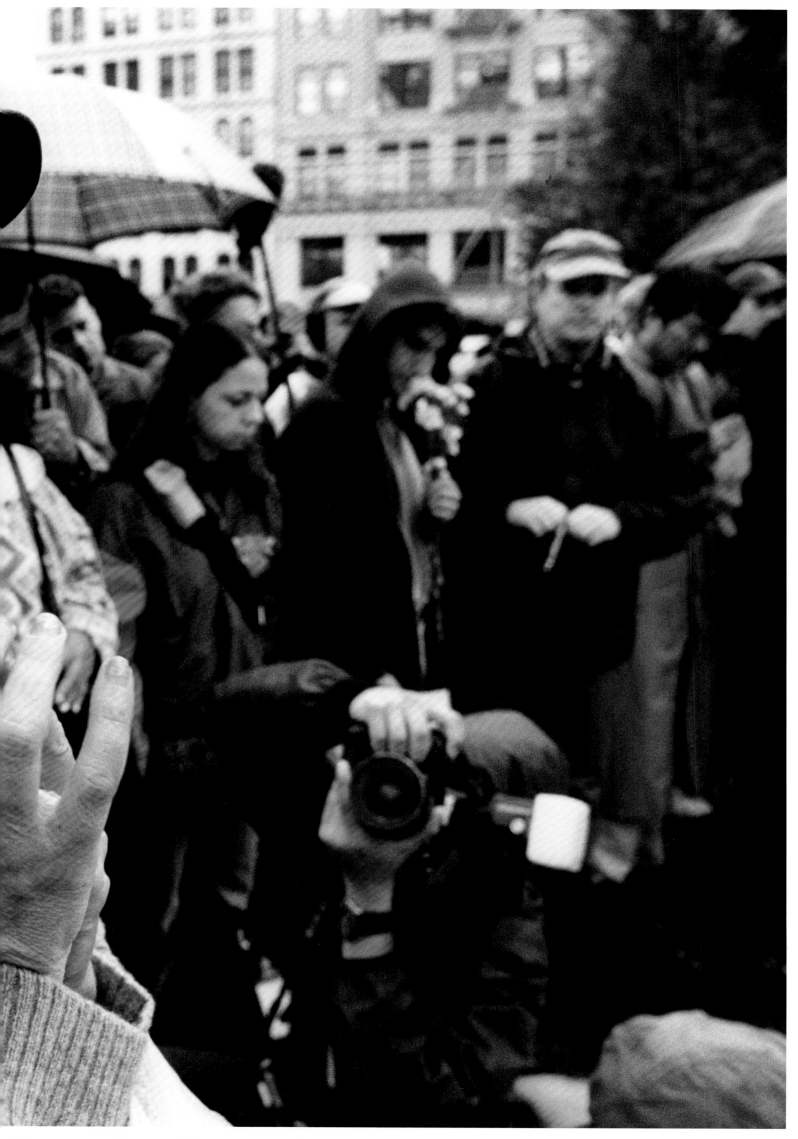

motions were really raw. All across the city, thousands of strangers gathered together to share their grief.

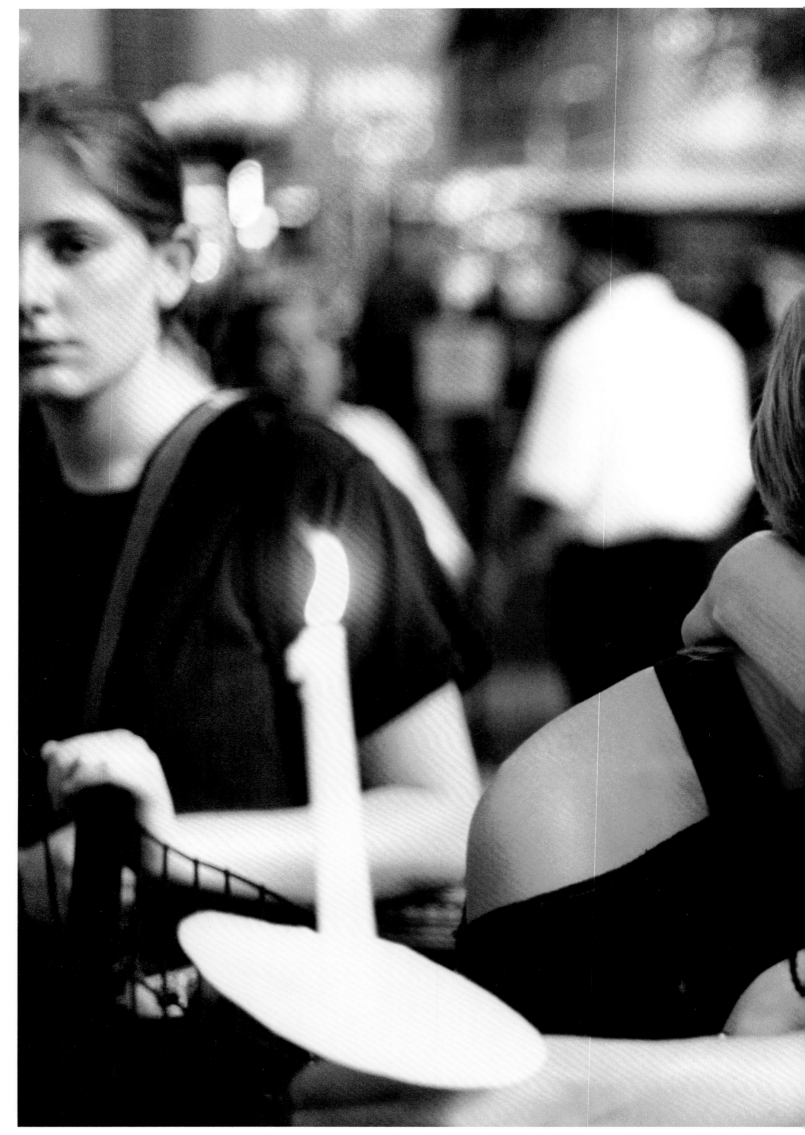

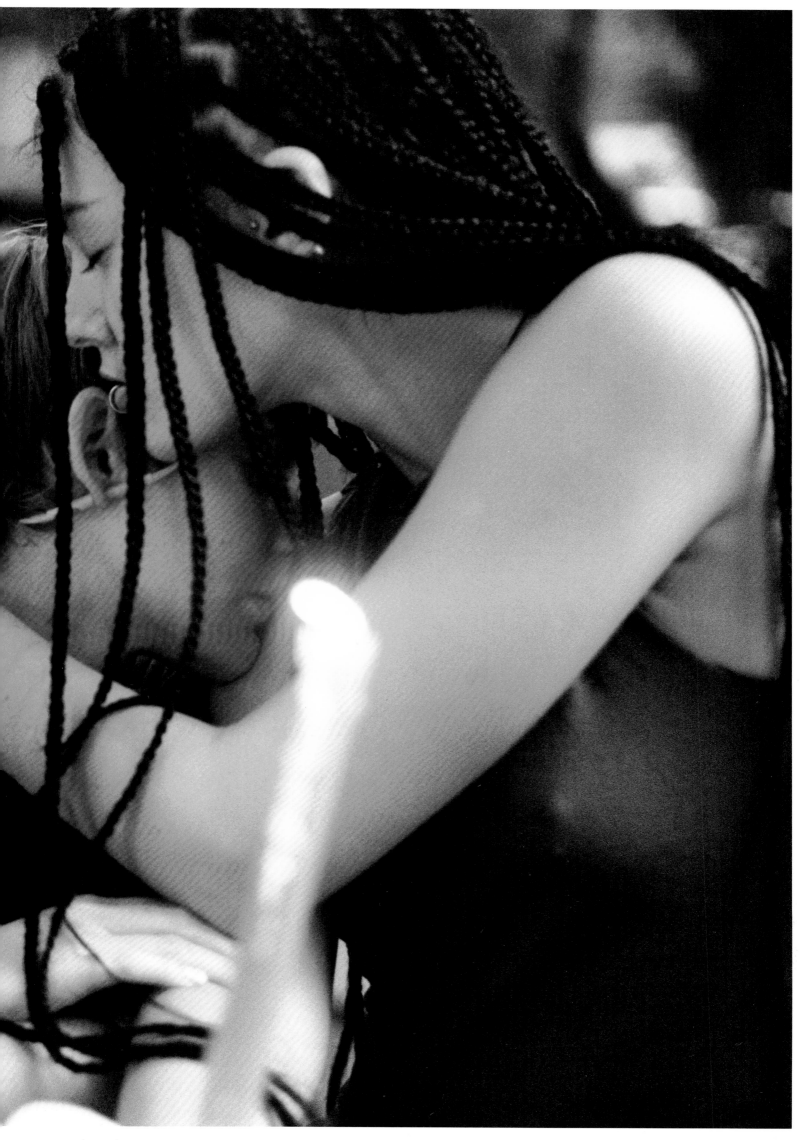

saw so much sadness, and people desperately trying to reach out to each other to give solace and comfort.

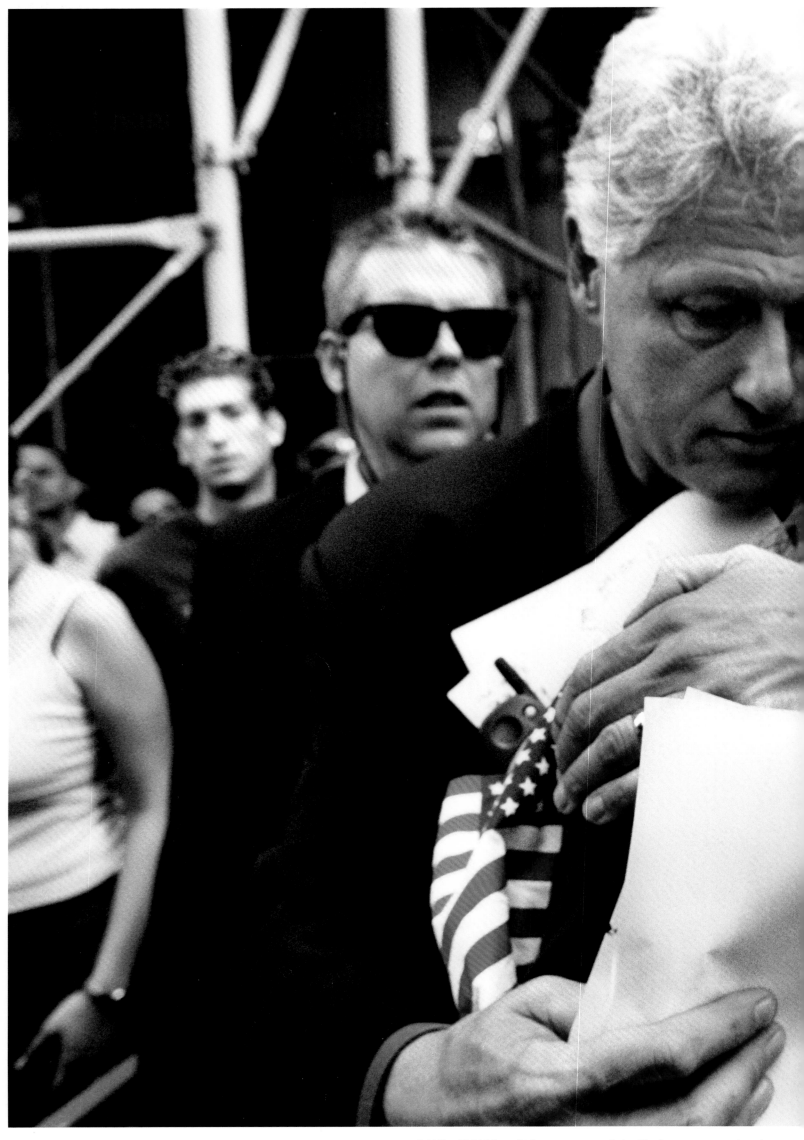

PAUL FUSCO: Clinton was with Chelsea near the Armory

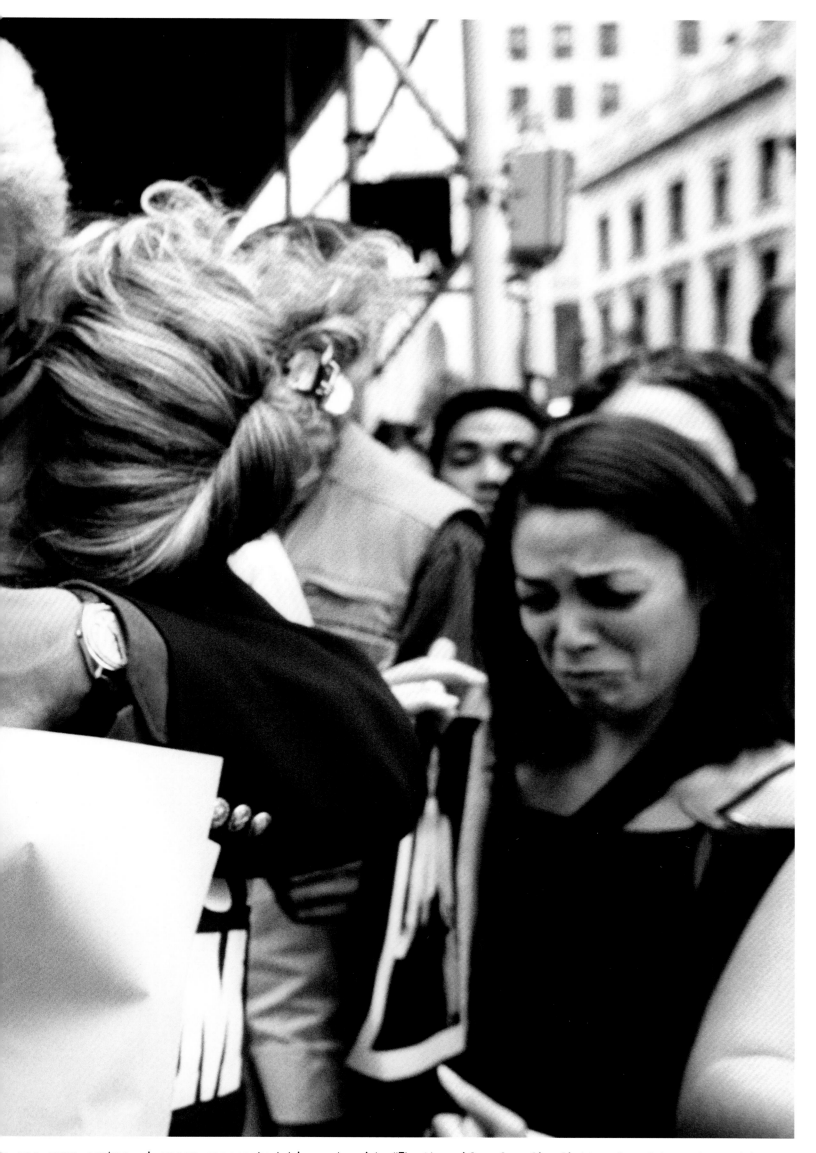

...e was very somber. A woman approached him and said, "I'm the wife of a firefighter," and he embraced her.

ELI REED

I was a Nieman fellow at Harvard, '82-'83. Most of what I studied was conflict—brushfire wars, new kinds of warfare, acts of terrorism. I've been paying special attention to things like that since then. I've worked in Central America—in Salvador, Honduras, Guatemala, Costa Rica, Nicaragua. I was in Beirut when the U.S. Marine barracks were blown up. I got there within fifteen minutes and got pictures. I've seen a lot of people in terrible situations.

Why am I drawn to conflict? Part of it is curiosity—a desire to see how stupid people can get. Part of it goes back to my childhood. My mother was a kind person. She passed away when I was twelve years old. But she had a smile that I always remembered. She had the ability to laugh at things that might drive others crazy. And I like to think that I have the potential to show that same spirit in other people.

Although I've covered wars and seen many catastrophes, I'm not really interested in catastrophes in themselves. I'm interested in seeing the goodness, the inner spirit of people, and how it survives. I think that was exhibited in a big way during this catastrophe.

I roamed the streets the day after the World Trade Center disaster. This was a great shock to the system, and when a shock like that occurs, people will respond in all kinds of ways. It doesn't surprise me that New Yorkers responded to this in such a generous way. New Yorkers, let's put it this way: one second, the way they say good morning is, "You want a punch in the mouth?" And five minutes later they're joking around together.

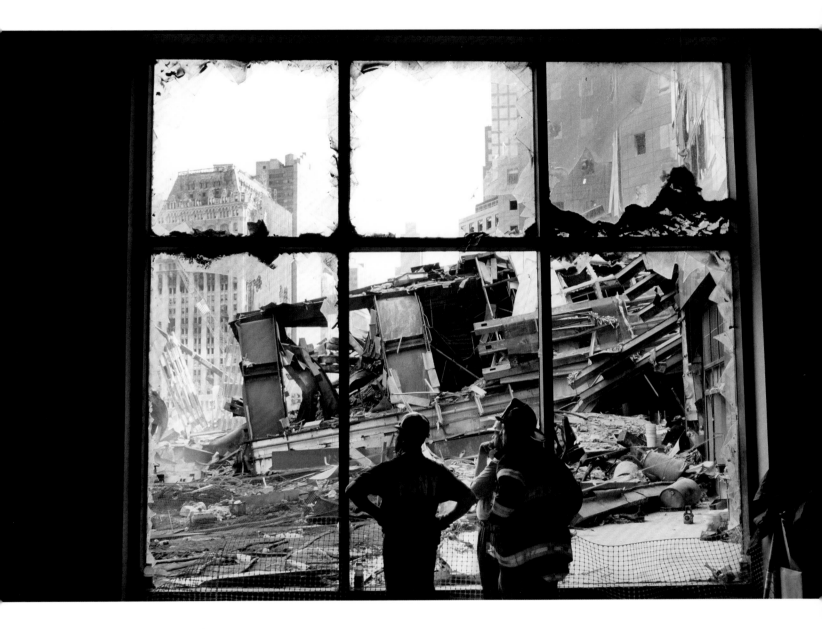

People were so kind during this. I always thought that was a part
of New York that others didn't see enough of. Deep down inside,
kindness and curiosity are a large part of what New Yorkers are.
When push comes to shove, the kindness comes out in all its glory.

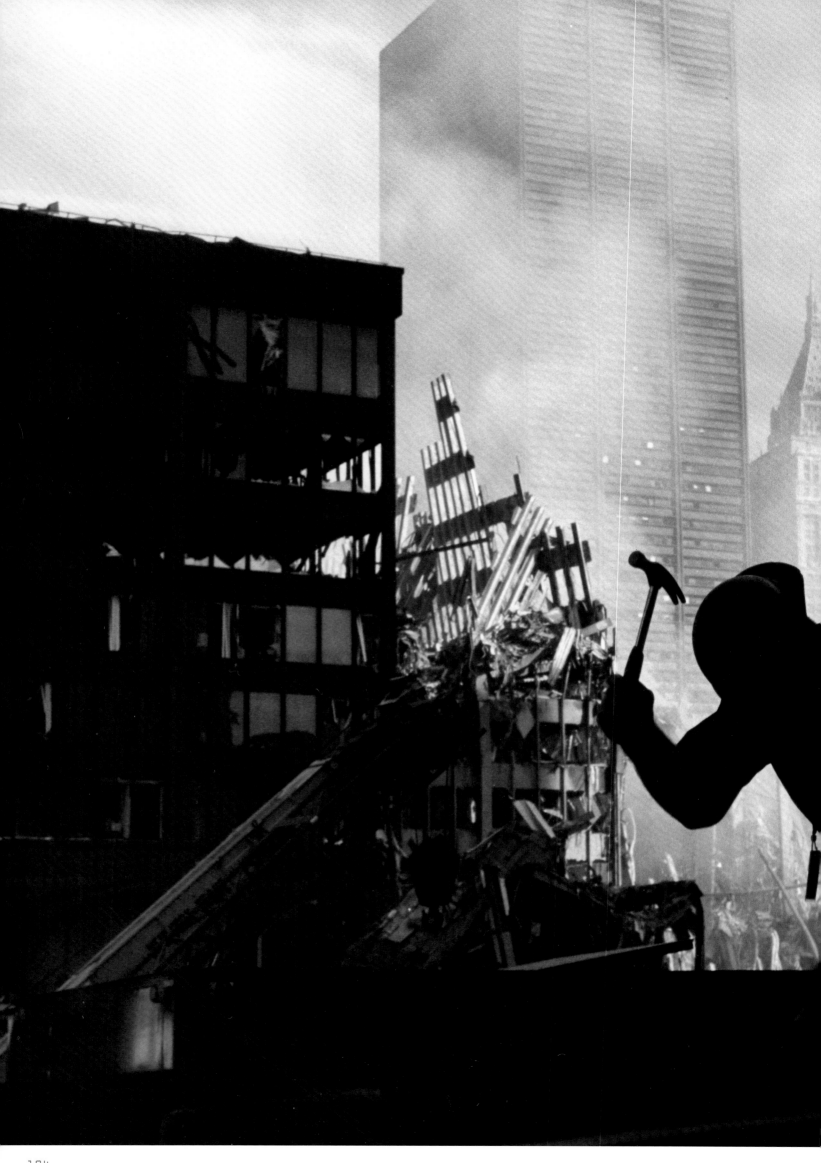

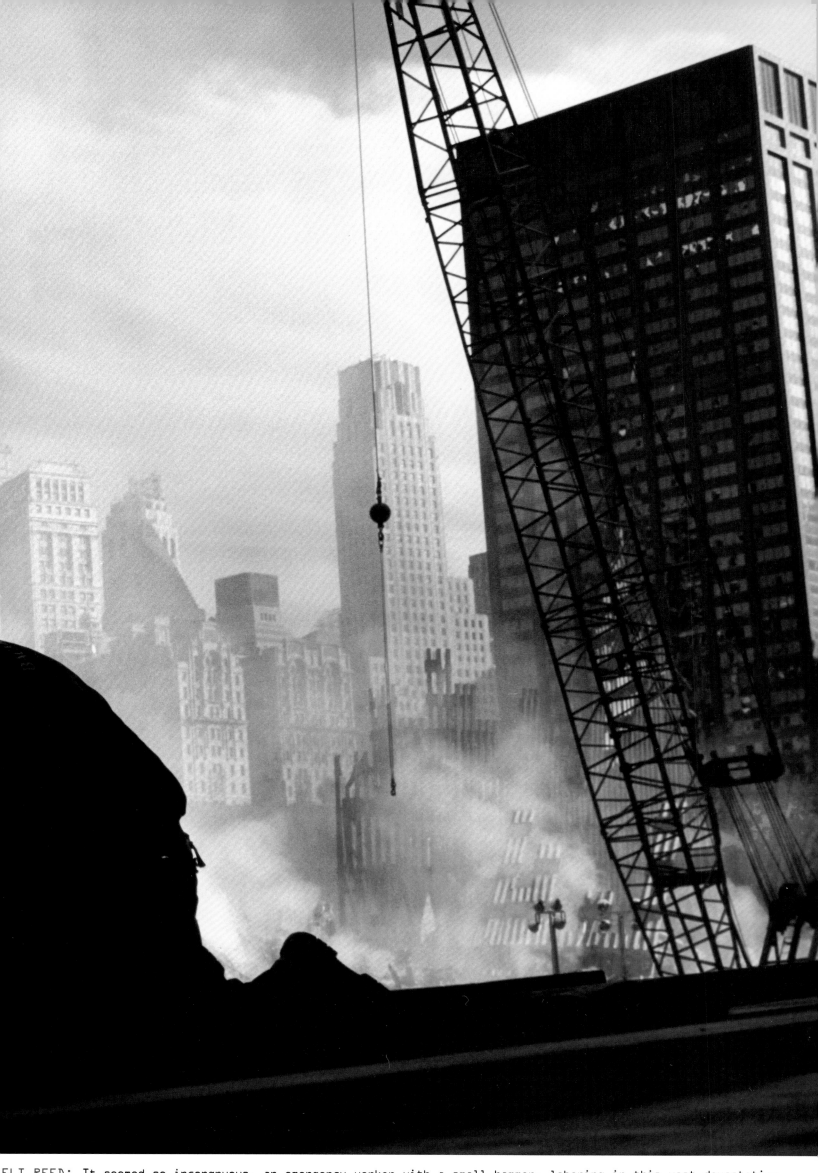

ELI REED: It seemed so incongruous, an emergency worker with a small hammer, laboring in this vast devastation.

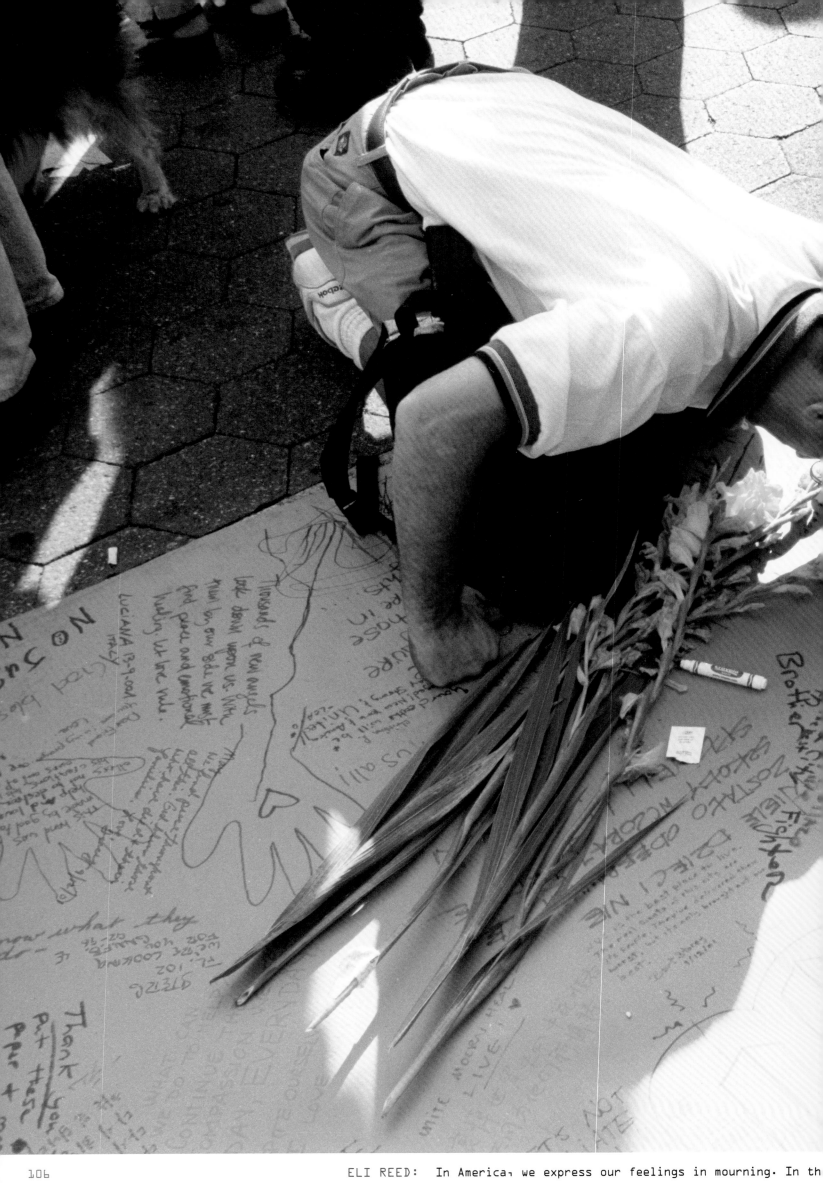

ELI REED: In America, we express our feelings in mourning. In th

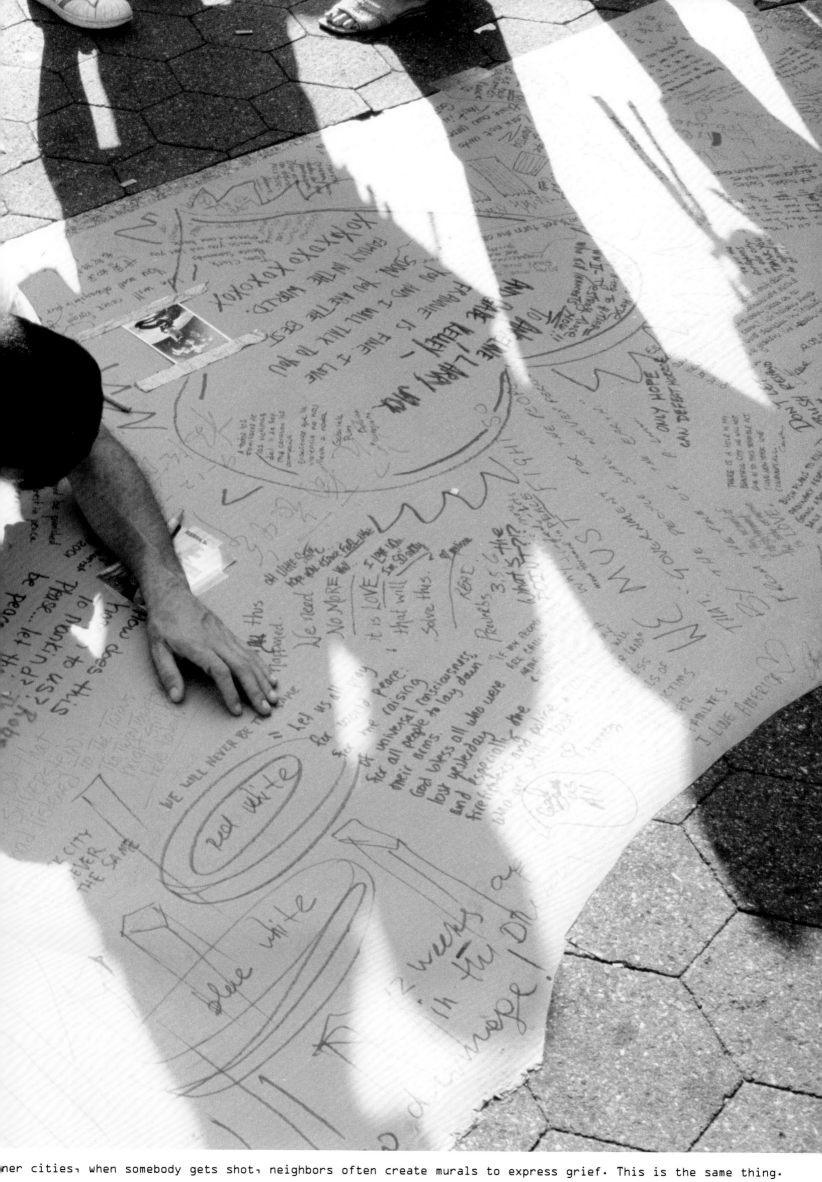

ner cities, when somebody gets shot, neighbors often create murals to express grief. This is the same thing.

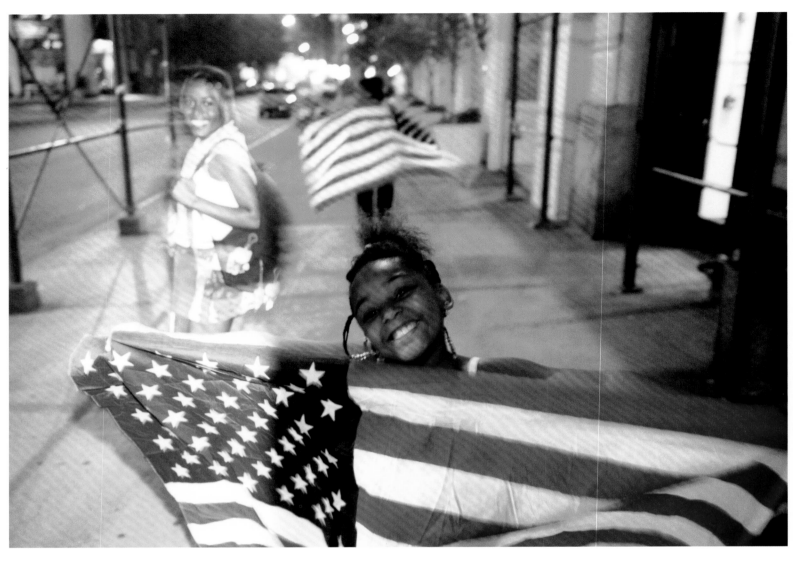

ELI REED: Almost immediately, you began to see flags everywhere.

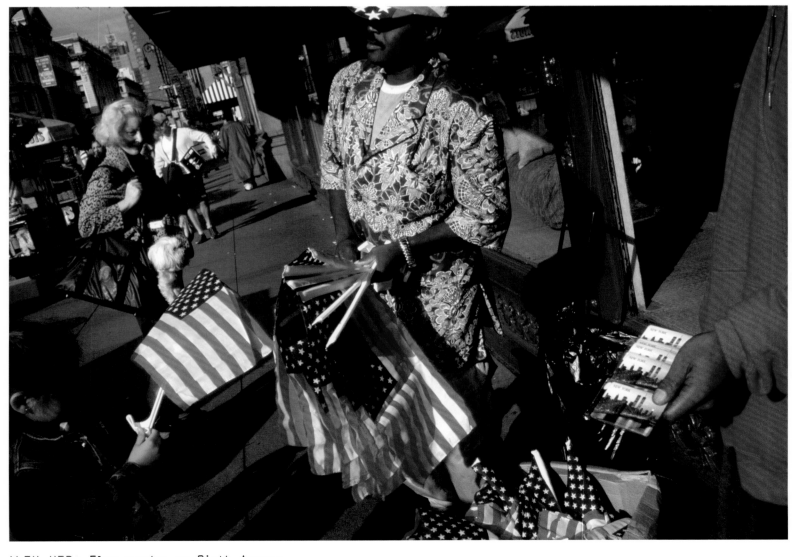

ALEX WEB: Flag vendor on Sixth Avenue.

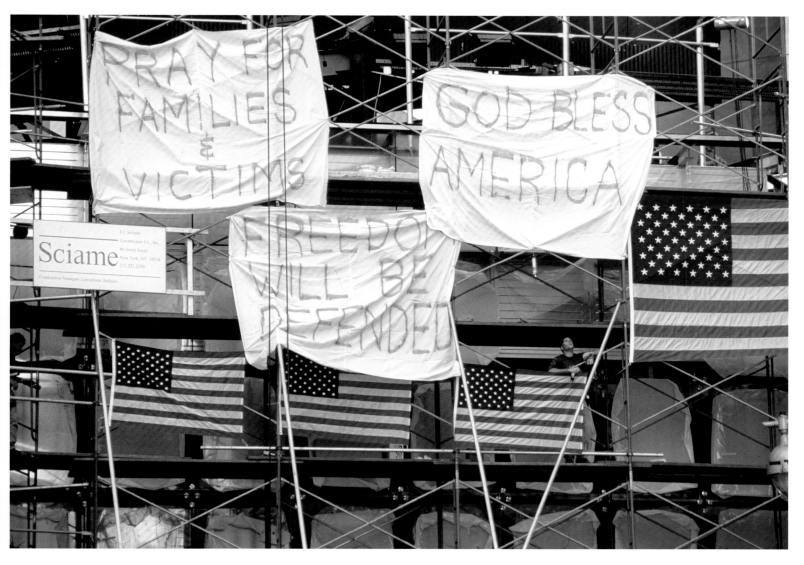

THOMAS HOEPKER: In some places, the flag seemed to symbolize America the strong.

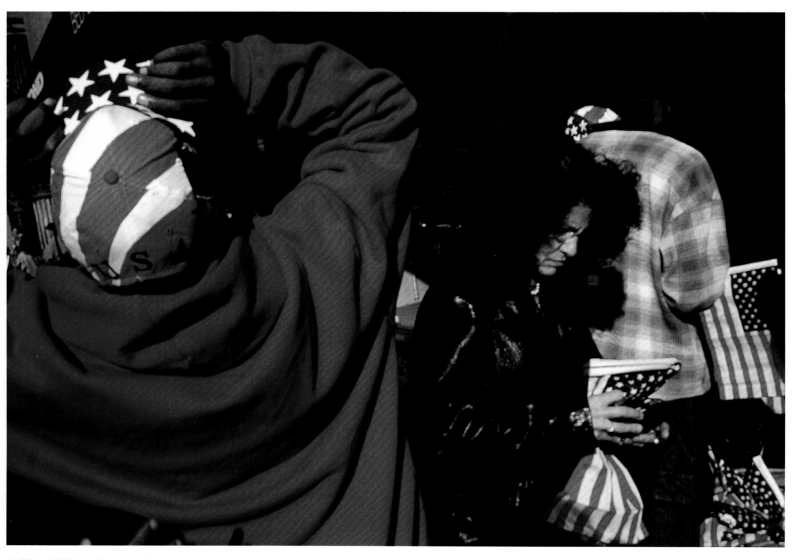

ALEX WEBB: Red, white, and blue had become the national colors of mourning.

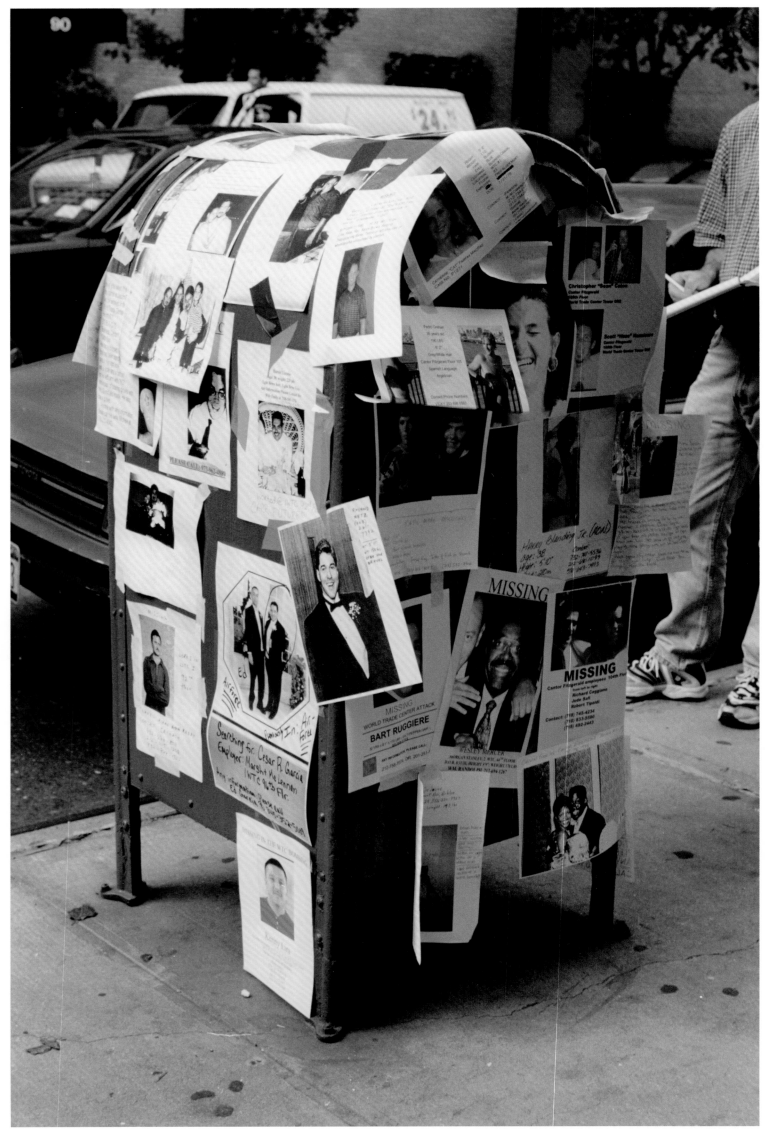

GILLES PERESS

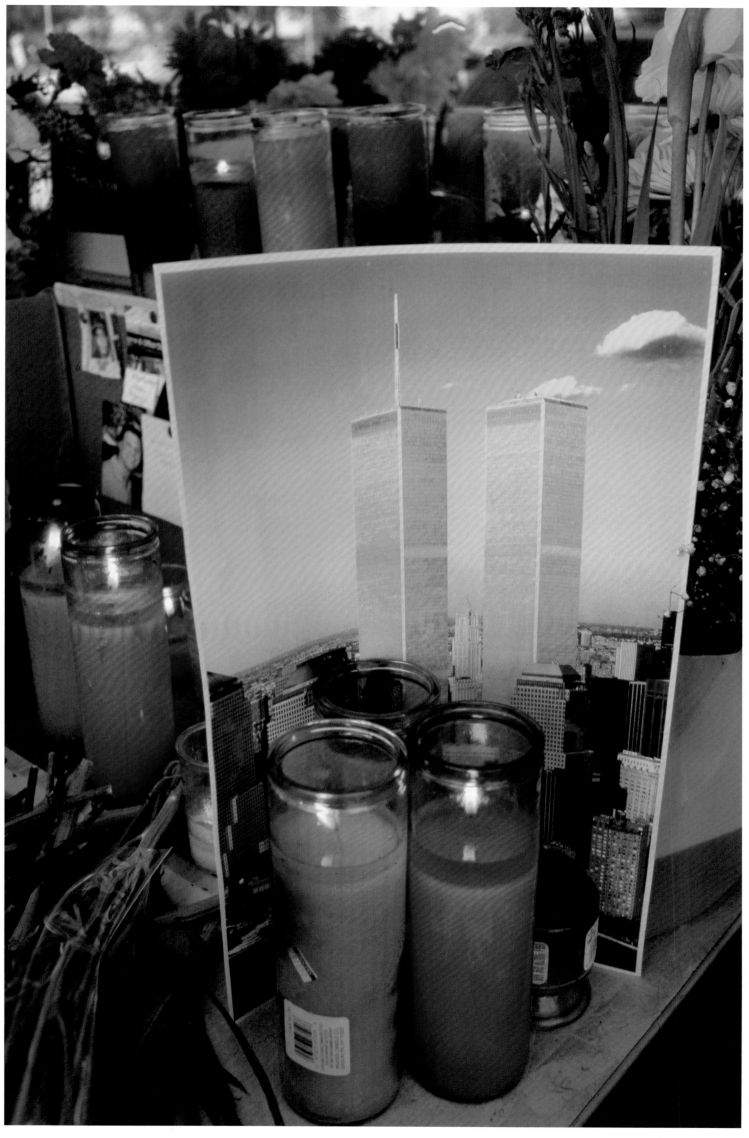

ALEX WEBB: Rather than simply respond in anger, New Yorkers grieved and mourned the dead.

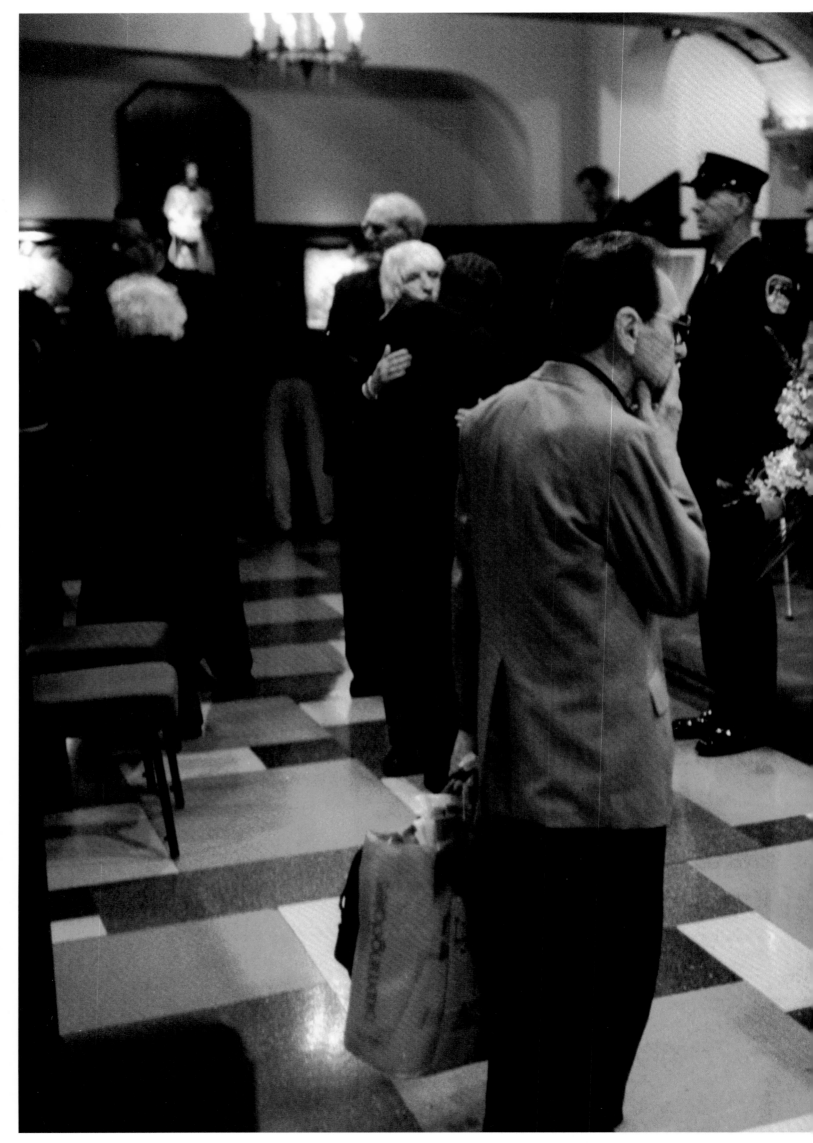

DAVID ALAN HARVEY: At the chapel across from the firehouse on 34th

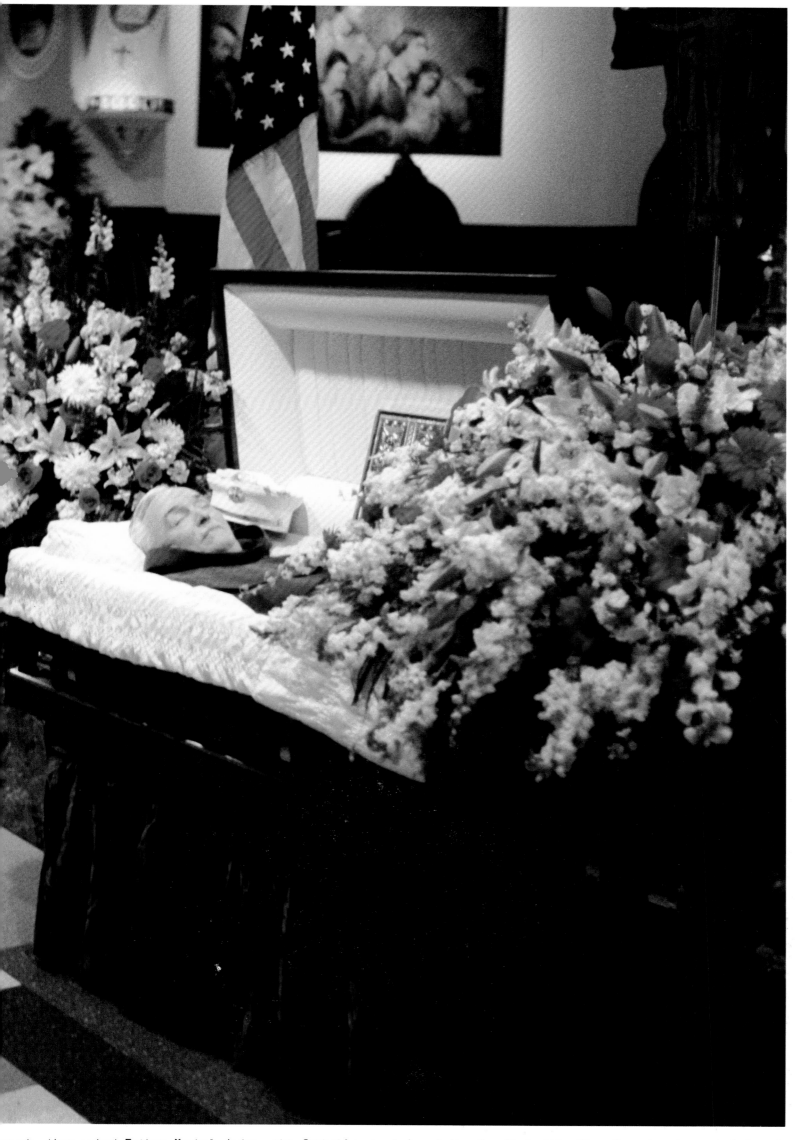

…reet, they waked Father Mychal Judge, the Catholic chaplain of the New York City Fire Department, much beloved.

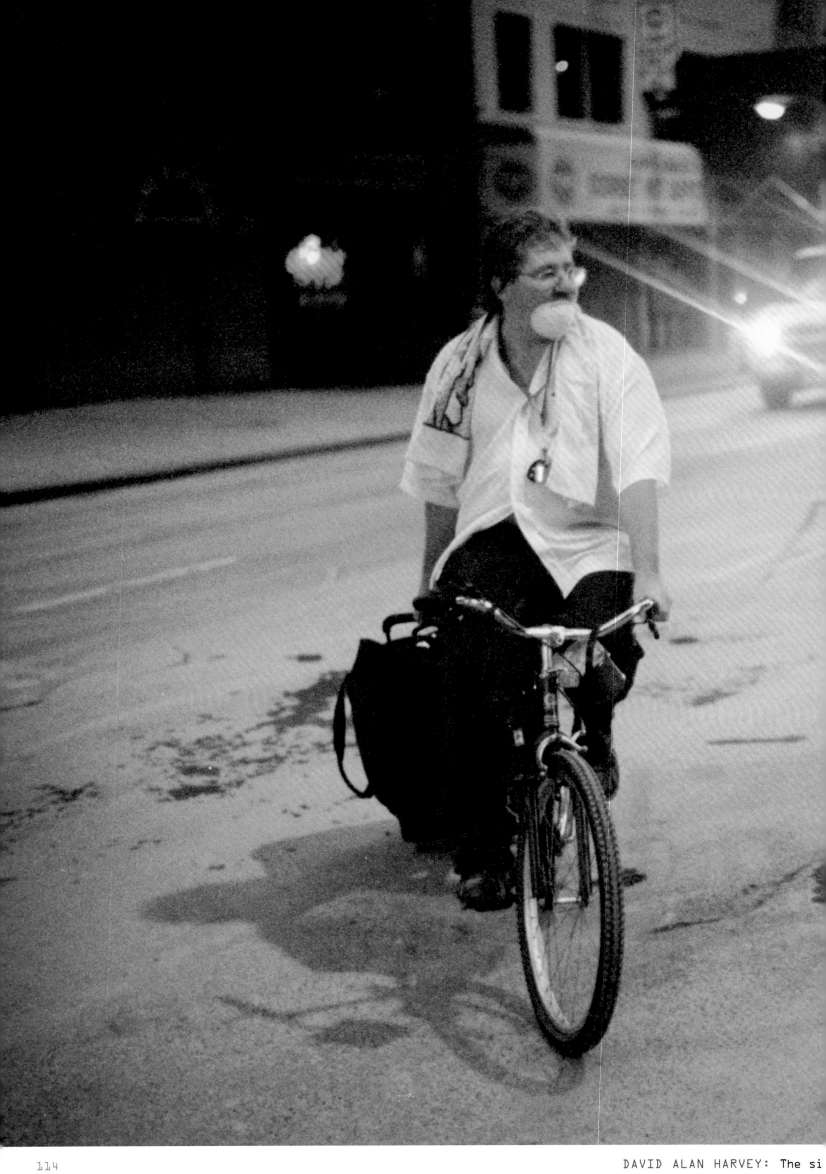

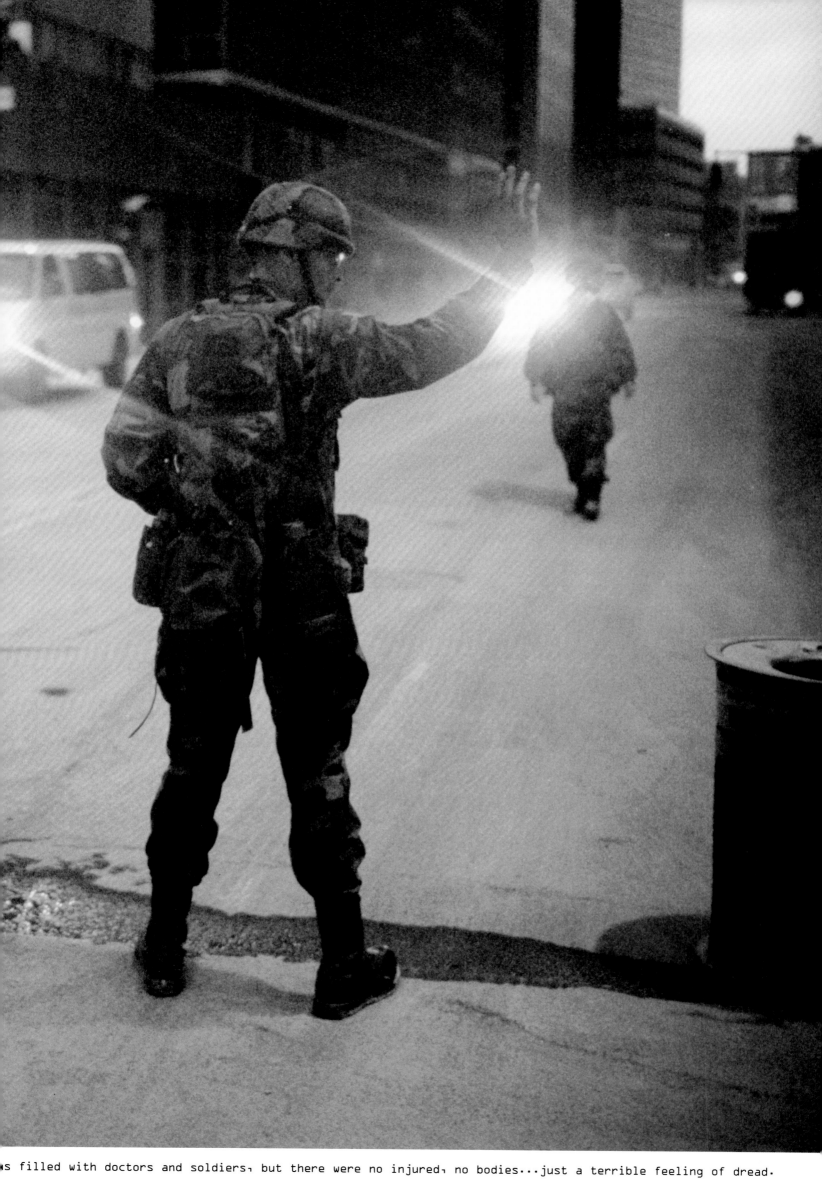

...s filled with doctors and soldiers, but there were no injured, no bodies...just a terrible feeling of dread.

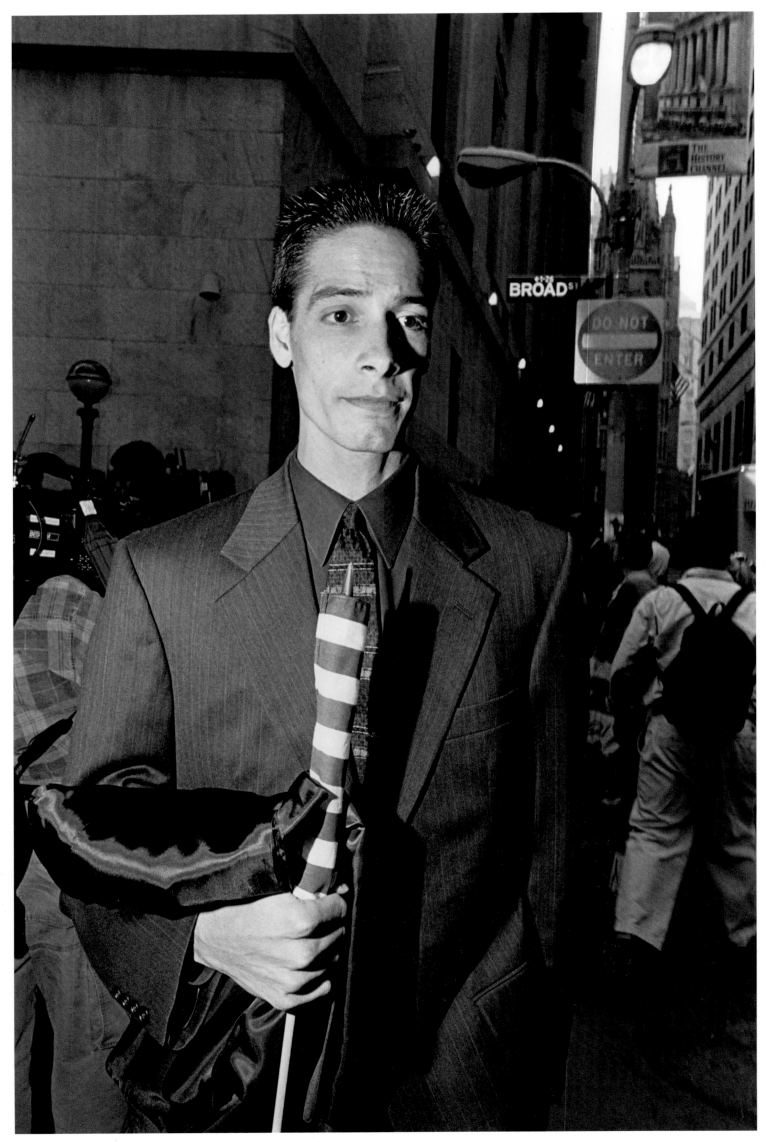

BRUCE GILDEN: On Monday, everyone went back to work on Wall Street. There were polic

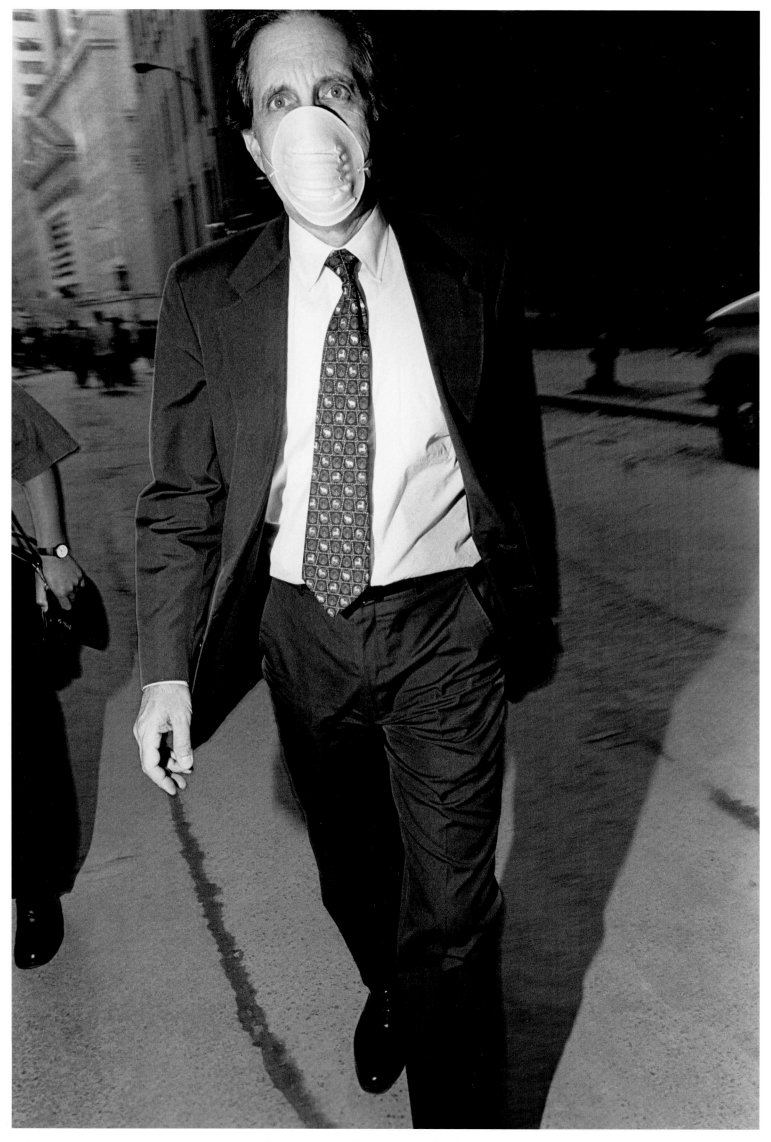

and soldiers everywhere. It seemed to make some people go deep inside themselves; others were guarded, cautious.

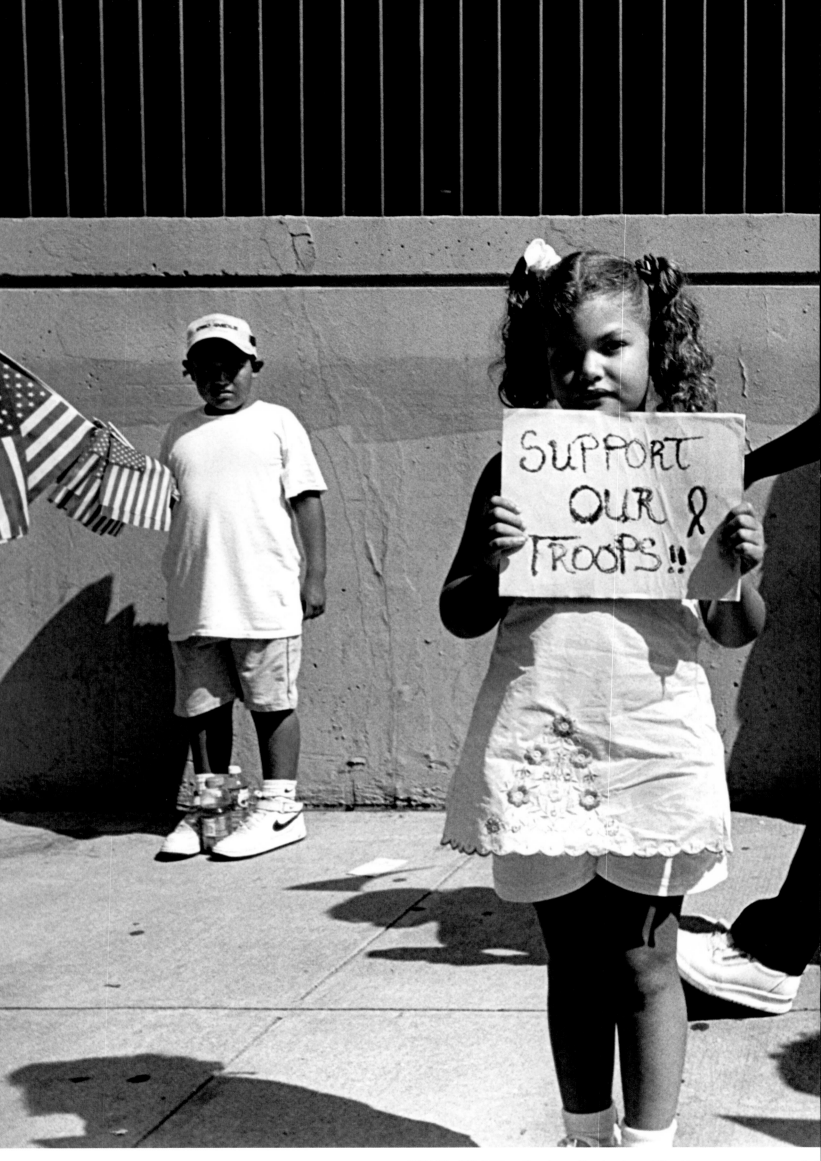

BRUCE GILDEN: Sunday, September 23, there was a memorial

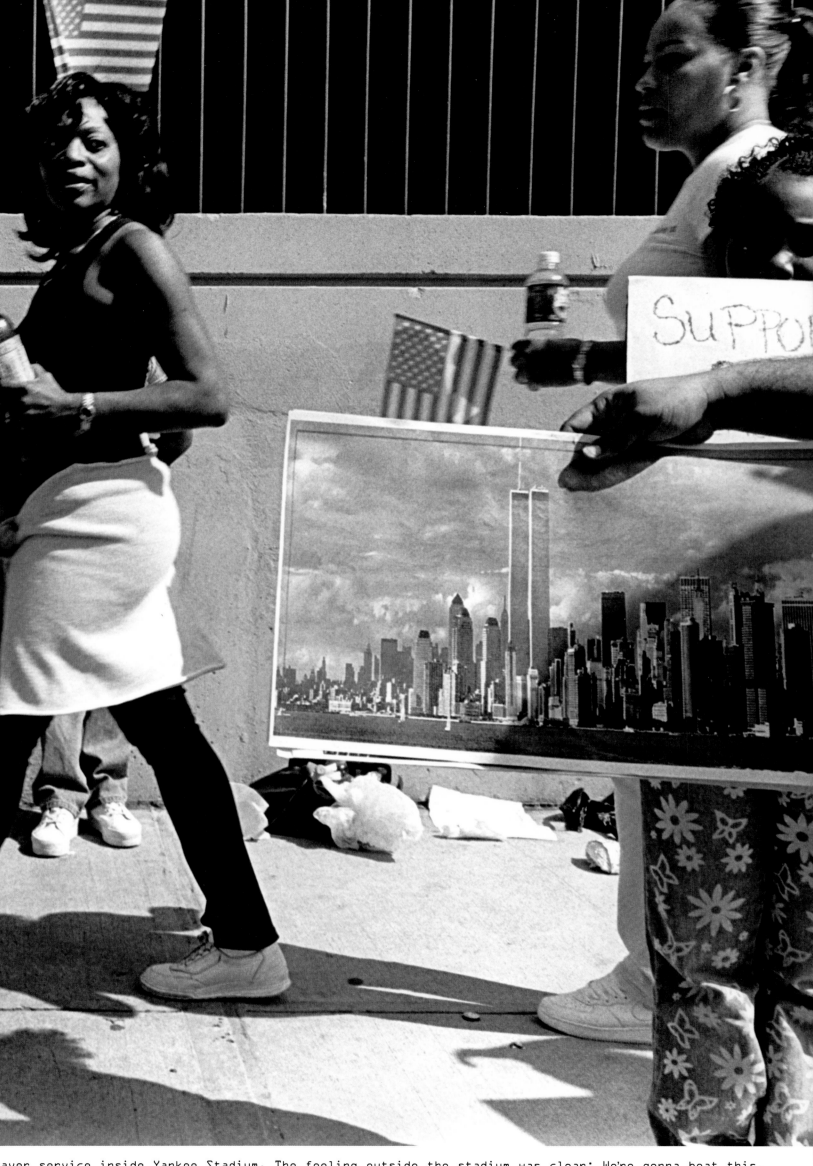

...rayer service inside Yankee Stadium. The feeling outside the stadium was clear: We're gonna beat this.

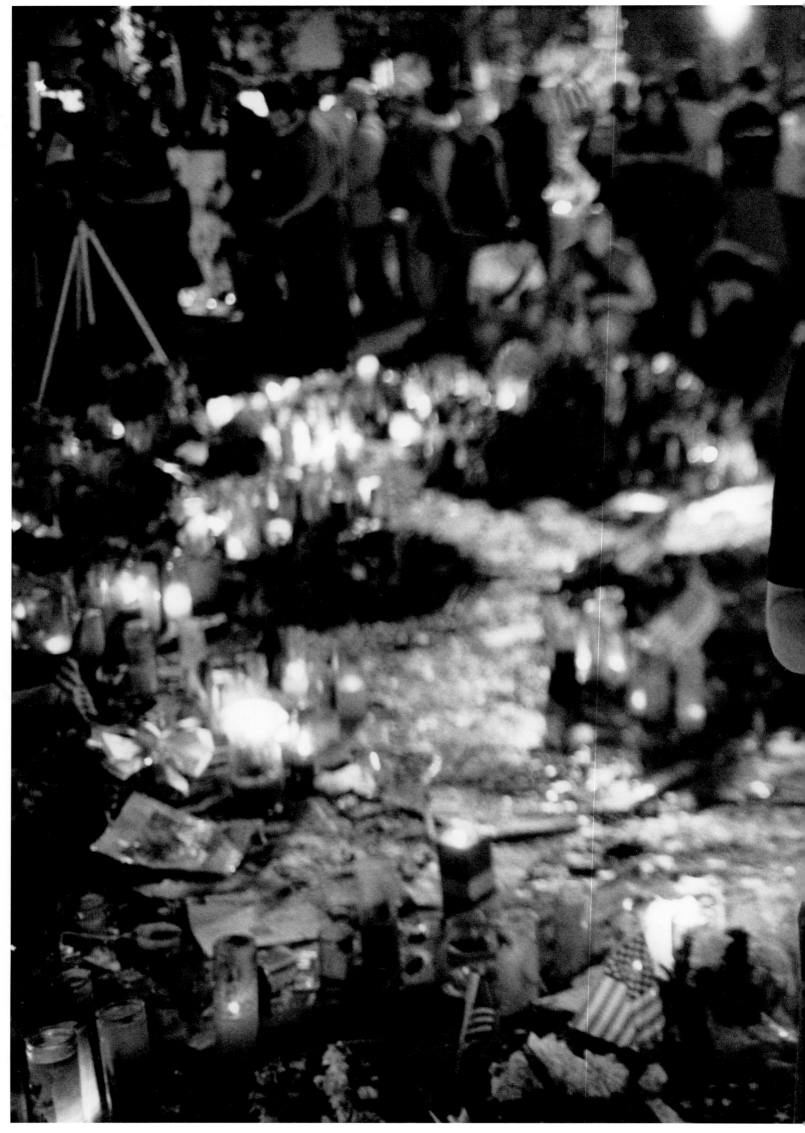

CHIEN-CHI CHANG: Around midnight, September 19, the crowd

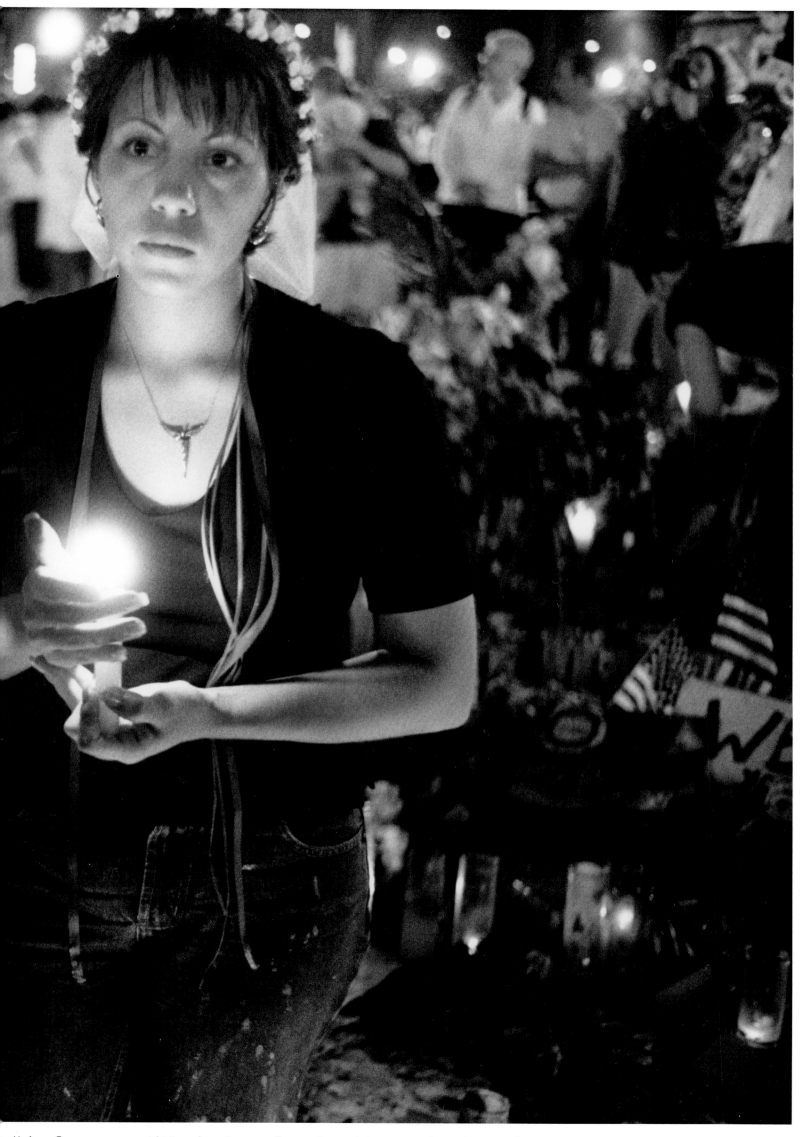

Union Square were still quite large. Some planned to stay through the night to keep the vigil lights burning.

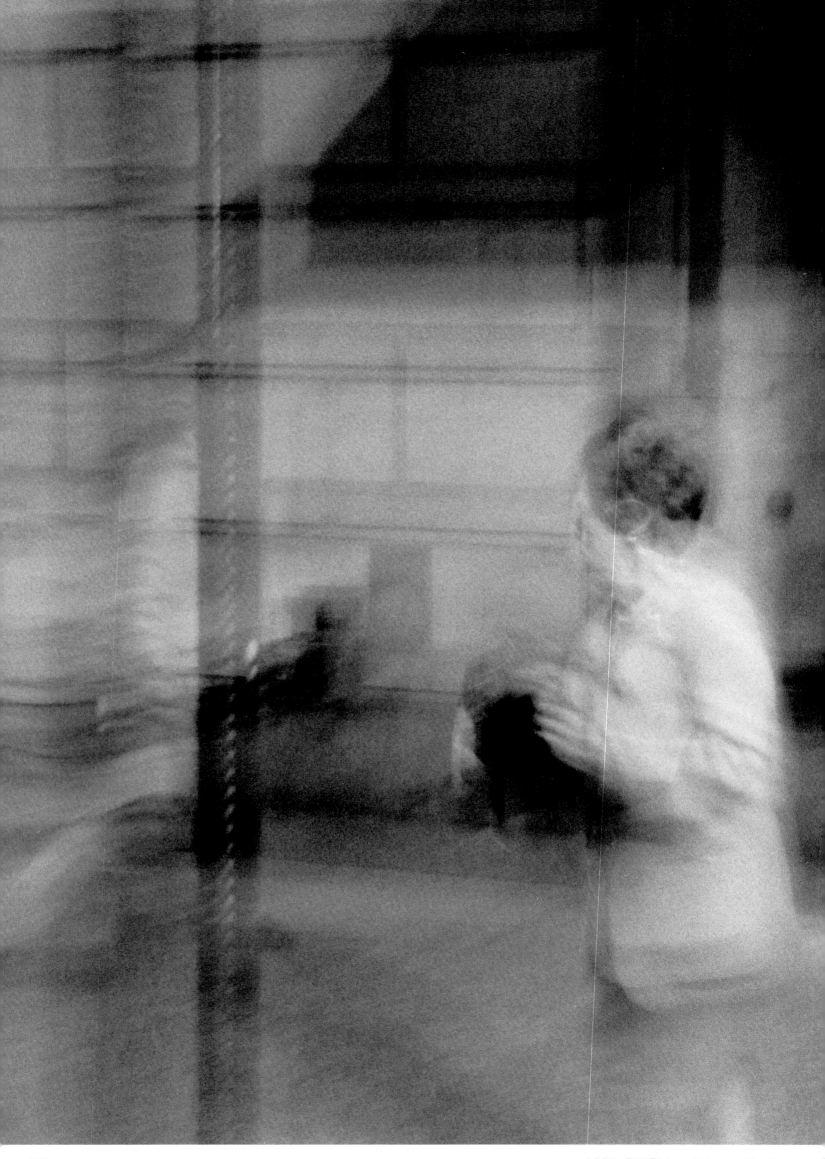

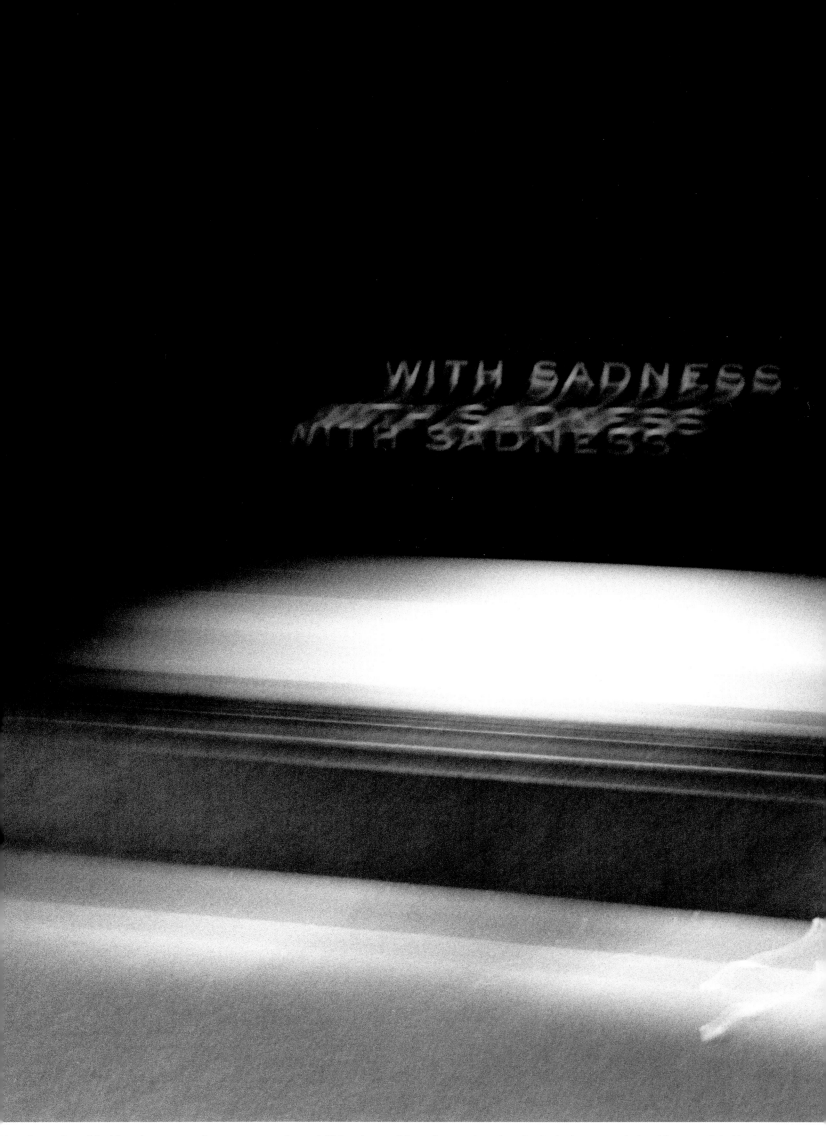

WITH SADNESS

've heard, all the images we've seen, we're still struggling to understand what happened in the world that day.

FAREWELL
TO THE TOWERS

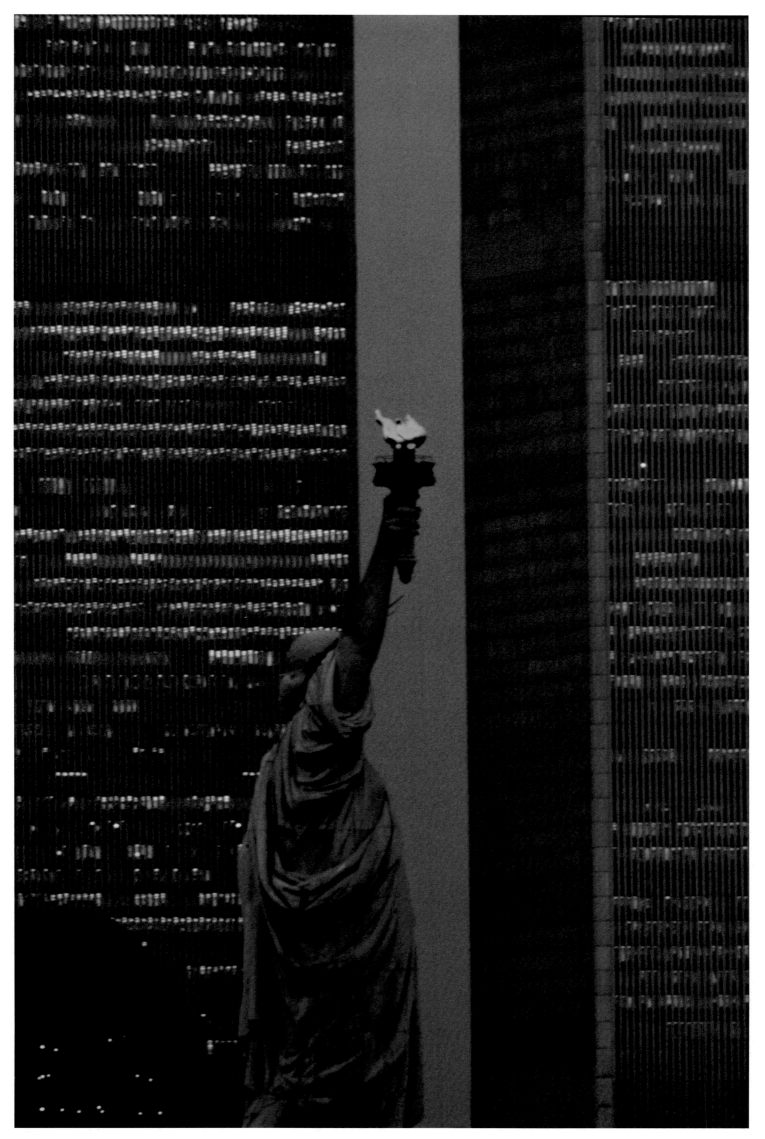

BRUCE DAVIDSON

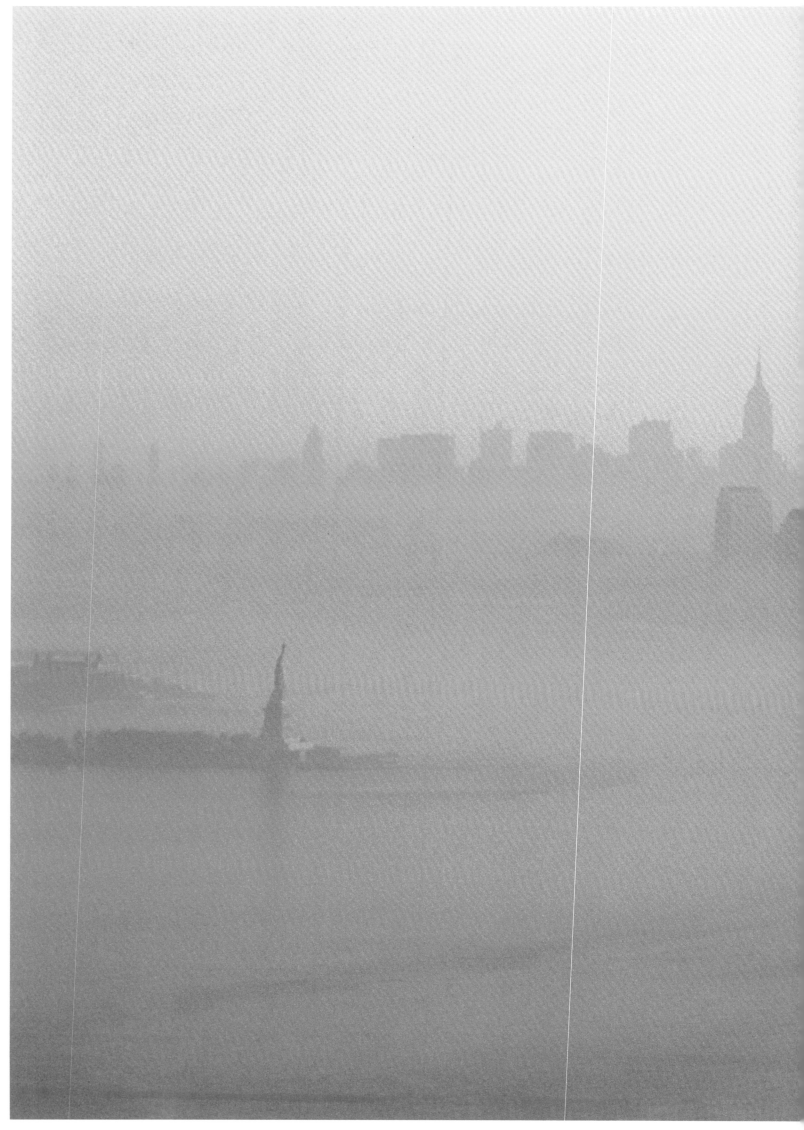

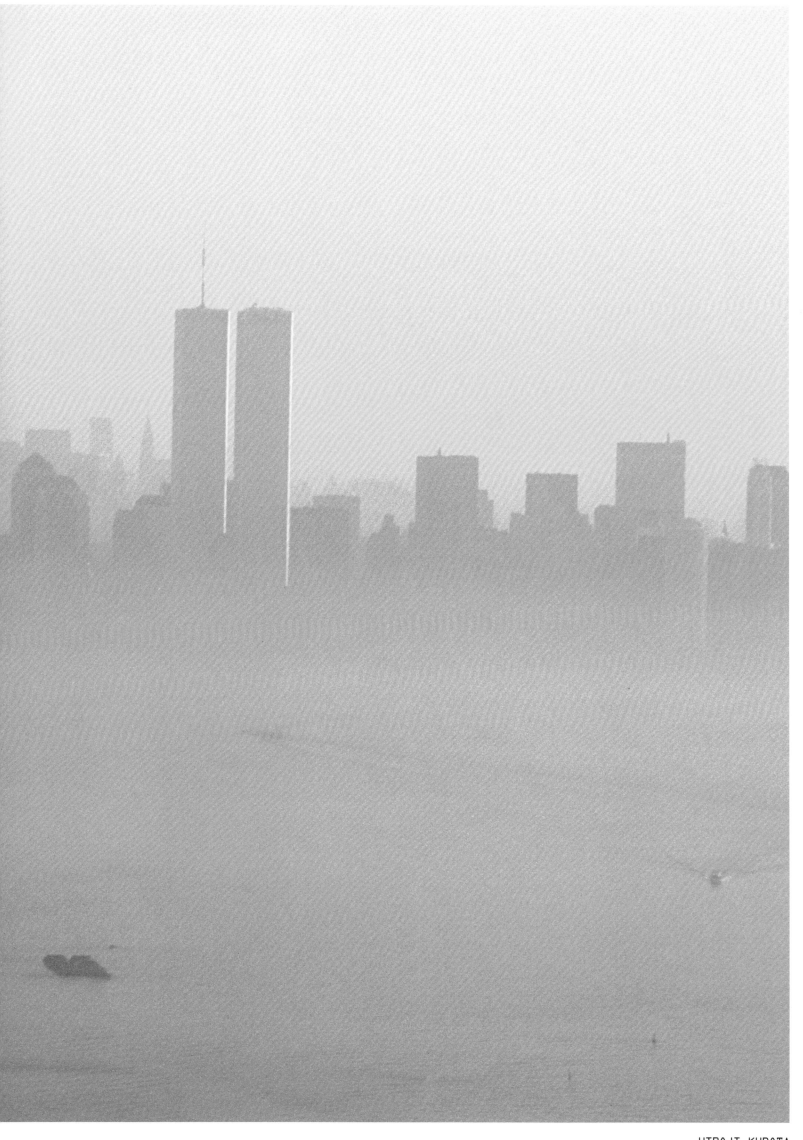

HIROJI KUBOTA

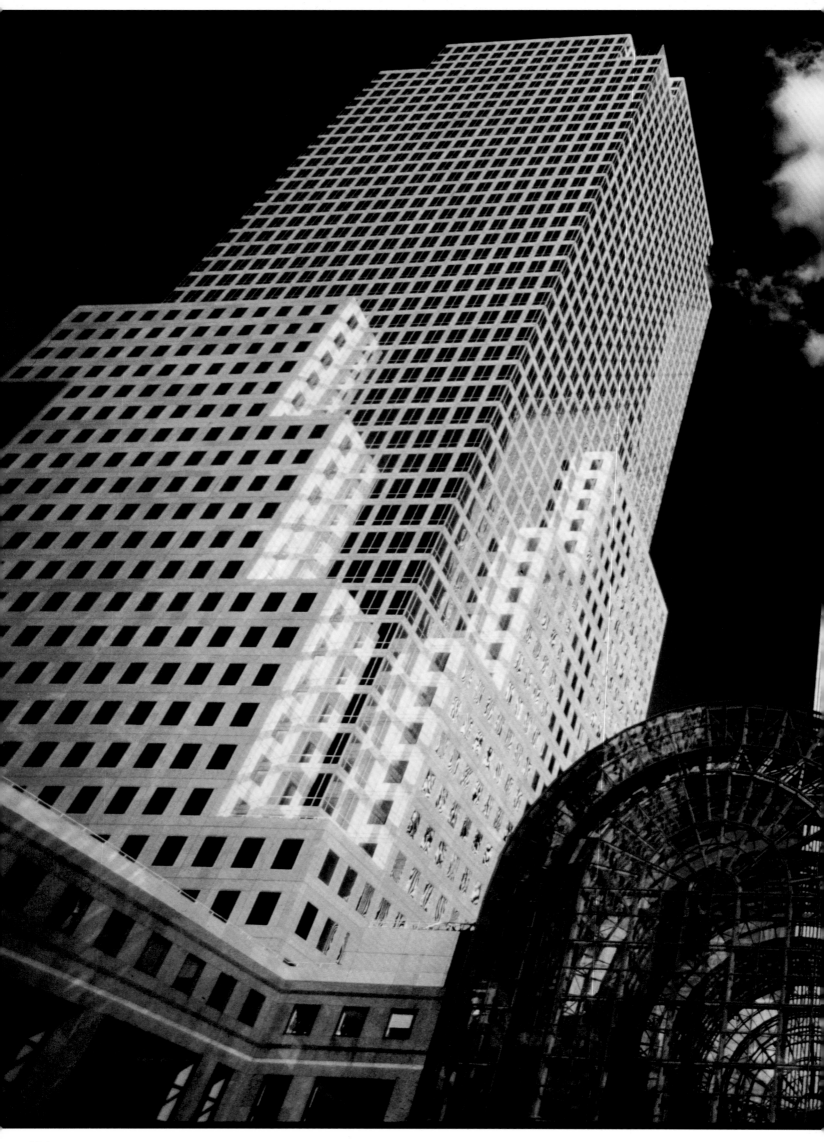

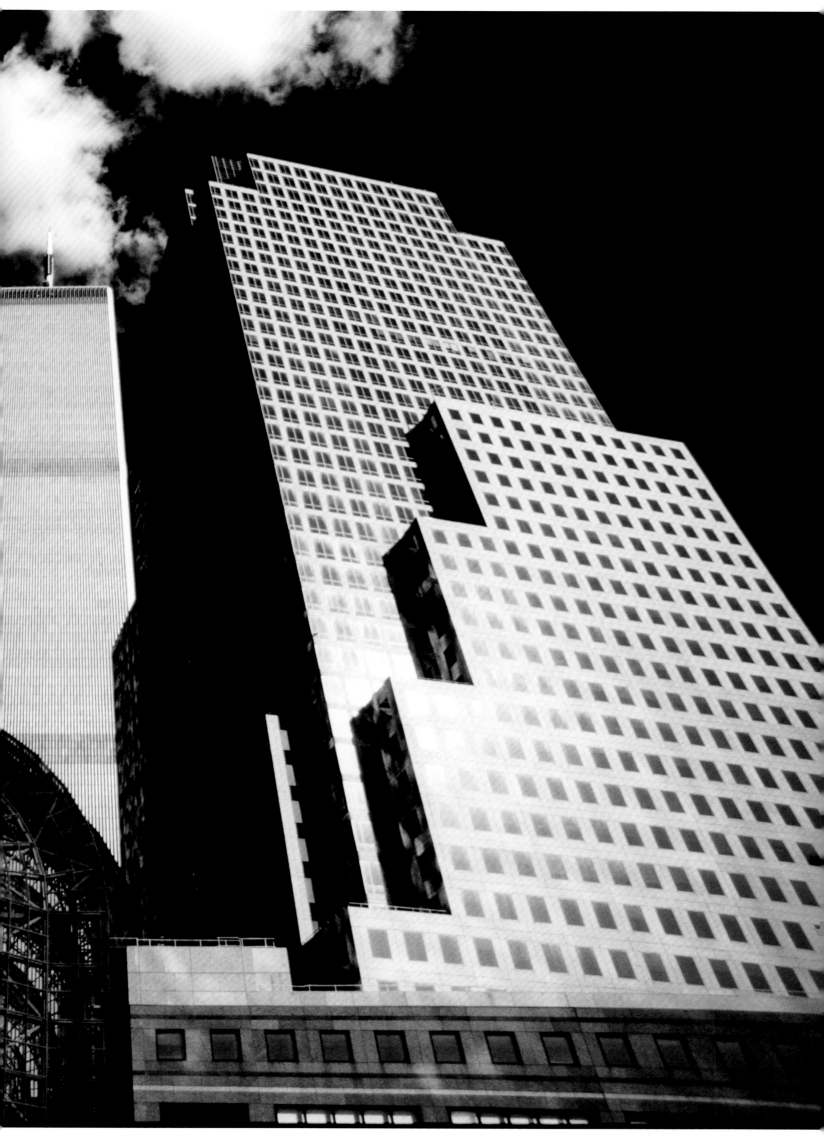

DENNIS STOCK

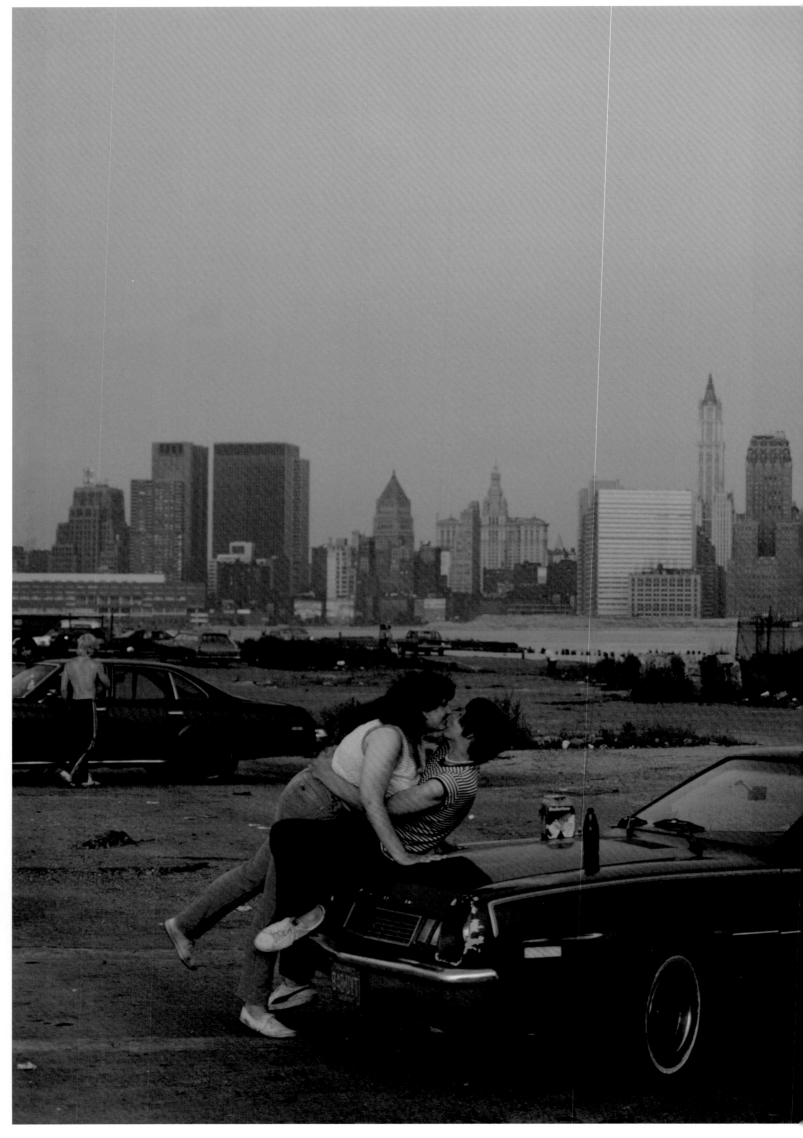

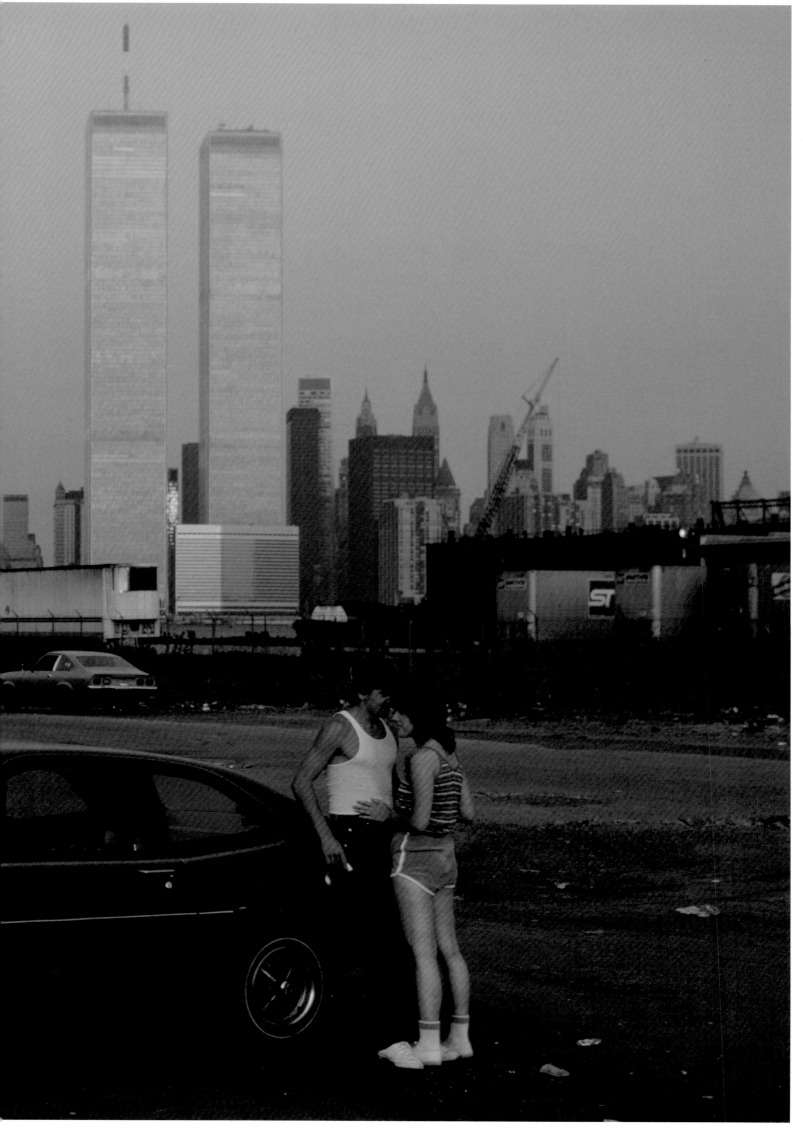

THOMAS HOEPKER

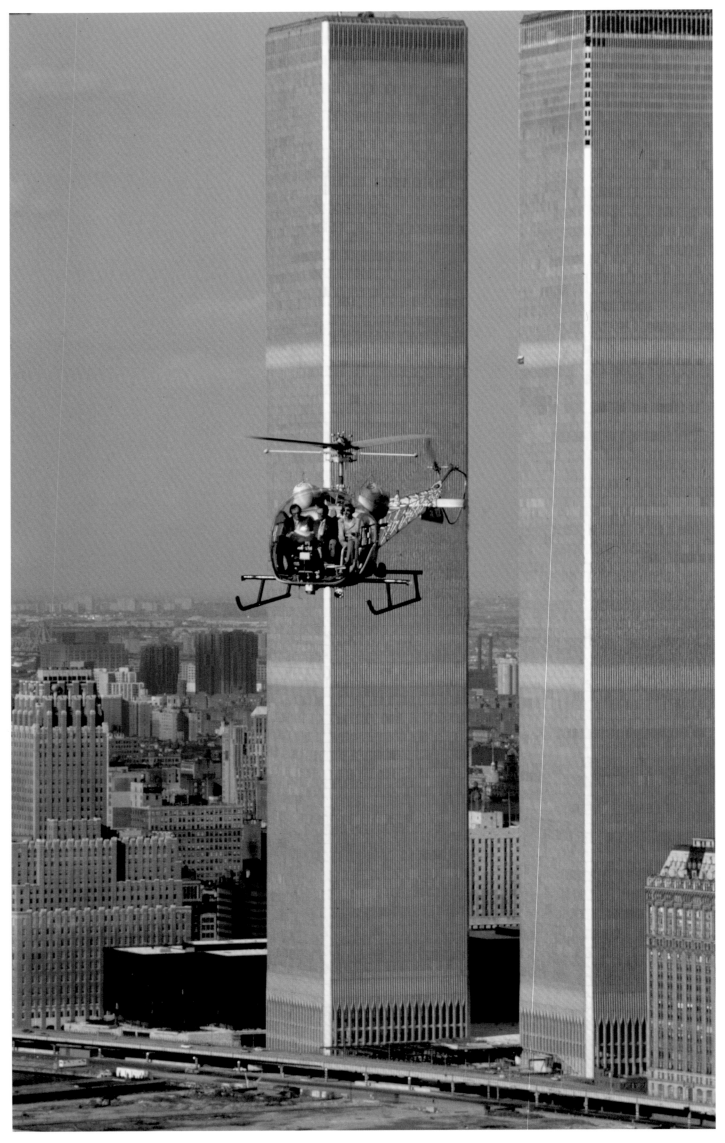

BURT GLINN

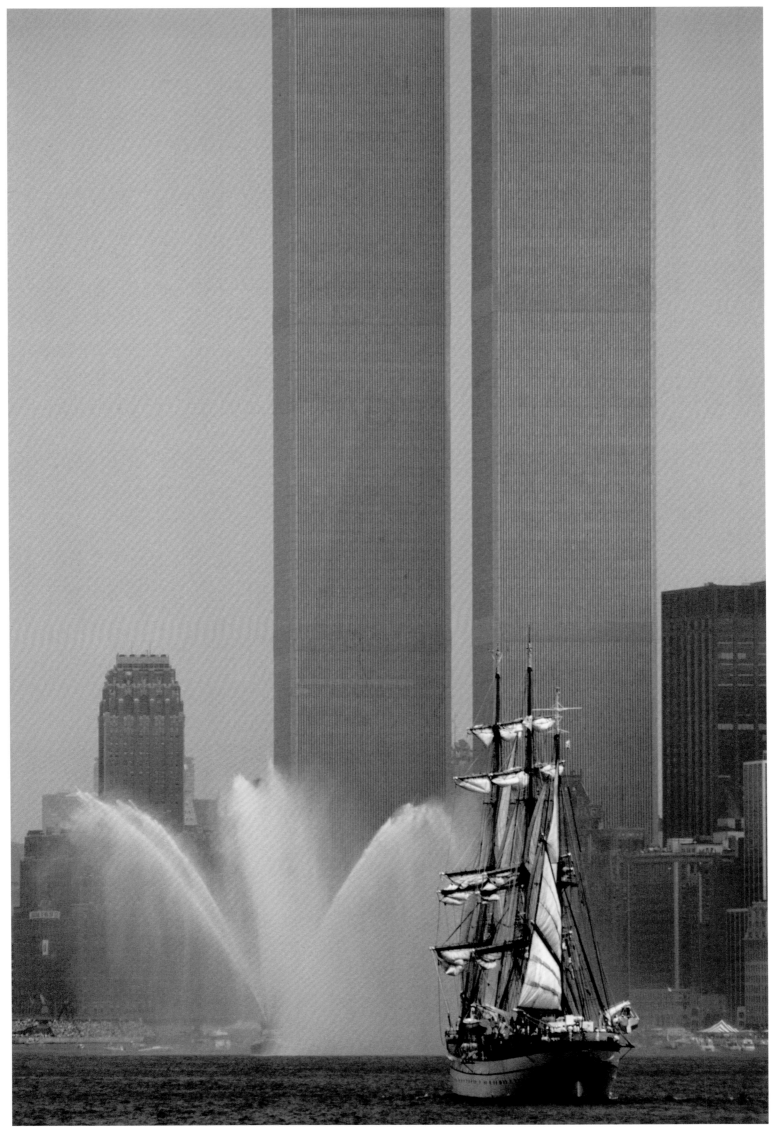

BURT GLINN

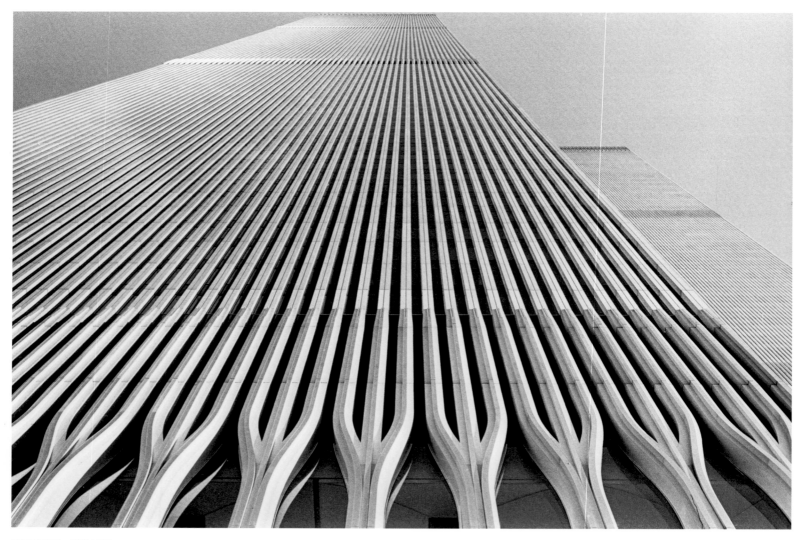

RICHARD KALVAR

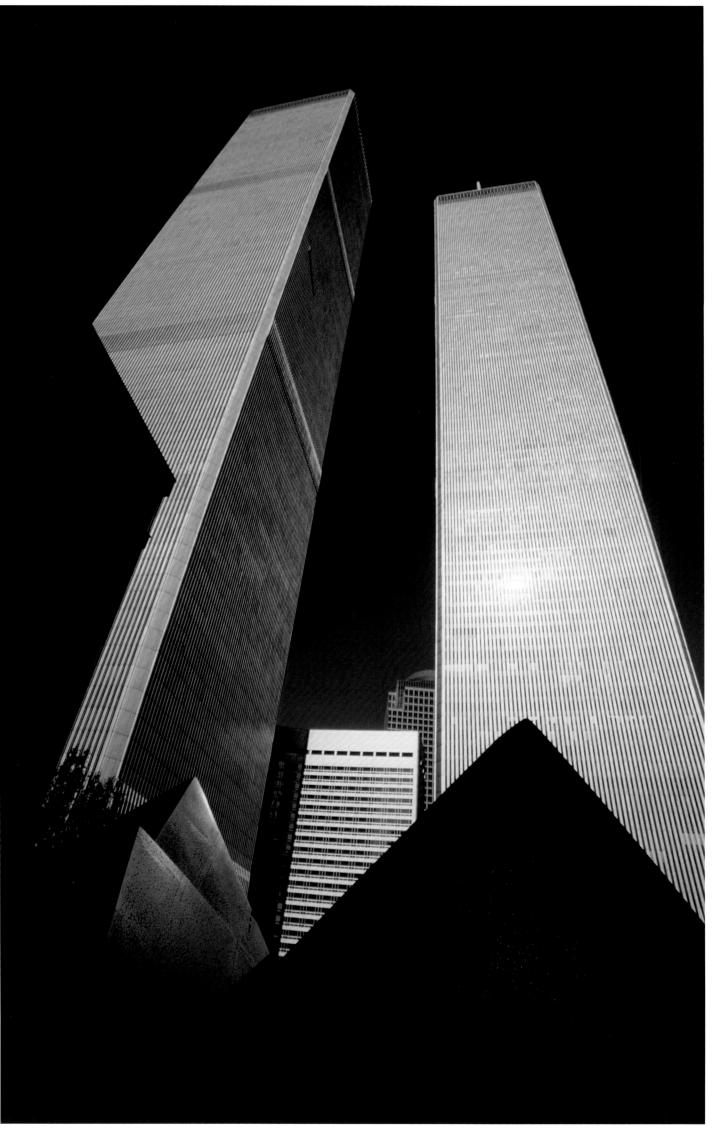

DENNIS STOCK

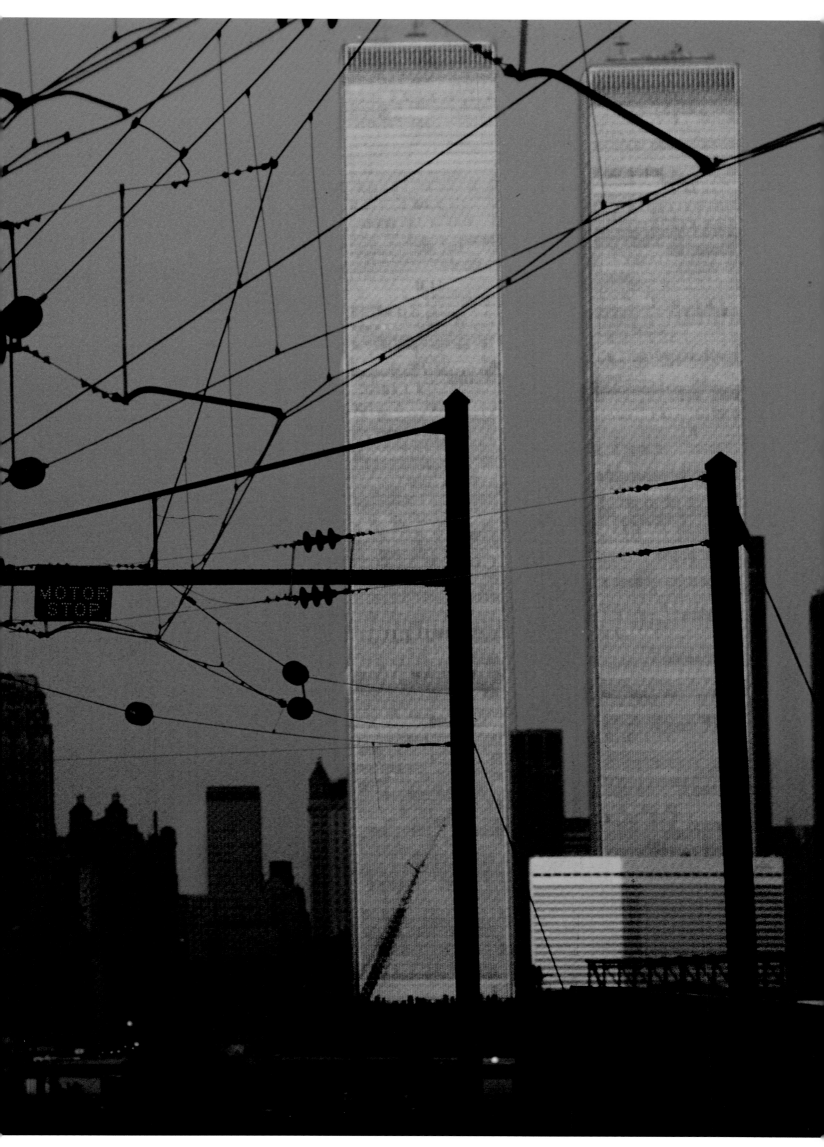

MOTOR
STOP

THOMAS HOEPKER

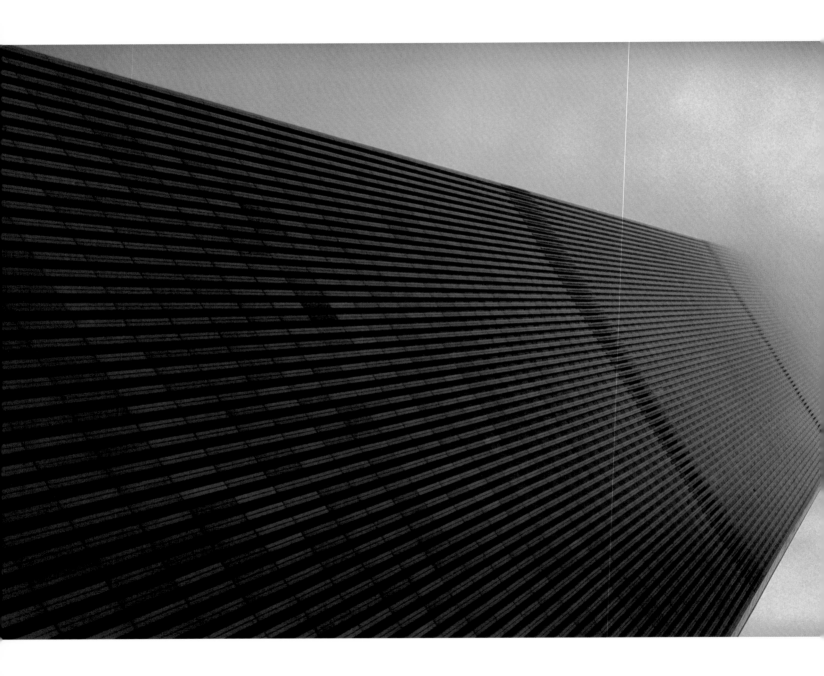

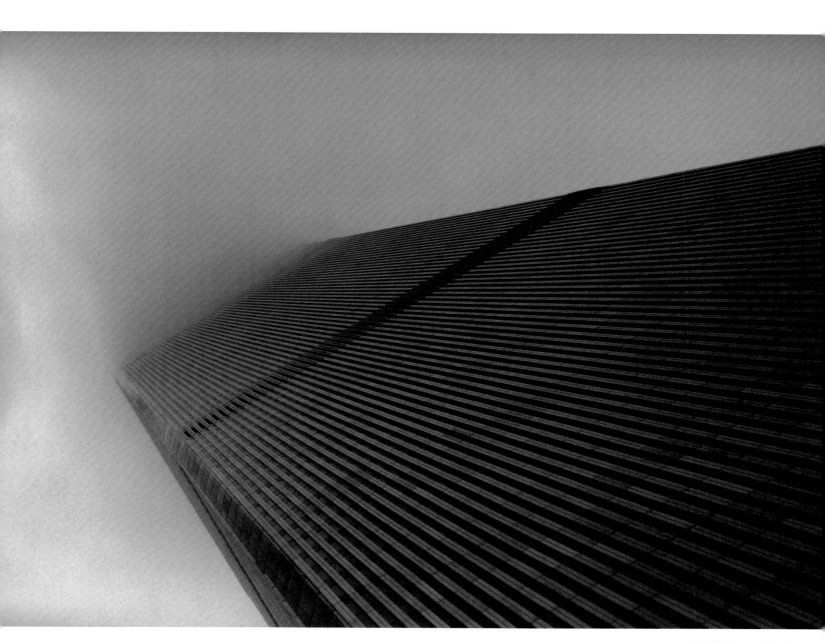

JOSEF KOUDELKA

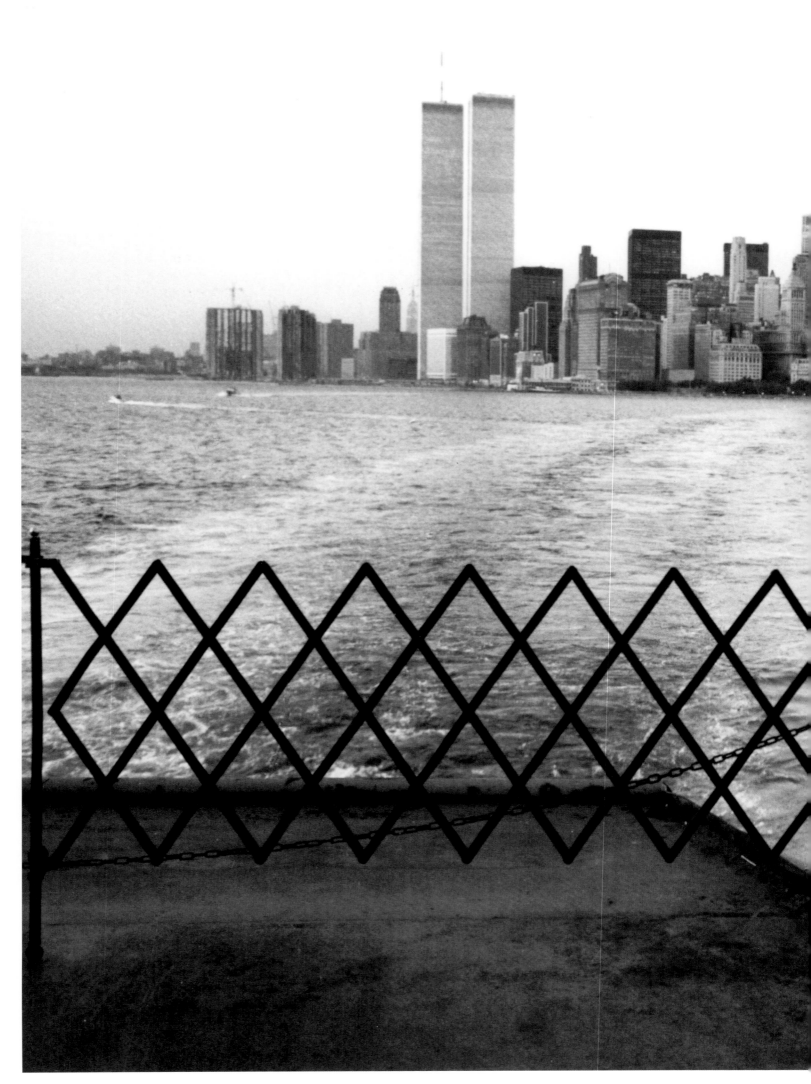

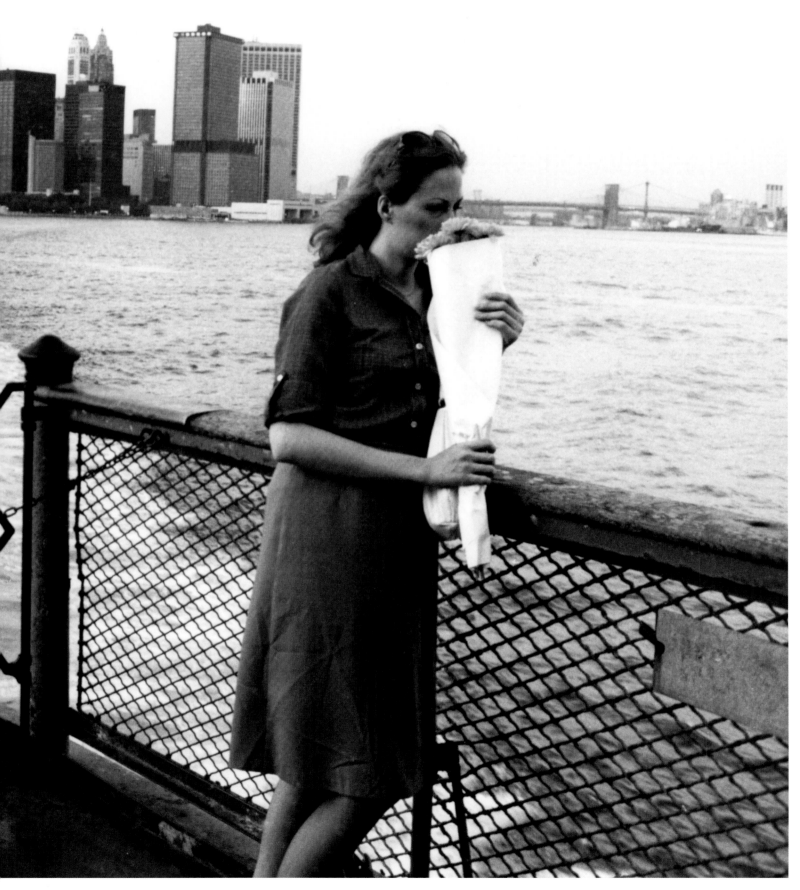

RAYMOND DEPARDON

Magnum Photos was founded in 1947 by four photographers—Robert Capa, Henri Cartier-Bresson, George Rodger, and David "Chim" Seymour. They created Magnum to reflect their independent natures as people and photographers, an idiosyncratic mix of reporter and artist that continues to define Magnum, emphasizing not only what is seen but also the way one sees it. The agency is a cooperative owned by its members; it has offices in Paris, New York, London, and Tokyo. Magnum currently has a total of 62 photographers—46 are full members, and 16 are nominees, associates, contributors, or correspondents. Member photographer Thomas Hoepker was the editor for this project, and director Nathan Benn the project manager; David Strettell deftly coordinated this undertaking for Magnum, and was assisted by Kim Bourus.

powerHouse Books is a stalwart, avant-garde publisher of photography, art, and popular culture non-fiction titles based in New York City. Started by Daniel Power in 1995 and greatly enhanced by Craig Cohen in 1996, the enterprise now counts Sara Rosen, Kristian Orozco, Susanne König and Kiki Bauer among its diligent staff. Associate publisher Craig Cohen was the production director for this project, Sara Rosen the publicity director, Kristian Orozco the sales trade strategist, and publisher Daniel Power the point man.

Yolanda Cuomo Design NYC is a graphic design and art studio in Manhattan's Chelsea district founded by design veteran Yolanda Cuomo in 1986. Renowned for training some of the best young talent in the business, she was assisted on this project by Kristi Norgaard, with collaboration by Astrid Lewis Reedy.

Kitty Barnes, the text editor for this project, is a writer and communications consultant for non-profit and corporate organizations nationwide. She was assisted on this project by Robert Goff.

A portion of the retail sales and publishers' net proceeds from this book are being donated to

THE NEW YORK TIMES 9/11 NEEDIEST FUND

The New York Times has established this fund to collect contributions to relieve the suffering of families struck by death or injury in the World Trade Center disaster, both civilians and rescue workers. The Times will cover all administrative costs, so every dollar contributed will go for relief.

Funds will be distributed by seven social service agencies and three foundations representing the uniform services. The agencies have agreed unanimously that they will do so according to a single uniform standard: need.

Additional contributions may be mailed to: The New York Times 9/11 Neediest Fund, P.O. Box 5193, General Post Office, New York, NY 10087, made by phone to (212) 556-5851, and online at www.charitywave.com or amazon.com/neediest.

ACKNOWLEDGEMENTS

The producers of this book are grateful to the many people and organizations who offered their time and talent to help make this book under difficult circumstances and demanding deadlines in the weeks after the September 11 attack on the World Trade Center. We would very much like to thank:

Rebecca Ames, Steve Antonelli, Raj Aya, Rick Bajornas, John Berthot, Steve Book, Ryan Brown, Ann-Marie Conlon, Laura de Korver, Sophie de Legnerolles, Andrew Freemont-Smith, Paul Gauci, Ben Gillis, Anne Greenberg, Sarah Hunter, Pablo Inirio, Malli Kamimura, Ernie Loftblad, Greg Morris, Matt Murphy, Jason Nakleh, Natasha O'Connor, Whitney Old, Daniel Parrott, Michelle Poir'e, Diane Raimondo, Robinson Varghese, Lalo Vela, Tom Wall, Jean Marie Walsh, Adam Wiseman, and Lizzette Zurita in the New York office of Magnum Photos for their professionalism and enthusiastic and unstinting support; writer David Halberstam for so precisely expressing what we all feel here; Daniel Frank and the dedicated group at Meridian Printing for that critical first expression of support; John Robinson of Gist for making the color separations without a moment's hesitation; Sandy Blaikie and Ron Raye of Acme Bookbinding and then Hunt Nichols and Dennis Dehainaut of BindTech and Fred Daubert and Mike Hill of The Riverside Group for quickly helping with binding; Kappa Graphic Board and Austell Box Board for their vital bookmaking components; Philippe Laumont and Baldev Duggal for perfect final prints needed for separation; Rick Smolan (and Leslie Smolan and Melanie Wiesenthal) for suggesting we contact Tom Kleimeyer, Tim Needham, Chuck DeWitt, and Betsy Mayo of Smart Papers, where the last ingredient needed to get this project done in book form came from (Knightkote Matte paper); Tom Sperduto of the U.S. Coast Guard for invaluable assistance; Frank Moster, Terry Wybel and the others at Continental Sales who convinced us (and then proved to us) that this idea of a book would be something important to and embraced by the American book trade.

NEW YORK SEPTEMBER 11, BY MAGNUM PHOTOGRAPHERS

© 2001 Magnum Photos, Inc.
Introduction © 2001 David Halberstam
Excerpt of "September 1, 1939" from *Another Time* © 1940 W. H. Auden, renewed by The Estate of W. H. Auden.
Published by Random House. Used by permission.

Published in the United States by powerHouse Books, a division of powerHouse Cultural Entertainment, Inc.
180 Varick Street, Suite 1302, New York, NY 10014-4606 telephone (212) 604-9074, fax (212) 366-5247
e-mail: info@powerHouseBooks.com
web site: www.powerHouseBooks.com

in association with Magnum Photos, Inc.
151 West 25th Street, New York, NY 10001-7204 telephone (212) 929-6000, fax (212) 929-9325
e-mail: photography@magnumphotos.com
web site: www.magnumphotos.com

Library of Congress Cataloging-in-Publication Data:

New York September 11 / seen by Magnum photographers ; essay by David
Halberstam.-- 1st ed.
 p. cm.
 ISBN 1-57687-130-4
 1. September 11 Terrorist Attacks, 2001--Pictorial works. 2. World Trade Center (New
York, N.Y.)--Pictorial works. 3. Terrorism--New York (State)--New York--Pictorial
works. 4. Disasters--New York (State)--New York--Pictorial works. 5. Rescue
work--New York (State)--New York--Pictorial works. I. Halberstam, David. II.
Magnum Photos, inc.

HV6432.N49 2001
974.7'1044--dc21

 2001052330

Hardcover ISBN 1-57687-130-4

Magnum Photos and powerHouse Books would like to thank the following suppliers for their generous support:
Smart Papers LLC, Hamilton, Ohio
Meridian Printing, East Greenwich, Rhode Island
Gist Inc. Prepress, New Haven, Connecticut
BindTech, Inc., Nashville, Tennessee
Acme Bookbinding, Charlestown, Massachusetts
The Riverside Group, Rochester, New York
Kappa Graphic Board USA, Chesapeake, Virginia
Austell Box Board Corp., Austell, Georgia
Duggal Visual Solutions, New York City
Laumont Photographics, New York City
Superior Printing Ink Co., Inc., New York City

A portion of both the retail and net proceeds from the sale of this book are being donated to The New York Times 9/11 Neediest Fund.
Money raised by the campaign will go to the seven New York charities supported each year by the Neediest Cases Fund to help those injured
in the attack or the families of those who died. The campaign will also support three foundations that aid New York City firefighters, police officers
and sanitation workers—the New York City Fire Safety Foundation, the New York City Police Foundation and the John Jay College of
Criminal Justice Foundation. The Times pays the fund's expenses, so all contributions go directly to the charities, which use them to provide services and cash
assistance to the poor. Contributions to the fund are deductible on Federal, state and city income taxes to the extent permitted by law.

Donations may be made with a credit card, by phone: (212) 556-5851 or online, courtesy of CharityWave.com or amazon.com/neediest.
For instructions on how to donate stock to the fund, call (212) 556-1137 or fax (212) 556-4450.
Checks payable to The New York Times 9/11 Neediest Fund should be sent to P.O. Box 5193, General Post Office, New York, NY 10087.

For licensing enquires, please contact Magnum Photos directly.

A complete catalog of powerHouse Books and Limited Editions is available upon request; please call, write, or visit our web site.

10 9 8 7 6 5 4

Printed and bound in the United States of America

Book design by Yolanda Cuomo, NYC